CITYSCAPE
PHOTOGRAPHY

CITYSCAPE PHOTOGRAPHY

JONATHAN EASTLAND

BT Batsford London

This book is for my son Adam and daughter Zoe.

Learn to see objectively;
see all there is to learn,
use the learning
and do the best you can
to make images worth keeping,
and pictures worth taking.

© Jonathan Eastland 1985
First published 1985

ISBN 0 7134 4337 5

Printed and bound in Great Britain by
Butler & Tanner Ltd, Frome and London
for the publishers
B.T. Batsford Ltd
4 Fitzhardinge Street
London W1H 0AH

Contents

ACKNOWLEDGMENT

Strictly speaking, an author's work is never all his own. This book is no exception to that rule and in producing the manuscript, shooting, printing and editing the pictures, advice and help has been sought and freely given by a great many people. To all of them my grateful thanks. In particular, to Mrs Jane Harvey of Canon UK Ltd loans department; to Harry Collins at Nikon UK; to my Editor, William F. Waller whose patience was over-extended on more than one occasion and without whose interest this book would not have come to fruition; to Barbro Hunter and the Swedish Tourist Office in London for making my visits to Stockholm a simple pleasure; to my brother Peter for the use of his pictures; and to my wife Caroline for her help with editing, her company and, most of all, her understanding.

1 Introduction and Scope

There is something fascinating about cities. So often, I have watched skylines receding or growing ever closer from the windows of trains or cars in many parts of the world. Occasionally, I am compelled by some curious, overwhelming need to stop what I am doing and venture into these concrete jungles to try and record a lifestyle which is so far removed from my own. I am but a casual observer of city and suburban life, of monumental building projects, bridges and glass houses, of the seedy sidewalks, dwelling units and the grim, but powerful images created by city planners who play with building projects and people's lives.

Form and shape, the effect of light and shade on blocks of stone, prefabricated concrete, on bricks and mortar and acres of glass, are the ingredients which first attract me. Through the camera lens, I see only pictures of these wonderful places; sometimes elegant and beautiful, sometimes ghostly and ghastly. Now and then, I am sucked in and allowed to stay and search deeper into these hearts of stone.

People who live and work in cities and towns and suburbia are, for the most part, the same as those who live outside – only different. The sidewalks of Paris are littered with cafes, bars and restaurants, often filled to overflowing with city folk from all walks of life. They read, engage in endless animated conversation, or simply watch the world go by. There is nowhere else quite like Paris: a city where people are not afraid to walk, to rubberneck, to laugh and smile. In New York, the ice-cream vendor on Broadway wears a peaked cap and looks like a policeman, his transistor radio securely shackled to the handcart with an oversized length of chain and padlock. In London, civil servants walk to work in Whitehall, toting umbrellas and briefcases in a manner which only an Englishman can. Nowhere are the English more English – and yet

Save for the style of environmental design which may give a clue as to the exact location, there is one small part of the resident community in every city which is much the same: the busker. In Stockholm I found these street musicians and performers colourful, drawing large audiences from under-amused throngs of passers-by; in Paris or London, buskers probably make as good a living and are as accomplished in their chosen act, but they often receive less attention from the public and, sad to say, Parisians will not have the pleasure of their company for much longer since new laws were passed making it illegal for street musicians to remain stationary in public places; in Greenwich Village and other parts of Manhattan, the busker lives on and thrives during the twilight hours, collecting tiny groups of enthusiastic fans often spread over a length of half a block. I have found buskers in metros, tube stations and underground car parks, not to mention pedestrian subways and the street pavement; gather them together from the four corners of the earth and it is questionable whether the casual observer could identify their country of origin. But their natural environment is as essential to the photographic requirement as their naturally colourful charisma.

This is not a book about architectural photography, though it does discuss some facets of the techniques used in that field. The photographer who has some knowledge of building principles and who understands the basic principles of constructional engineering may be at a slight advantage over the

one who knows nothing, in that some aspects of cityscape photography may be recognized more easily and rapidly. Essentially, this book is designed to prime the photographer into thinking about and searching out pictures in an environment which may have hitherto been ignored.

It explores shape and form and how these are altered continuously by light conditions. It shows how some pictures rely to a large extent on graphic form to create impact, atmosphere and drama, how people fit into these building blocks to lend scale and animation, and how people are used effectively in some photographs to give the onlooker more than just a feeling of a sense of place or a sense of being there.

Throughout the book I have tried to encourage the reader to look at people and photograph them in a different way from the norm: to try and show them visually as they really are, conditioned by the environment in which they live, instead simply of using them as insignificant props. Looking at people commuting to and from work, for example, will necessitate venturing into the world of transport: railway stations, airports, bus depots and quite ordinary locations where the photographer will find both the normal and the bizarre at the turn of the head.

Certainly the most fruitful location to begin looking for pictures is in your own 'backyard': the city or town in which you live. Cityscape photography is not confined to the metropolis; the material for subjects is all around us, in cities, large and small, in sprawling urban areas as well as provincial towns which may, because of some authoritarian hiccup, never attain the distinction of being labelled a city. Intimate knowledge of a given geographical area will at the outset always be more useful than a few sketchy ideas about a place only seen on the pages of an atlas. Perhaps, when one is more sure of style and technique and one has some ideas of what to look for and where those ideas will be most readily transformed into pictures, it will be time to venture further afield.

Unlike landscape or general travel photography, images of cities and their environs have to be built up step by step: it is only the rare and exceptional individual picture that can tell the whole story. Cities are such vast jigsaw puzzles sprawling in every direction that even long-term residents may not at once recognize their own backyard when confronted with it in two-dimensional form.

Over the years, I have found many colourful and exciting cities and suburbs on foreign soil. The images of the homeland that I treasure most are often, by comparison, drab reflections of places visited or lived in. But they are not cold images. They are full of memories of happy times and whimsical nostalgia. Perhaps this has to do with the way we see things generally. Visual perception – that which affects the way we see photographically – is a long but important topic which is explored further in Chapter 3. More than anything else in photography, it is a subject which can, and often does, provoke endless conversation, occasionally verging on that old tormentor, 'photographic art'.

Whatever the viewer's feelings about art and true representation may be, one thing hardly ever changes. Our European climate bathes cities, urban areas, industrial sites and chimney stacks in a sort of warm, grey luminance, which artists have tried for centuries to capture on canvas. Many photographers find such lighting qualities irresistible and essential for their work; a quality of light which is not found in those other parts of the world where climates are warmer and contrasts harsher. The variety of English weather never fails to inspire, come rain or shine. Use it to add depth, brilliance, form, warmth, mood, and so on. The reader is invited to study closely the quality and direction of light used to make the images reproduced in this volume, but do not stop here. The learning process must be continued at every opportunity: use the pictures reproduced in other books, magazines, newspapers, on television and in the cinema. What did the photographer want to portray? How did he/she do it, what optics were used and will you remember tomorrow what you saw in print yesterday?

The purpose of visual study is to help further the understanding of technique and lighting. Do not attempt to copy the work of other photographers; plagiarism of genuine 'works of art' is rarely successful and actually teaches the student little about his or her own capabilities. The study of the work of painters, on the other hand, can often stimulate the imagination and produce a pot-

pourri of ideas and themes which the photographer can begin to explore with a camera, hopefully discovering *en route* that there are so many facets to this particular subject that exhaustion will never be a problem.

Many of the pictures in this book have been taken in transit: visits to major cities of the world were hardly ever the result of long-term planning. Often they only came about because I was on my way to, or they were close to, some other assignment and, perhaps because these visits were spontaneous, casual affairs, a magical spell was often cast which has taken me back on more than one occasion. At other times, closer to home, images of the way certain buildings or structures look in different lighting conditions have plagued me until I can no longer sit still without trying to capture it on film, the only incentive being to create the picture. What I might do with it afterwards is another thing. The essential point is that, in the first place, photography should be a pleasurable occupation; learn to see the way a camera sees, not how you think it ought to. Be patient, be meticulous and be inspired by the great things which surround our humble lives. 'The purpose of art,' said Margaret Bourke-White, 'is to find beauty in the big things of the age.'

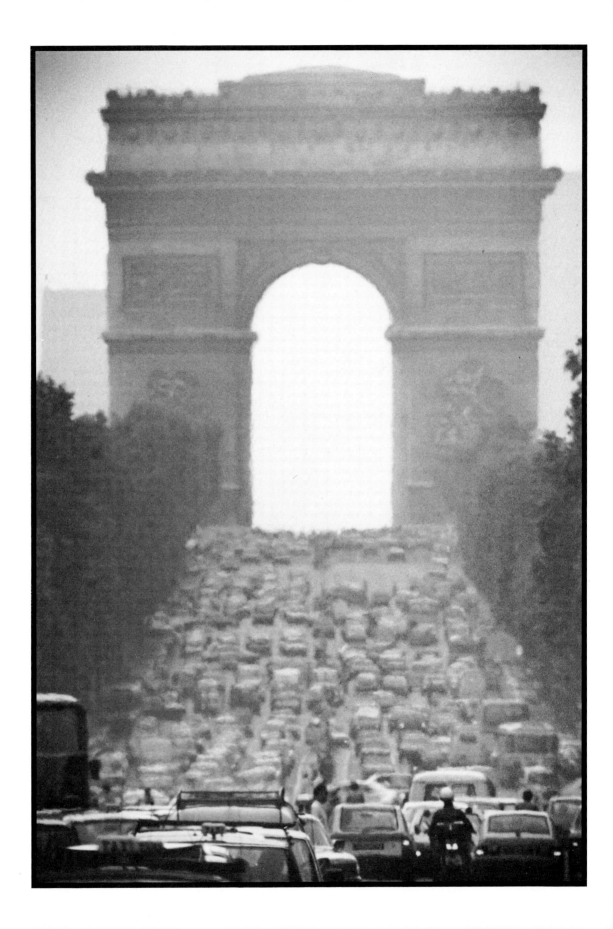

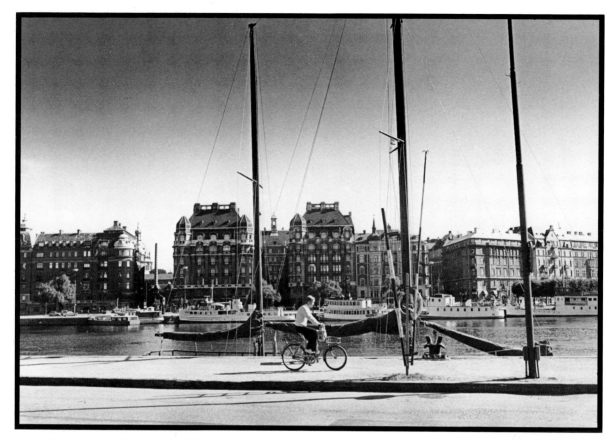

2 Stockholm: *waterfront of the Old Harbour (Nikon F; 35mm Nikkor; HP5 with light yellow filter)*

1 Paris: *the Arc de Triomphe from a distance of about 1 kilometre ($\frac{1}{2}$ mile)*

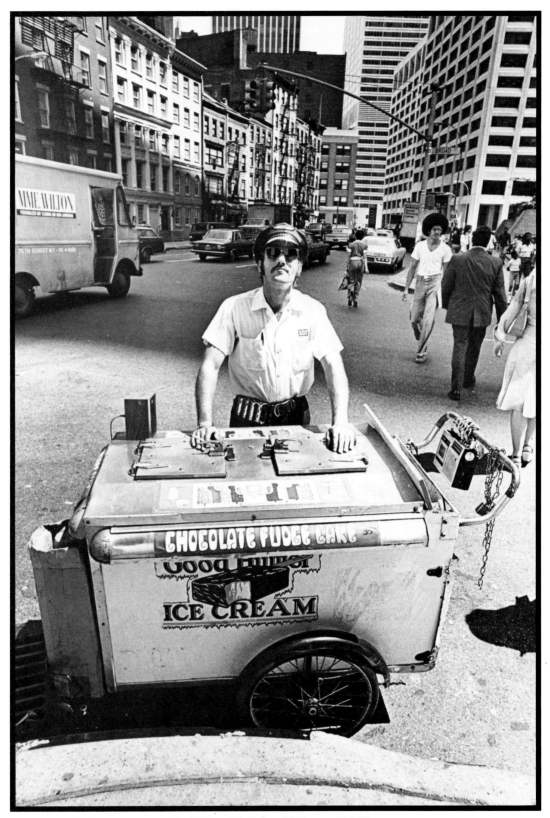

3 New York: *The ice cream vendor (Nikon F2; 24mm Nikkor on Tri-X)*

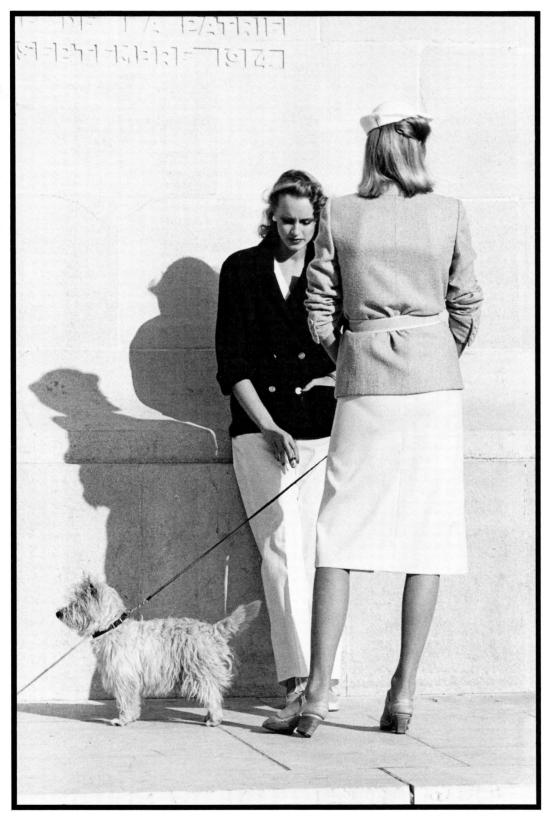

4 Paris: *Ladies in the park, Champ du Mars (Nikon F; 200mm Nikkor; Tri-X)*

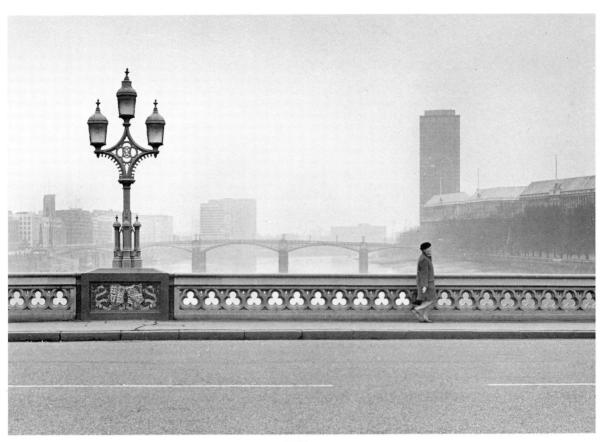

5 London: *Westminster Bridge (Nikkormat FTn 50mm Nikkor-H, Tri-X)*

6 Stockholm: *city centre (Nikon F2; 20mm Nikkor lens; polariser on Tri-X)*

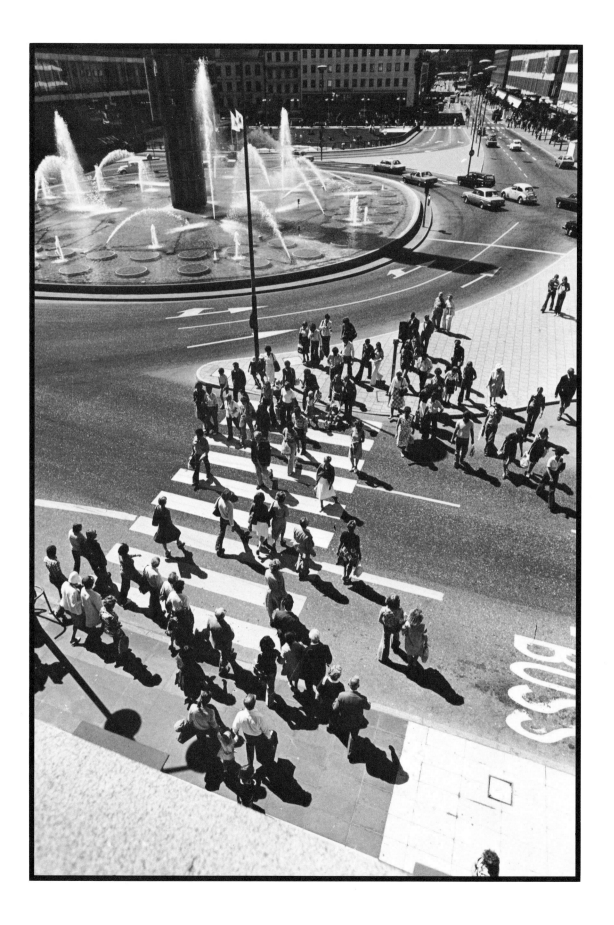

7 Paris Metro: *the blind accordionist (Nikon Rangefinder; fl.4 Nikkor 50mm; Tri-X)*

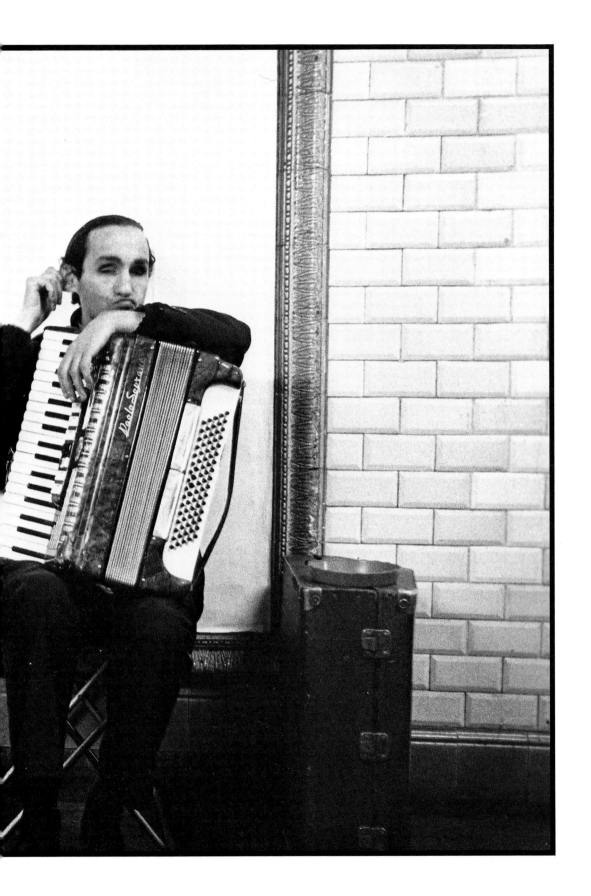

8 Providence, Rhode Island: *diesel truck (Olympus OM1; 70-180mm zoom lens; HP5, no filter)*

2 Architectural Techniques and Equipment

The photographer of cityscapes is not bound by the strict disciplines of pure architectural photography. However, it will be useful to understand the uses to which architectural photography can be put and the parameters within which pictures can be made, before wider fields, using other subject elements, are drawn into the composition.

RECOGNIZING THE PHOTOGRAPHIC POSSIBILITIES

There are three basic groups of architectural photography:

the survey

the illustration

the picture

The survey requires documentary information: the purest form of record which may be of use to students, historians, designers of stage or film sets, artists, illustrators, technicians and architects. We are not concerned with making a *picture* of the subject, but with allowing it to be reproduced as faithfully as possible. This may and often does necessitate using large format view cameras which are equipped with all the necessary vertical and horizontal movements, swings and tilts capable of controlling distortion and depth of focus. The subject may have to be recorded from several different positions in order to show the various aspects of architecture or construction, or both.

The illustration is concerned with presenting the subject in such a way that its emotive qualities predominate; the viewer is immediately conscious of elegance, beauty or historical association in the subject, rather than in the photograph. Various subtle heightening devices may be used to improve what might otherwise be fairly uninteresting natural surroundings: the use of foliage – natural or imported for the occasion – adequate sky space to improve isolation and filters to improve tonal contrast in black and white or richness (saturation) and to correct colour balance with colour reversal and negative materials. An indirect benefit of carefully controlled exposures may also illustrate the subject's architectural qualities.

The picture is the result of careful and selective composition using the aesthetic values of the whole or part of a building or buildings. This information is presented in such a way that its graphical interpretation will have impact on the viewer. The desired effect may be achieved using any number of devices or a combination of device and technique. The raw material for such pictures may be provided by an infinite number of sources, including graveyards, bomb or demolition sites, high-rise tower blocks, shops, precincts, terraces, buildings of historical or architectural importance, sculpture, decoration, and so on. Pictures may result from patterns created by brickwork or other materials, repetitive building techniques, avenues, motorways, lamp-posts, chimneys; or from texture or the graphic design presented by one building or a collection of buildings when viewed from certain angles. The picture is not necessarily concerned with presenting useful information to the student of architecture but may do so indirectly.

Elementary knowledge can help the photographer to decide whether certain aspects of architecture are graphically more interesting because of association. For example, knowing the difference between Renaissance or Baroque periods; the ability to differentiate between romantic and more formal works will not only help with planning but also with recognition of more important as-

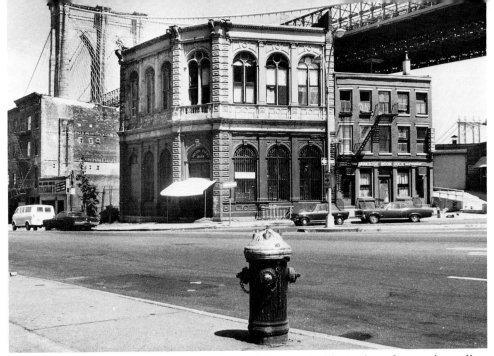

9 *Fulton Ferry Bank building, Brooklyn, New York. The architecture of this building dates from about 1880, but the ornate façade is mainly a construction of pressed steel. The fire hydrant in foreground adds a little depth to this otherwise ordinary, but interesting record. (Nikon F, 35mm Nikkor lens, Tri-X)*

pects of design and composition. Historical knowledge of various forms of architecture will often present entirely different possibilities for pictures of buildings that may otherwise pass by unnoticed or ignored. In other words, knowledge of the subject may, and often does, help to inspire photographic possibilities.

The photograph of Fulton Ferry Bank (*Fig. 9*) interested me not through any financial consideration, but from a sociological and architectural viewpoint. Dominated by a towering Brooklyn Bridge, the old bank must have been a godsend to commuters travelling the short distance by ferry across the East River to lower Manhattan. Architecturally, it is fairly commonplace amongst thousands of similar midtown city buildings; however, the constructional details were more interesting. The decorative mouldings around doors, windows and eaves were not painstakingly constructed brick by brick or moulded in liquid plaster, but pre-formed by the mile from zinc-plated mild steel, cut to length and bolted in place. Rusting examples of this kind of decoration can be found all over Manhattan, Brooklyn and in other American cities. To the student or historian,

it is a useful illustration of cosmetic application; to the lay person, interest is primarily stimulated by nostalgia for an epoch long past.

In another example, a toll bridge spanning the Itchen River in Southampton had been gnawing away at my photographic conscience on and off since work on the bridge first began more than a decade ago. For generations, people on both sides of the water had commuted back and forth by a ferry dragged on steel cables: a rather archaic mode of transport by modern standards, but so pleasant and so unrushed. Not only would an enormous bridge sever the delights for thousands of daily seaborne crossings, it would have a dramatic effect on the lives of waterfront residents and shopowners. And, moreover, this was no ordinary bridge: when finished, its architecture would dominate the city skyline. High enough to allow great ships to pass below, the span bit deep into the landscape on either bank. How to interpret all of these facets photographically presented a challenge which kept me occupied for some time. The bridge is one of those subjects that encourages the photographer to return time and time again. Lighting is the key to the reason why.

Ideally I wanted to make a picture that would show how the enormous, arching span of the bridge dominated its surroundings: a view that would be instantly recognizable by all who lived under its shadow. The picture

had to show the architectural elegance of the construction and, at the same time, indicate to the viewer its sociological consequences.

This theme later developed into an idea for a full-length pictorial feature. For the time being, however, I was mainly concerned with investigating the possibilities of several angles, all of which, I thought, could produce the one picture I had vaguely formed in my mind. Several positions were possible but only one presented itself initially as being the ideal spot: the belfry of a nearby church. Many obstacles at ground level – trees, lamp-posts, buildings among others – partly obscured the view I wanted.

Before attempting the picture from the church tower, I shot a roll from ground level using the Bronica and a 300mm lens which I hoped would compress the vista sufficiently while allowing a fairly large proportion of buildings in the immediate vicinity of the bridge to be retained. The bridge is constructed mainly of concrete and in bright contrasty light this material was illuminated with great effect, making the great arch appear like a huge white gash across the skyline. Early one bright spring morning I began shooting, using a light orange filter and HP5. I gave an extra half-stop allowance for the haze which, even at that time of the day, was already beginning to build up over the water. I could have increased the exposure by a further 20 per cent or so to give extra detail to the buildings below the bridge which were mostly in shade, but this would have spoiled the overall effect I was trying to achieve.

The result of this first shoot was very disappointing. Two factors were against reasonable success from the outset. One was height: I needed more than I had from the same vantage point, but that was impossible bar importing a mobile crane and cradle. The other was light: even early in the morning, the light was still not contrasty enough for the effect I was after and, on looking further at the prints I had made with the Bronica, I decided that the angle of light was too frontal and what was really needed was more *contre-jour*. I waited several months before attempting to shoot the scene again, realizing that the kind of sharp contrasty light at the end of the day in late autumn would probably be far more suitable. I visited the area several times in between in

order to satisfy myself that I had not overlooked other picture possibilities. It was lucky that I did, for there was one view of the bridge I had not seen before. A railway station served the small population on the eastern side of the bridge and from another road bridge crossing the tracks it was possible to make an interesting view incorporating the lines.

Towards the end of an October afternoon, I filled the car with as much equipment as I could find, including several telephoto lenses, a couple of medium wide angles and a Canon 35mm Tilt and Shift lens. Starting on the river bank virtually under the columns of the bridge, I set up the tripod with the Canon AE-1 and 35mm lens attached and began making a few trial exposures.

The light was badly overcast, almost stormy, with the sun breaking through every few minutes or so. These were not pictures which I had planned in advance, but rather than go straight for the church belfry shot or the railway lines, I had decided at the last moment to see if looking through a wider lens than I had previously envisaged would give me some different ideas.

By the time I had waited for the sun to break through and coincide with buses passing overhead or ships passing beneath the bridge, most of the afternoon was lost. The sky clouded over completely. By half way through the following day, the depression had moved on and in its place a superb clear low light lit the deep blue, almost purple sky. This time I went straight to the church tower. Using a Nikon FG and 80–200mm zoom lens with a light yellow filter, I made several exposures on Ilford HP5. Looking through the viewfinder, I felt slightly disappointed that the image before me was still not the one I had so clearly fixed in my mind. Somehow, the hugeness of the bridge was entirely lost by the extra height gained for a clear run at it. At ground level once more I moved quickly on to the railway, made three exposures in very quick succession as the light was fading fast and returned to the darkroom to process. There would have been little point in waiting around, since I was already working at full aperture at about 1/125 second. Any slower than this and the traffic on the bridge would have blurred. It was essential that it be caught stationary for the pictures I wanted.

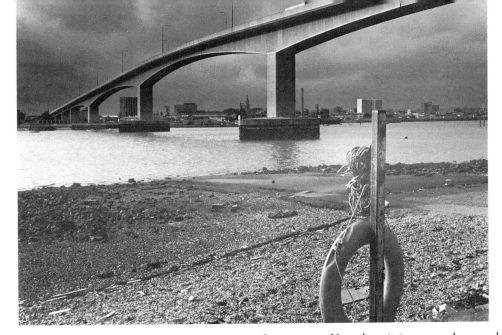

10-12 *This bleak concrete monstrosity spans the River Itchen at Southampton, England, and replaces a mode of transportation which, although slow and archaic, was the heart of a small riverside community. The ferry used to run from the far side of the river to the now empty slipway just in front of the lifebuoy. Every evening around five, the ferry gates would open and a flood of people hastened home to tea. Now they sit in cars or buses and wait at jammed toll gates, isolated from the world and the flowing river 80 feet below. Fig. 10 was made on a Canon A-1, tripod mounted and fitted with the Canon 35mm Tilt and Shift lens with HP5; Fig. 11 on a Nikon F with 200mm f4 Nikkor, Tri-X; and Fig. 12 with Nikon FG, 200mm Nikkor zoom also on HP5 with a yellow filter in late afternoon.*

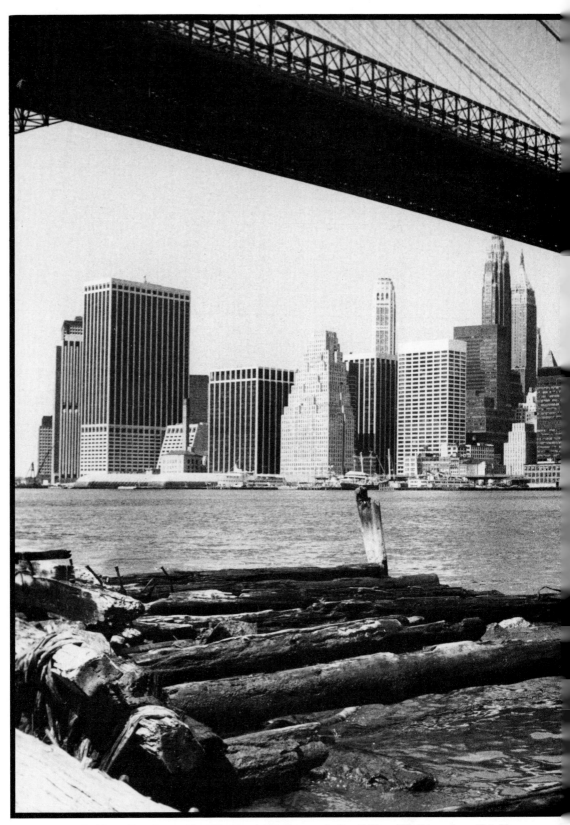

13 Brooklyn Bridge: *East River, New York and Manhattan skyline (Nikon F2; 24mm lens; Tri-X)*

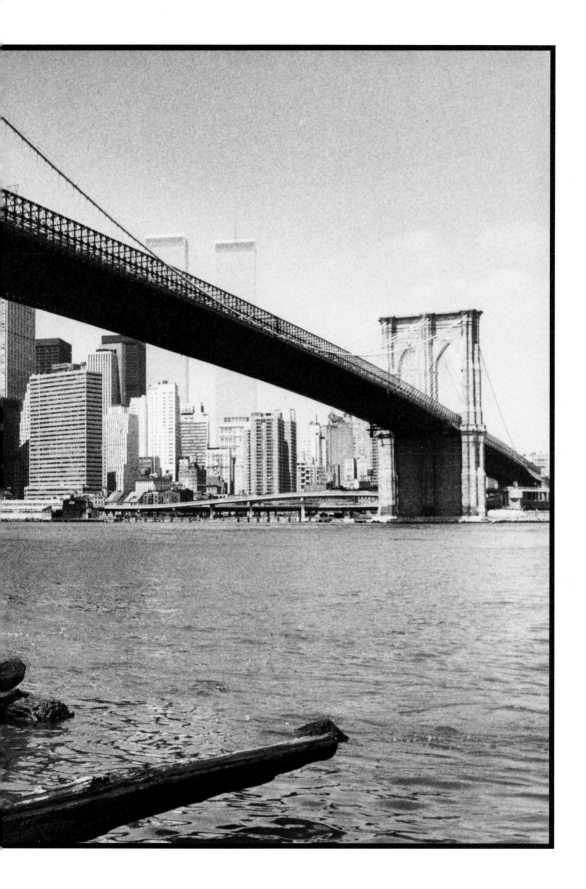

In the darkroom, I used Ilfospeed grade 5 paper to bring out the extreme contrasts of light and shade. The negatives had been deliberately underdeveloped by about 15 per cent so as to lose as much shadow detail as possible while retaining the full effect of back lit highlights.

At last I felt I was making progress with the subject, although I must admit I still had reservations regarding one primary photograph I needed to illustrate the feature. The more I thought about this, the more possibilities came to light. The pictures I had shot from the church tower were not entirely satisfactory, though from an environmental view they were interesting. Although I knew the area well, perhaps I was just too familiar with familiar scenes. Either there was something I had missed or the picture just wasn't there.

Why dwell on it? Because there are some subjects that, however grand or subjectively photogenic, continue to elude and, when that happens, I become obsessed with the challenge. Bridges make fascinating subject matter; many are an interesting concoction of nineteenth-century (or earlier) engineering ideas and design. Brunel's bridge over the Tamar at Plymouth is a fine example of superb craftsmanship, resembling a huge elongated steam engine boiler that has warped and twisted with time. But what can you say about its aesthetic qualities? It certainly isn't an elegant bridge. There is plenty of texture and form but, to be photogenic, it needs an enormous steam engine, with great shafts of smoke belching into the sky, thundering out of the bend towards Plymouth, some time late on a crystal-clear November afternoon following a shower of rain.

But there are other bridges. In New York, I used a 24mm wide angle lens to photograph Brooklyn Bridge from a vantage point on the riverside which allowed a comprehensive view of the downtown Manhattan skyline. The span of the bridge leads the eye comfortably across the East river into a view which has been seen many times before. None the less, this kind of pictorial scene perfectly fits the bill as an editorial travel illustration. Very little detail can be seen in the bridge and even less in the distant towers, yet, taken as a whole, the picture evokes dreams and memories of visits to come and of visits past.

Each object then, be it bridge or building, will have some architectural or engineering feature which governs the photographic possibilities, but in making pictorial records, for whatever purpose, the photographer should be attempting to associate these features with the surroundings. This not only alerts the viewer to the purpose and function of the object, but helps to establish a sense of place, can confirm or enlighten personal associations and may, if the photograph is outstanding, provoke endless discussion or comment.

RISING FRONTS: ARCHITECTURAL PERSPECTIVE

The problems facing the photographer of buildings and urban landscapes are twofold and both are related to one another in terms of visual perception and mechanical expertise or technique.

When photographed from any normal – i.e. street level – position with fixed axis lenses, vertical lines are reproduced in the two-dimensional print form as angled and infinitely convergent. The easiest way to see how cameras with fixed axis lenses distort verticals can be shown by the use of a simple frame measuring about 25×20cm (10×8in.) cut from a piece of black card. Hold the card in a vertical position, about half an arm's length from the eye, while viewing a building. The building will appear to topple backwards after having some invisible force exerted on the façade. This distortion becomes even more apparent in photography when the camera is fitted with optics which are of shorter focal length than the standard lens.

With fixed axis lenses on 35mm cameras there are no simple solutions, although it is perfectly possible to lessen the degree of apparent distortion when this itself is not required as a device to make the picture work. This is the second part of the problem: how to use such devices to provide deliberate

14 and 15 *Two examples of how different lenses can be used to interpret the same subject in different ways. In Fig. 14 I used a 300mm Nikkor on Nikon F to pull together these constructional elements of bridge building. There is a good indication of size; the scale is amply illustrated by workers atop one of the pylons and there is a generally busy atmosphere of 'building' going on achieved through compression effects.*

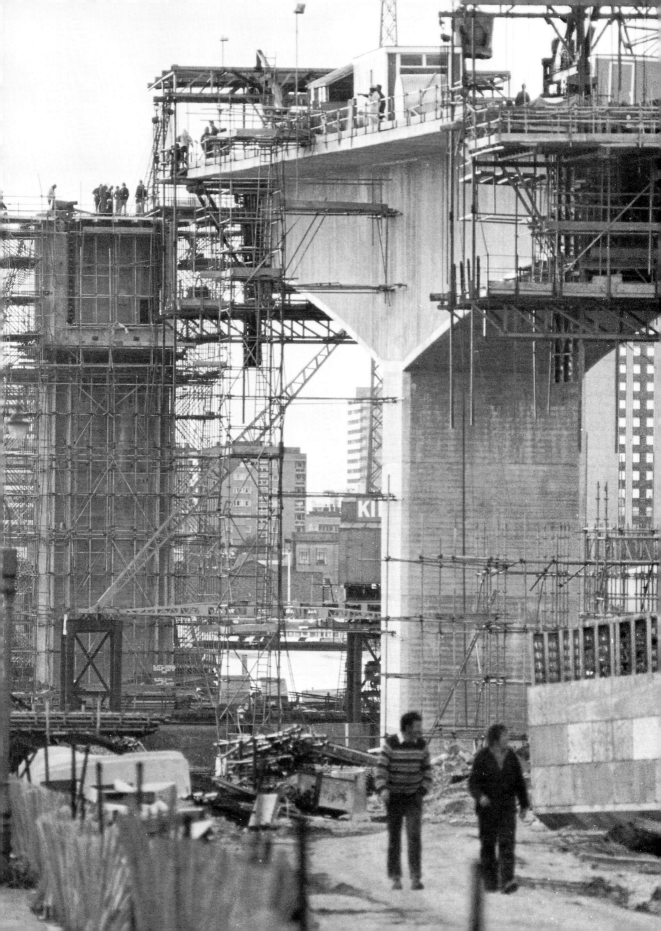

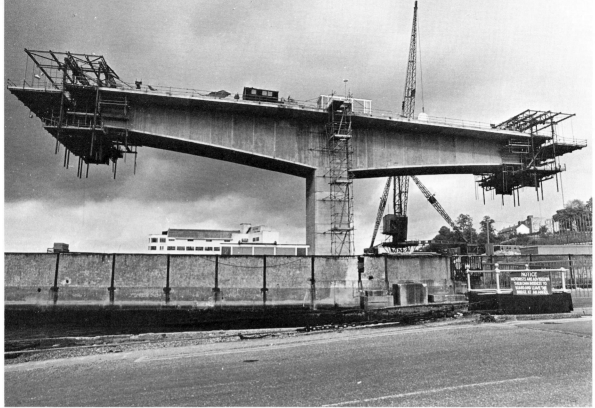

15 *This picture is concerned with imparting design information to the interested engineer as well as the lay person. It relies for impact solely on the design features of the pylon and span section apparently being held up by good old thin air! However, there is no scale provided and the viewer would have to be informed via a comprehensive caption that the bridge height would be 80ft when completed. (28mm wide angle; yellow filter on Tri-X)*

distortion without the viewer realizing the degree of deceit employed by the photographer. We will deal with this a little further on in the chapter.

Where no stand camera with horizontal or vertical movements is available and where fixed axis lenses are all the photographer has to hand, it is often confinement which forces the photographer to use wide angle lenses in order to fill the frame with the desired subject.

Where all that is required is a record for historical or sociological purposes, photographs taken at normal adult height from the opposite side of the street may be quite acceptable. The use of a 35mm or 28mm lens will be desirable in most instances in order for the whole building to be framed. In some cases, wider lenses - a 24mm, a 20mm or even a full-frame 15mm - may be necessary.

When using wider lenses in close-quarter situations, converging verticals can some-

times be made less apparent by placing the bulk of the subject in the upper half of the picture frame. While this means that only half of the actual picture area is being used, the ability to manipulate the subject within the frame will have the apparent effect of reducing the degree of distortion in an upward direction. Use of extreme wide angles in this way can often lead to a less acceptable distortion: that of converging verticals in a downward direction (*see Figs 21-7*).

Wider than standard lenses will also have the effect of foreshortening vertical proportion: an effect which may reduce the apparent overall size or height of a building in such a way that any impression of grandeur or hugeness gained by the viewer from the shooting position is diminished in the final print. Preferably, the camera should be tripod-mounted and a small circular spirit-level used to ensure that the base of the camera is level. Since there is no way at street level that the correct height can be attained, the viewing must be critical, allowing for a tendency toward vertical distortion, rather than the reverse.

Alternatively, the small- or medium-format user can employ longer focal-length lenses. From a distance and some convenient position where a little height can be gained,

longer lenses have the effect of reducing apparent vertical distortion. At the same time, there will be a noticeable reduction in spatial volumes between the camera lens and objects in front of it. This effect, known in photography as optical compression, will become more and more apparent as the focal length of lens is increased. Purists in architectural photography have always maintained that any compression effect should be avoided where possible, the ideal objective being in the region of one and a half or, at most, two times the normal focal-length lens. This allows some restitution of normal rectilinear perspective without exaggerated compression.

Optical compression in photography is, as much as anything, an illusion, rather than a distortion of reality. Many photographers use telephoto lenses to bring subjects closer to the film plane, so that the image area may be adequately filled. In other words, the telephoto lens is being used as a kind of image-magnifying device taking the place of a normal or standard lens when obstacles prevent the camera from being moved to a closer position.

In the photography of buildings, it will pay the photographer to move back; to dispense with wide angle lenses and use the longest focal-length lens possible in the environmental circumstances. In looking at a large building with the naked eye, most of us are first impressed by size in relation to other objects around it, or in relation to people standing by, stairways, windows, etc. Any impression of hugeness, height or sheer volume is usually lost when normal or wide angle lenses are employed, because they do not retain in the final print the visual perspective or the correct proportion of objects which so impressed the viewer at first sight. By stepping back and viewing the object from a distance with a longer lens, the proportion of people to building is retained as is the effect of hugeness or dominance. In fact, what you are seeing in the finished print is actually closer, from the point of view of scale, to the stereoscopic view seen by the eye.

Many readers will have noticed that, in addition to the focal length of any lens given by the manufacturer in instructional leaflets or brochures, quite often the angle of view of the optic is also given. To learn more about the illusion of perspective there is a very simple test which anyone owning an ordinary camera and one telephoto lens can conduct.

Chose a location where you can photograph a general scene of your town or city from a distance of about 1 mile (1.5 kilometres). You will need a crisp day, clear of atmospheric haze, relatively slow-speed, fine-grain film, a tripod, or something solid on which to rest the camera, and a medium yellow filter. Using a 50mm lens on a 35mm SLR (some standard lenses may be 55mm), or a 75mm or 80mm lens on a medium format 6×6cm ($2\frac{1}{4} \times 2\frac{1}{4}$in.) camera, shoot an accurately exposed photograph of the scene in front of the camera. Make several frames with fractional adjustments for exposure and development. Before you move the camera, select an area within the standard lens view which you can frame carefully with the telephoto lens. Make several more frames, again varying for exposure.

Once you have processed the film, make a 24×18cm (10×7in.) print from the whole frame using the best negative of the scene shot with the standard lens. Then make another similar sized print from the best telephoto negative. Dry the two prints and lay them out on a flat table top. On the standard view print, mark out with a chinagraph pencil (a biro will do), the area of print covered by the telephoto shot. Return to the darkroom and make another print, this time from the standard view negative using only the area you have marked with the pen. To register a more or less exact duplicate, put the enlarged telephoto print in the enlarger easel and use it to obtain the correct enlarger magnification from the standard lens negative. Once this is done, make a properly exposed and developed print, dry and return all three prints to the table.

You will notice that the perspective in all three prints is identical. In selecting a portion of the standard lens negative for enlargement, all we have done is to present the viewer with a more accurately proportioned view of that part of the scene. Using a telephoto lens does not distort the perspective, it simply changes the scale of the view by being more selective. The angle of view is diminished but still the buildings are in correct proportion to their surroundings. One other advantage of the telephoto lens is that

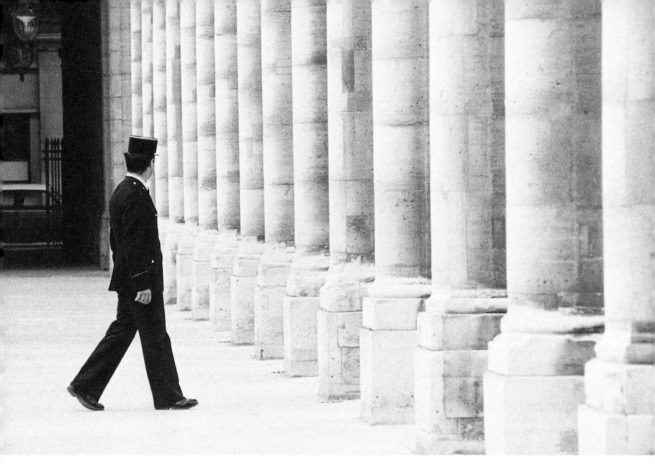

16-18 *Effects of optical compression are easily seen in these three illustrations. In Fig. 16 a 200mm lens was used to isolate a small area of the subject which is seen in Fig. 17 from exactly the same position with a 35mm lens. By carefully counting the number of columns visible in Fig. 16 and comparing with the same number in Fig. 17, the reader will at once have a clearer idea of the purpose for which different lenses can be used. In Fig. 18, I felt the graphic design created by the use of a longer lens in making this picture of the columns of the Parthenon in Paris would have more impact than the more usual view of the whole building which would have been shot from further down the street with a wide angle lens. (HP5; Nikkor 80-200mm on Nikon F)*

17

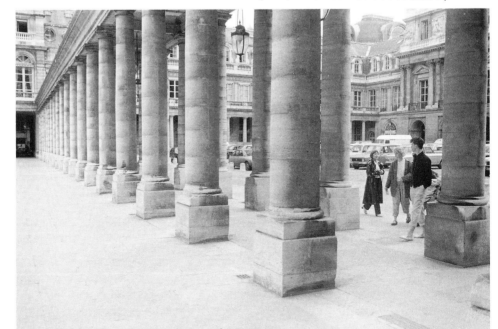

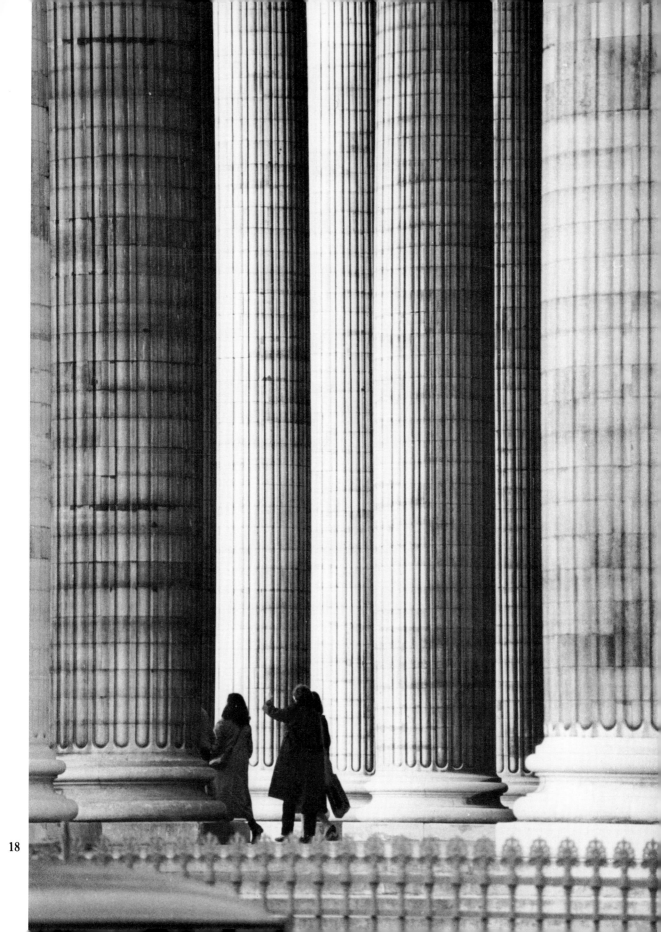

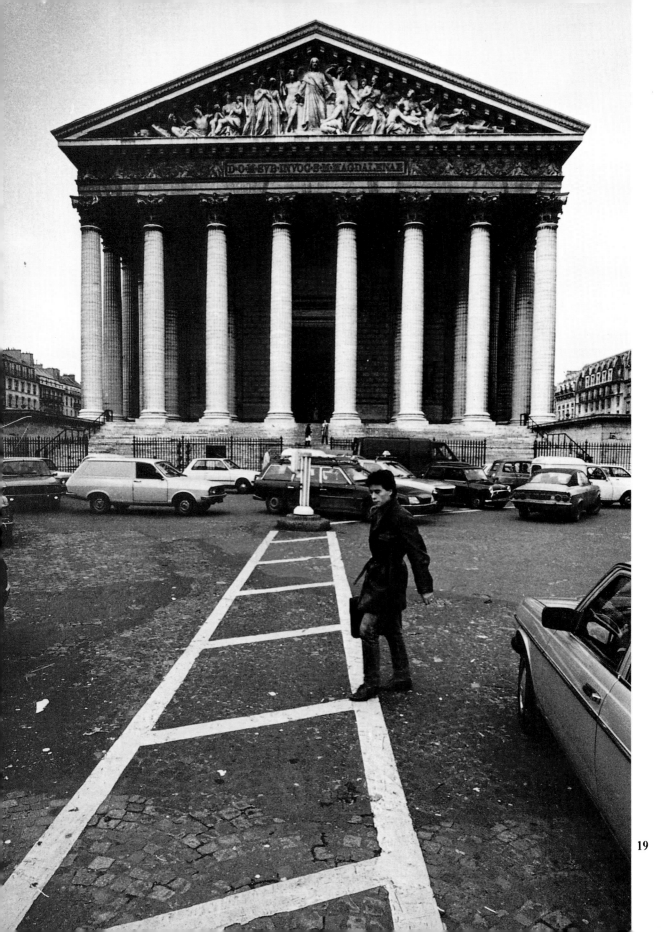

it gives us sharper, more detailed photographs which are free of the grain associated with enormous enlargements of small portions of a standard negative.

Of course, it should be remembered that, as with wide angle lenses which are used because needs must, telephoto lenses cannot always be used. In a world which seems to be full of expanding concrete jungles, there will be many obstacles which come between the telephotographer and his/her subject, but all possibilities should be explored before turning to the wider lens.

19 and 20 *Buildings of historical architectural importance are often almost impossible to isolate from their surroundings. The photographer may have to explore local environs for the best possible vantage point, seek permission to obtain access to the roofs of other buildings, and so on. Traffic going about its everyday business is another problem, especially if, as here, the vantage point happens to be in the middle of the road. This view of La Madeleine, in Paris was taken with a 20mm Nikkor lens and yellow filter on HP5. The columns of the same building are seen in Fig. 20 made with a 28mm Nikkor with yellow filter and which compare with Fig. 18. This picture may have little interest for the lay person but would probably be of considerable importance to the architectural student or historian.*

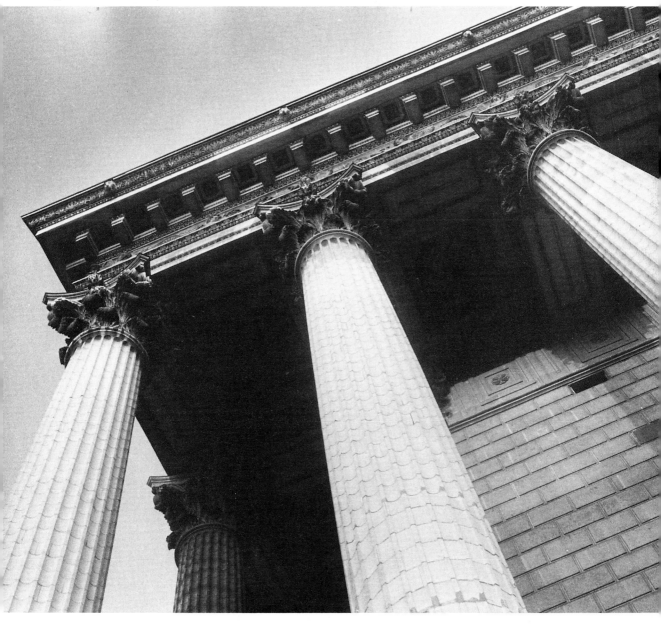

21-23 *The problem of perspective control and buildings which appear to fall over backwards is amply illustrated by a number of pictures reproduced in this book but probably not with such clarity as in this picture of skyscrapers in Paris. The camera, a Nikon F fitted with a 20mm lens, was placed about 10 m (30 ft) from the base of the foreground building, at ground level. The pentaprism head was removed to facilitate easier viewing of the subject and passers-by (required for scale). In Fig. 22, the same lens and camera were used with a red filter to create a completely different effect based on converging lines to give the effect of height. Similar buildings in the same area of La Defense are seen in another picture with an altogether different meaning.*

Fig. 23 *This was made using a 28mm lens fitted with a graduated yellow filter and poses a question of the problems of modern urban environments.*

In photographing the Arc de Triomphe, my aim had been to confront the viewer with an image of monumental proportions. For comparison I use a picture taken with a 28mm wide angle lens on a 35mm rangefinder which I shot from an open-top car while speeding around Etoile. From the sidewalks in this vicinity, thousands of photographs are taken each month of this very famous building. From this position, pictures cannot give any real indication of the grandeur or size, or how the Arc totally dominates the broad avenues leading up to it, or how millions of Parisians are confronted with the traffic problems which exist around it daily. From some great distance and equipped with a 600mm telephoto lens toward the end of a very hot autumnal afternoon, I spent 20 minutes standing on a traffic island, watching and shooting. I made several frames, each one obviously different because of the changing traffic situation. Through the viewfinder it was apparent that a blurring effect of the Arc would be made more noticeable by the mixture of exhaust gases and hot air rising off the old cobblestoned avenue of the Champs Elysées, because telephoto lenses also compress the mass of air between camera and subject. It was just the effect I wanted, hoping that the final picture would suggest to the viewer something positive but devoid of detail, a monster dominating the lives of every-one who had ever passed beneath its awesome arch.

Had I used a lens of shorter focal length, say 200mm, I would have had to position the camera much closer to the Arc to obtain a full frame and in decreasing the size of lens and moving closer to the subject, peripheral elements closer to the camera would have appeared larger in the final print, as they do in the 28mm lens picture, thus reducing the effect which the primary part of the subject has on the viewer.

In contrast, the picture of Montparnasse Tower (*see colour section*), shot through the trees of Luxembourg Gardens with an 80-200mm zoom lens, leaves the viewer with little to look at except a combination of pattern and form. In black and white, the attempt to show the solitariness of this building using the same optical technique, works less well than in monochromatic colour. But here we have a problem because, in both media, the viewer is first of all forced to segregate the straight lines of the tower from the jumbled irregular pattern of trees. In black and white, the picture is a confusing mess dominated by random black lines and shapes. In subdued colour, the eye can differentiate the shapes more easily but, because there is no real clue as to scale the viewer is left to wonder about the purpose of such a picture.

Taken closer with a very wide angle lens, or from further back with a very long telephoto, the result could have been more informative and interesting. I use the picture to illustrate how subjective viewing of a subject can often persuade the photographer that a good photograph is in the making. What actually impressed me at the time I made the picture was the colour of the light rising behind the tower, and I wanted to isolate the building to show how it rose like some huge beast from the gardens below.

As always, it is partly the problem of preconception which must first be solved before any choice of lens can be made. This may necessitate walking, or travelling many miles in order to arrive at the right distance from the subject in order to see first whether the original idea for a picture will work.

Paperwork can help to give rough ideas of what a picture may look like and, in some instances, you may not have to deviate far from the sketch to arrive at the real thing. At other times, because of contrary lighting, bad atmospherics, overcrowding, buildings not being where they are shown to be on a map, or new ones having been built which interfere with transit lines, a new approach will have to be sought.

In a strange city, this will sometimes prove to be a time-consuming occupation, which is why a good supply of detailed maps showing locations of historical monuments, items of tourist interest, as well as building plans and underground and bus routes, should be an essential part of the photographer's kit.

Exact locations from which to shoot may be much easier to reach by car, but I have found that in travelling from A to B a great many opportunities for other pictures along the route are often missed. Quite often, you will see from the window of a train the very footbridge needed as a camera platform: a view hitherto unseen and which would be quite impossible to see from a car.

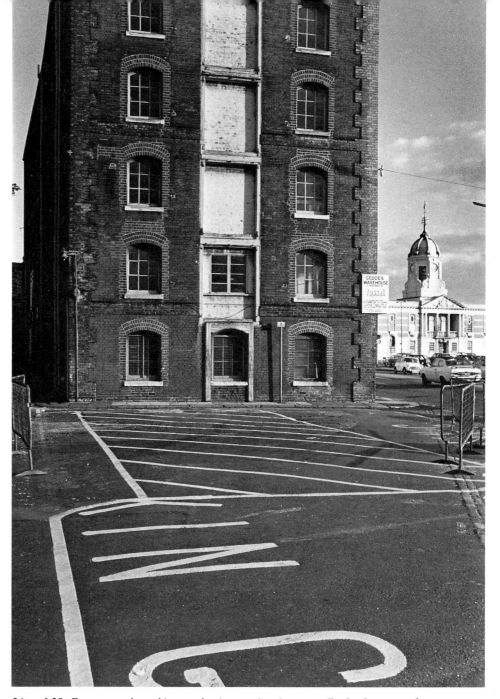

24 and 25 *From a purely architectural point of view, it is doubtful whether the three preceeding pictures would serve much useful purpose. Proportions in all three are distorted beyond correction in the darkroom and any information which could be gleaned from constructional details or scale is minimal. Equipment capable of shifting the lens off its normal axis is essential for the purist. The miniature SLR user will find Perspective Control or Tilt and Shift lenses available for most marques of camera as well as for some larger format (120/220) roll film cameras. These two shots of Geddes Warehouse in*

Southampton, England, were made on a Canon A-1, using the 35mm Canon Tilt and Shift lens mounted on a Benbo tripod. I waited until very late in the day so that the low light would give the best modelling on windows and brickwork. The film was HP5 shot through a yellow filter and processed in dilute HC-110. One interesting point about this particular lens was its overall acute sharpness even at maximum shift from the normal axis, with virtually no noticeable vignetting. Results with the Nikon 28mm PC lens were somewhat disappointing by comparison.

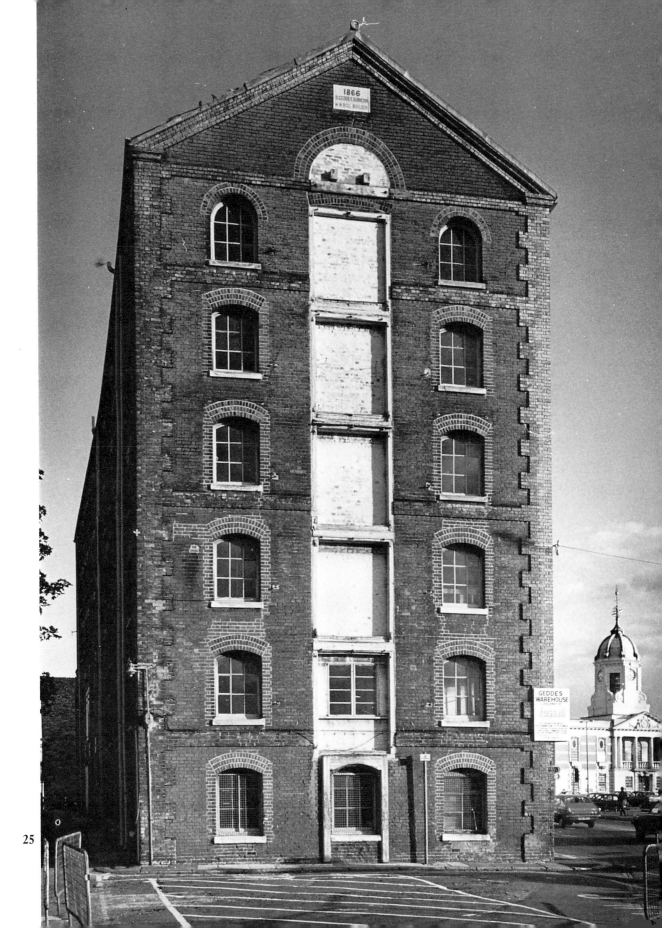

26 *A classic example of how the normal fixed axis lens distorts perpendicular perspective. This shot, using a 28mm lens with yellow filter, was taken from fairly close to the main building. The camera had to be tilted upward in order to fill the frame completely with the chimney stacks. This picture also effectively shows the apparent reduction in height of the chimney nearest camera; correct proportion can only be shown effectively using longer telephoto lenses.*

27 *There is, however, occasionally a limit to how far back one can actually go with a long lens, and this is one example where the longer telephoto lens would have served little purpose. The view of these buildings at Hjortorget in Stockholm's city centre was only possible from across the street with a 24mm wide angle lens fitted with a polarizer. While the camera vantage point was not exactly level with the centre of buildings opposite, distortion has been minimized by carefully adjusting the film plane fractionally downward.*

The one disadvantage in travelling on public transport, of course, is that the photographer has to carry a lot of equipment and this can be the most tedious part of the whole operation. Be selective. Don't attempt to carry more than is reasonably comfortable. Photographers don't really need three camera bodies all in use at the same time. Zoom lenses have the added advantage of cutting down weight where you might have carried three prime lenses. Then again, good-quality zoom lenses do not come cheaply.

28 *In journalistic terms it is debatable whether strict adhesion to the architectural principles of photography serves any useful purpose other than to show that verticals do not lean over. In many instances, the miniature camera user may run into problems which cannot immediately be solved on location and, while a variety of lenses may be necessary for any number of different purposes, Perspective Control types are not normally included in the pure photojournalist's bag, except on rare occasions. This picture of dwelling units in the town of Taby, Sweden, was made with a 20mm lens and is quite acceptable when included in a story concerning social environment. Other pictures might show views from the top story apartments, close-ups of family life, and so on; the distortions at each end of the picture do not matter.*

SPECIAL EQUIPMENT: CAMERAS AND LENSES

Much of the foregoing assumes that, so far, the requirements of the cityscape photographer differ somewhat from those of the commercial operator who may be required by clients to produce pictures which accurately portray the architect's or constructor's viewpoint of one or more buildings. Not all architects or engineers have the same photographic requirements, though there are bound to be occasions when the production

29 *New York: Manhattan waterfront on South Street. Compare with the picture of Brooklyn Bridge on pp. 24-25. Both were taken from the same position; this one, isolating a building of some architectural interest which pre-dates a 1924 Fairchild Aerial Survey of the area, with a 200mm Nikkor lens on Nikon F. In the bridge picture, this building pales into insignificance as just another grey blob on the skyline. Here, the longer lens and use of small boats and other waterfront buildings helps to give the right proportion. Yet another example of Feininger's lesson that monumental subjects need to be photographed with equally monumental lenses.*

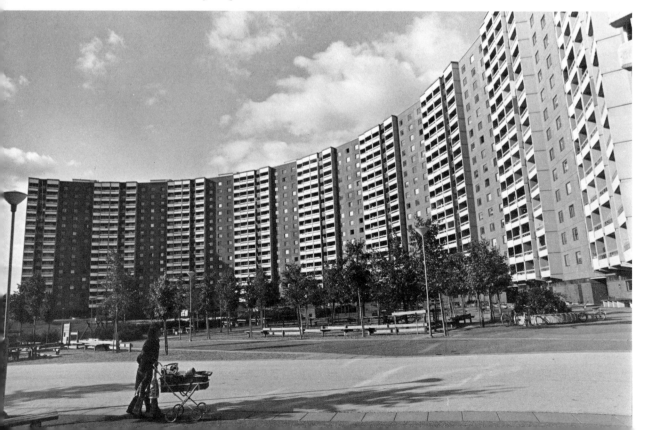

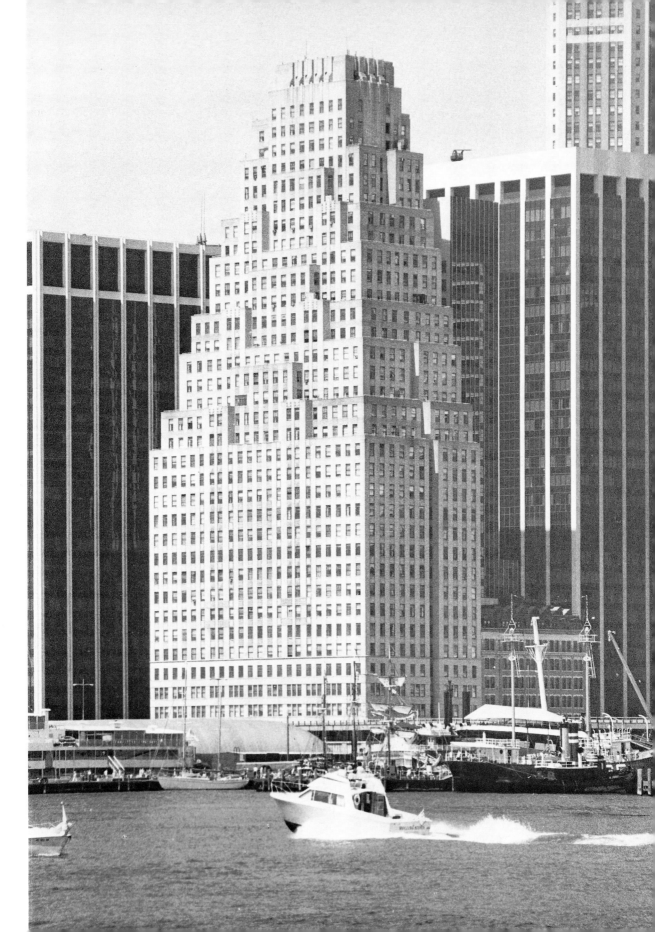

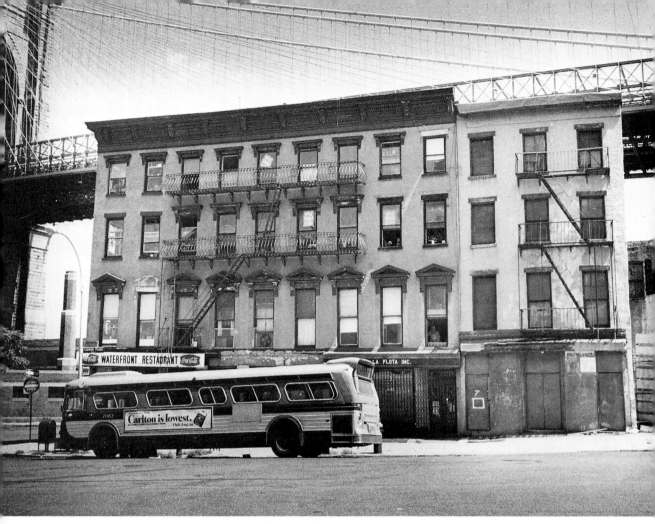

30 *Interesting architecture for the student on Cadman Plaza near the East River waterfront New York but, without height, the fixed axis lens on a small camera distorts the verticals. (Nikon F, 35mm Nikkor lens, Tri-X)*

of technically accurate photographs becomes necessary. Without the right equipment, the task of producing correct results becomes progressively more difficult as the workload from a variety of clients increases.

Architects may also need pictures of a more journalistic nature showing how various buildings are seen by the people who live in or work around them. They will also need pictures, from time to time, which illustrate as accurately as possible environment, scale, spatial volumes, mood, materials in use, constructional features, and so on.

Perspective Control lenses

Fortunately for the small and medium formats, lenses have been developed which allow a limited degree of correction to be made to the distortions that become apparent when using fixed axis optics. Tilt and Shift, or Perspective Control lenses are produced by a number of leading brand camera manufacturers, including Nikon (who, incidentally, were the first people to produce and market the PC lens), Pentax, Canon, Contax, Yashica, Minolta, Olympus and Leica in 35mm format, and Bronica, Rollei and Pentax for the larger medium format cameras. The Leica lens is made by Schneider of West Germany, who, by the time this book is published, may well have received sufficient demand to begin marketing the same lens with a variety of adaptors so that it can be fitted to virtually any camera.

While none of these lenses offers all the facilities, or even the extent of movements, to be found on a larger format field camera or monorail, they do help significantly to increase the scope of subjects which the smaller format user can tackle successfully.

44

Rather than elaborate with a detailed comparative account of the relative features of each lens, I have listed all makes currently available. I have deliberately left out prices, since they vary so much and of course, will be different in other countries. As a rough guide, Nikon's 35mm PC would be approximately the same price as a good medium telephoto prime lens, while the Bronica and Rollei lenses, which are also made by Schneider and feature fully automatic diaphragms, cost as much as the price of two or three camera bodies for which they are designed!

In the 35mm range, Nikon produce two PC lenses, a 35mm and a 28mm. Both are of the manual diaphragm type with optics rotating through 360° at 30° click-stop increments. The Pentax lens is by far the heaviest, but it does have the interesting feature of built-in filters, which, when one considers the large size required for most of these lenses, is quite a cost-saver. The Canon lens has a tilt facility which makes it somewhat more versatile than any of the others in this small format range. I found it an exciting lens to use, inspiring infinite possibilities for creative picture-making.

31 *This steel frame construction was photographed from fairly close quarters very early in the morning in an attempt to show it is possible to make adequate architectural photographs with the minimum of equipment. Bronica EC fitted with Zeiss 80mm Zenzanon standard lens, light yellow filter on HP5. The camera was tripod-mounted and the resulting slight distortion corrected on the enlarger.*

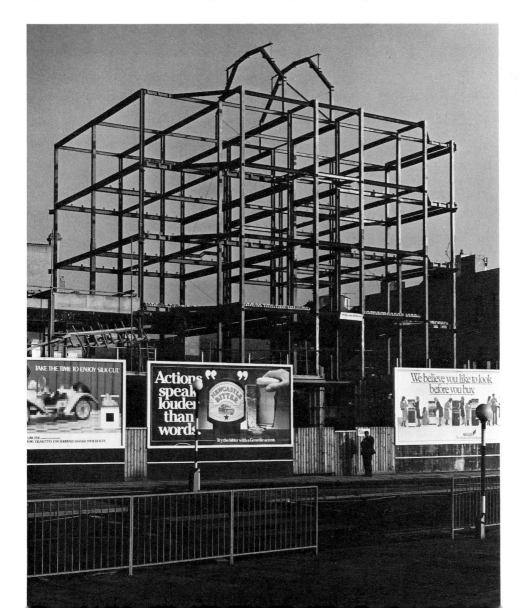

PERSPECTIVE CONTROL LENSES FOR 35mm SLRs

Camera	Lens	Aperture	Focal Length	Elements	Diaphragm	Control
Canon	Canon TS	f/2·8	35mm	9	manual	Shifting range left to right swing 11mm. Range of tilt 8° + or − up or down. Combination of swing and tilt. Lens rotates.
Contax/Yashica	Distagon PC	f/2·8	35mm	9	manual	63°–83° acceptance. Correcting perspective 10mm displacement. Can be displaced at 15° intervals
Leica	Curtagon PA	f/4	35mm	7	manual	63°–78° acceptance. Image circle 70mm. Displacement by 7mm in every direction
Minolta	Minolta Shift CA	f/2·8	35mm	9	automatic	Full circle shift, without rotation, variable shift. Variable field curvature control

PERSPECTIVE CONTROL LENSES FOR 35mm SLRs

Camera	Lens	Aperture	Focal Length	Elements	Diaphragm	Control
Nikon	PC-Nikkor	f/3·5	28mm	9	manual	Up to 11mm off-centre for perspective control, shift using milled knob with graduations of 1mm intervals. Lens optics rotate 360° click-stop every 30°. 74–92° of acceptance
Nikon	PC-Nikkor	f/2·8	35mm	7	manual	As 28mm model, however angle of acceptance 62–78°
Olympus	Zuiko	f/2·8	35mm	8	manual	Vertical and horizontal shift to increase max. angle of acceptance to 83°
Pentax	Pentax SMC-M Shift	f/3·5	28mm	12	manual	360° rotating barrel

Notes

With the exception of the Minolta lens, all the other optics have to be used with stopped down metering. The Pentax lens can be used on other K mount SLRs like the Cosina and Ricoh. Pentax also has the only PC lens for 35mm SLRs with built-in filters.

PERSPECTIVE CONTROL LENSES FOR MEDIUM FORMAT SLRs 6 × 4·5cm, 6 × 6cm and 6 × 7cm.

Camera	Lens	Aperture	Focal Length	Elements	Diaphragm	Control
Bronica ETR	Zenzanon-E Super Angulon PCS	f/4·5	55mm	10	automatic	Lateral shift 12mm, rise 12mm, fall 10mm, tilts 10° up or down. Image circle 104mm
Pentax 67	SMC Pentax Shift	f/4·5	75mm	9	manual	360° barrel rotation, maximum shift 20mm in all directions
Rolleiflex SLX	PCS-Super Angulon	f/4·5	55mm	10	automatic	Horizontal shift 11mm left or right. Vertical shift 12mm up, 10mm down. Vertical tilt of up to 10° each direction

Filter	Closest Focusing	Weight
58mm	0·3m	550g
70mm	0·3m	700g
Series 8	0·3m	290g
55mm	0·3m	560g

Filter	Closest Focusing	Weight
72mm	0·3m	380g
52mm	0·3m	320g
49mm	0·3m	310g
BI	0·3m	611g

Filter	Closest Focusing	Weight
104mm	0·5m	1650g
82mm	0·7m	950g
104mm	0·5m	1650g

The Scheimpflug Rule

The image circle – the circular area in which there is sufficient illumination and image sharpness for obtaining acceptably sharp negatives – is quite a lot larger in PC lens construction than in normal, equivalent focal-length optics. The excess covering power makes it possible for the lens to be constructed with relatively large ranges of off-axis shifts. These perspective controls can be used to correct converging vertical lines, to move the camera when photographing mirror or reflective subjects where the camera's own mirror causes unwanted reflections, and to control focus or depth of field.

Simple axis shift of the lens is not enough in itself to control depth of focus and this is one advantage which the Canon lens has over others in the smaller format. Bronica's Super Angulon and the Rollei equivalent both have tilts and perhaps, before we go any further with this, it would be as well to look at the history and principle behind this facility.

The tilting movements are based on a principle established by one Theodore Scheimpflug who investigated the alignment of camera and optical planes and that of the subject, with reference to optical geometry, which would produce the maximum image sharpness. Bruce Pinkard in *The Photographer's Dictionary* (B.T. Batsford, 1982) says Scheimpflug 'discovered that if the object plane is not parallel with the film and lens plane, the lens can be manipulated so that the three planes intersect. This will then produce maximum sharpness and depth of field with the least linear distortion of perspective. Fixed body cameras do not have the facility to make these corrections, but view cameras and most large format cameras are equipped with bellows and swinging, tilting and shifting lens and film planes, making it possible to improve considerably, the optical performance of the camera.'

Using a theoretical example of practicality, let us say you were required to photograph a building at reasonably close quarters from an angle corresponding to a corner view. The façade of the building comprises a number of columns, which, in the final print, must all be in sharp focus.

Using a conventional fixed lens would require stopping down as far as possible to retain the greatest depth of field, but this might not be sufficient. Nor would any vert-

ical distortion be corrected. By employing the tilt mechanism on a shift lens, the depth of field can be dramatically increased, without resorting to the stop-down method, by angling the lens in the same directional plane as the subject. Vertical distortion can be corrected simultaneously by shifting the centre of the optic from its normal axis until the picture is distortion-free.

It should be stressed that the PC or shift lens can only offer a facility for limited correction. It is not possible, by using one of these special optics on a small, hand camera, to transform the instrument into a fully fledged view camera. Considering, also, the relatively high price of these lenses, one should bear in mind that, if usage is to be occasional, it may pay to hire the equipment for the time required, rather than purchase it outright.

THE SCHEIMPFLUG RULE

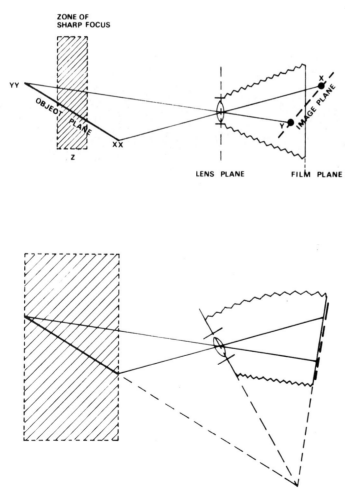

Medium format photography

This is not the end of the story by any means because in the field of medium format photography (6 × 6cm, 6 × 7cm and 6 × 9cm) there is still a comparatively wide selection of specialist equipment which already incorporates some of the features found in the larger format monorails and field cameras. Furthermore, a great deal of second-hand equipment which may now be classed as vintage or only fit for the local museum can still be found in excellent condition at reasonable cost. The experienced amateur considering moves from small format to more versatile larger format equipment may well benefit by hunting around, rather than by taking out a second mortgage.

Over the years, I have managed to collect a variety of lenses, large format bodies, extension bellows, roll film backs and cut film holders – all in usable condition. With a little patience and some simple tools I have adapted bits and pieces for a variety of uses. An early Burlington Burroughs 6 × 9cm roll/plate camera was butchered for its rangefinder and f4·5 Ektar lens and Graflex roll film back to fit an ancient German folding camera of the same format which had very fine vertical and horizontal shift controls. The 6¼in. f3·5 Taylor Hobson lens from a 5 × 5in. Williamson Aerial camera was adapted for use by asking a local engineering firm to produce a bronze threaded sleeve to fit a very sophisticated set of Bronica bellows, equipped with swings, tilts and shifts. A veteran Speed Graphic 5 × 4in. field camera was given a new lease of life with additional lenses salvaged from otherwise useless equipment and mounted in simple wooden panels as well as a polaroid back made out of one of those early Swinger cameras.

The 'compact' explosion of the last decade has certainly helped to obscure more specialized equipment of an earlier decade. Most of it was purely mechanical – not that that is any drawback – and the overall standard of construction and finish was excellent: good, honest, heavy metal. Many of the lenses too were superb, certainly as good as you will find on some modern cameras. If improvement is necessary, optic manufacturers like Schneider and Nikon have vast ranges of specialist lenses available which can be fitted to most mounts of the larger format cameras.

Camera specialities included the **K1 Mon-**

obar which first came on the market in 1960. Believe it or not, this was a 35mm format camera, complete with ground glass focusing screen as well as all the swings and tilts to be found normally on much larger format monorail cameras. The camera was constructed with equal precision and lenses mounted in leaf/compur type shutters were available in a variety of focal lengths.

Another interesting piece of equipment particularly useful with this subject is the **Widelux**, a 35mm, ultra wide, panoramic view camera developed first in 1959 by the Panon Camera Co. of Japan. The lens is a fixed focus 26mm f2·8 Lux special, mounted into a special revolving drum-type shutter with speeds of 1/15 second, 1/125 second and 1/250 second. A spirit bubble atop the camera body and super wide optical finder are other features of this superb piece of equipment which gave the user 11 24 × 59mm panoramic snaps on a 20-exposure roll of film. The resulting transparencies can be screened using a 6 × 6cm projector and black-and-white negatives enlarged using a 75mm or 80mm lens. A Russian equivalent was also available for a time, but the lens was nothing like as good as the Panon model. The Widelux camera is still manufactured and available in the UK from Edric Audio Visual Ltd in Gerrards Cross, Buckinghamshire.

Moving away from fixed lens cameras in the medium formats, the general practitioner with more than a passing interest in architectural photography; but with no desire to spread wings to sheet film, may consider a number of other roll film alternatives.

The **Plaubel Pro Shift 69W** employs a

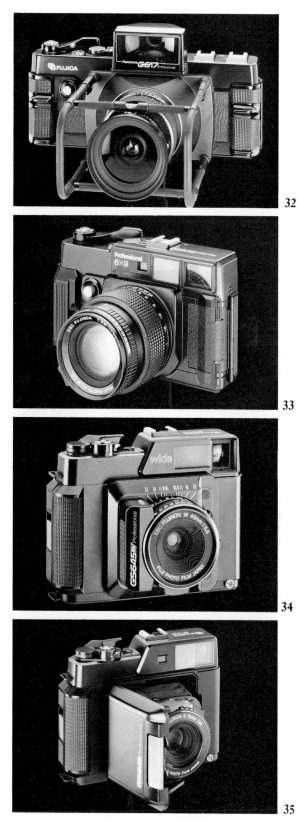

32

33

34

35

32-35 Four relatively new medium format designs from Fuji in Japan, all using 120 or 220 roll film. The G617 Panorama Camera will appeal to professionals and advanced amateurs; the 6 × 17cm format has a variety of applications. The other three are updated versions of older roll film designs, providing both 6 × 9cm and the ever popular 6 × 4·5cm format in a compact and easily portable form. The GS645 will be of particular interest to miniature format users who want a slightly larger format without the bulk of a standard medium format SLR. (Photographs courtesy Pelling & Cross)

49

47mm f5·6 Super Angulon lens giving a 93° angle of view over a 6 × 9cm format. The camera has a two-way shift coupled to the viewfinder which allows limited correction. The **Rolleiflex SL66** has a lens-tilting facility up or down through 8°. This facility is of little use in controlling perspective but affords the user some latitude with regard to depth of field. The **Horseman VHR** is a 6 × 9cm technical/press camera featuring parallax correction and international spring back. The rangefinder is fitted with coupling cams for 75, 105 and 180mm lenses: a thoroughly useful all round piece of equipment.

Large format photography
Toyo, Linhof, Sinar, Gandolfi (now back in production after a short break) and Horseman are all names synonymous with even larger formats, from 5 × 4in. upwards through 5 × 7in., 8 × 6in. to 10 × 8in. and, in some cases, larger. A 5 × 4in. field camera is about as large as could be usefully employed by the cityscape photographer. The collapsible non-monorail type provides sufficient movements in the vertical, horizontal and front panel tilts which might be required for general use. The cameras are fairly big and

a substantial tripod, though not essential, will help to make life a little easier. In addition, to cut out the need for film holders, most field types accept roll film backs and the smaller image area of these gives an effective increase in focal length when using optics normally intended for standard work with the 5 × 4in. format. The original Folmer **Speed Graphic** is now produced by the Toyo company in Japan and is marketed by George Elliot in the UK. One or two modifications have been made but the camera is still essentially a wonderful piece of equipment and probably the most portable and easy to use camera of its type.

These few paragraphs concerning specialized equipment could easily be elaborated into several chapters; there is so much in the way of larger formats which is interesting. But, in the context of this book, it would not serve any real purpose and, in case the smaller format user is suddenly feeling inadequately equipped, let me stress again the point made earlier: the principles of architectural photography and the mechanics of controlling distortion are simple tools easily employed, some knowledge of which can only help to further expertise. Other controls exist which can help the photographer not equipped with PC lenses or view camera movements.

Enlarger distortion control
The correction of distorted verticals using an enlarger is not an alternative to correction made at the time of exposure on the camera in the field; it is only an aid. The degree of success to which it is possible to make corrections in the darkroom will also depend to a large extent on the versatility of equipment available.

Ideally, the requirement would be for an enlarger which has almost as many movements as a fully adjustable camera. The lens panel, negative carrier and easel should all be capable of independent tilts not only in one direction – a single arc moving left to right – but also back and forth when the instrument is used facing the operator in its

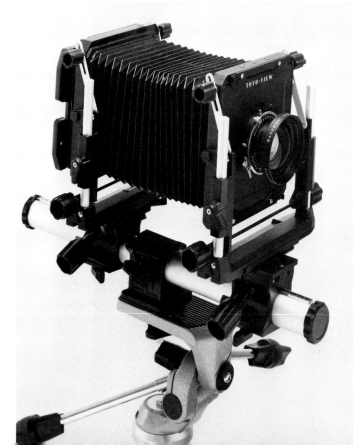

36 The Toyo 5 × 4 monorail, a specialist's tool with all shifts and tilts, revolving back etc: the ultimate tool for pure architectural work. It can also be fitted with a variety of different lenses, roll film and polaroid back.
(Photograph courtesy George Elliott & Co.)

normal bench-mounted position. If this is not possible, some means of rotating the negative is necessary. A rotating negative carrier is a feature of some enlargers designed with distortion controls and those without will only be capable of producing the correct results with difficulty.

Having said that, it should be emphasized that it is by no means essential to have all these movements on an enlarger in order to accomplish some degree of correction.

Converging verticals can be corrected to a certain extent simply by lifting one end of the paper easel. A pile of books or block of wood used to hold the easel at the required height are the only extras needed for this primitive but time-honoured method. There are, however, a number of drawbacks, not least of which is the problem of maintaining sufficient depth of field in the enlarger lens over the whole print area. Lenses designed for flat field projection have very shallow depth of field and, additionally, may not perform at their best when used in the fully stopped-down mode. In colour work, stopping down the lens as far as it will go can cause other problems. Reciprocity failure, due to the necessarily increased exposure times, as well as shifts in colour balance, are problems which will take time to overcome in the less sophisticated darkroom. The biggest headache using this simple method is that of cropping.

The projected image is no longer rectangular or square, but trapezoidal, producing an image which is longer than the original. The print, once cropped at the sides, will be long and narrow with the consequent new distortion resulting in an apparent increased height of the subject. Some allowance could be made for this in shooting the original, but that would seem to defeat the object of using certain lenses. Moving back further and using longer lenses tends to eliminate these distortions anyway, as we have already seen. Where simple distortions can be corrected without exaggerated movements of the easel, the final print will be acceptable, otherwise it is not a very satisfactory method for professional use.

OTHER EQUIPMENT AND SMALL FORMAT CAMERAS

In this chapter we have covered some of the items which may be of more interest to the photographer concerned with buildings. But this is not a book about architectural photography as such; the concept is altogether far wider and to this end there are any number of pieces of equipment or combinations which the photographer using small or medium formats may need.

Tripods

Normally, I am not one to be seen carrying a tripod around the streets, but quite recently I replaced an ageing Japanese model with one of the relatively new Benbo tripods manufactured in the UK by Kennett Engineering. For a tripod, the investment was considerable, but it is big, sturdy and very

37 *The Benbo 'carrot principle' tripod described in the text, mounting a Nikon FG with 80-200mm zoom Nikkor. This is a substantial tripod especially suitable for use in awkward situations and capable of mounting the heaviest equipment. The illustration shows a ball and socket head in use, but a normal three-way pan and tilt head is available from the manufacturers, Kennett Engineering.*

functional. Using the carrot principle in which all three legs and a rising (or dipping) extension arm are locked in virtually any position needed by the twist of a substantial lever, once I had worked out the knack of setting it up, the Benbo is a delight to use. A baby version is also available which is probably more suitable for photographers with light-weight, compact SLRs.

For some work, a tripod actually makes life easier. If there is a certain view which includes a number of stationary objects and you need to wait around for the human animation, then a tripod can certainly take some of the strain. More importantly, perhaps, you will be certain, having previously framed up the main subject, that you get the view you wanted and not one in which the subject is slightly off centre or spoilt because the horizon dipped violently – often the case when trying to grab a picture at a second's notice.

I did spend some time surveying the vast range of tripods which are now available in most retail outlets before doubling my budget on the Benbo. There were many which looked fairly substantial, but no real replacements for the Japanese tubular-leg model with which I had worked for well over a decade. Also, I wanted a tripod that would feel rock-steady when erected, as I planned to use anything from a 35mm SLR to a 5 × 4in. field camera on top of it. It's no good having an aluminium extrusion that whistles and vibrates like rod rigging in a gale when a heavy-weight Bronica is strapped to the pan and tilt head.

If you do not own a tripod and have no intention of taking one around with you, a very useful support is the monopod. It is usually adjustable from a few inches to a few feet and gives adequate support to a hand-held camera when using long lenses and slow shutter speeds. I know of a number of photographers who carry this type of support strapped to the outside of a gadget bag. Two models are available from Kennett Engineering in the UK (their equipment is marketed in the US by Spiratone).

A tripod should be mounted securely on a firm footing through which vibrations cannot affect camera movement. 'Obviously!' you may cry. Well, perhaps to some. In my other occupation as a marine photographer, I have watched cameramen not familiar with floating platforms, mount their tripods and monopods on the decks of heaving boats, usually directly above a thundering diesel engine. So, if the motion of the vessel has not upset their co-ordinated use of pan and tilt or ball and socket, the high-frequency vibrations from below decks will have certainly played havoc with shutter speeds. On land, you can expect vibrations from other sources: trains rumbling overhead on elevated tracks or below street level; cars and heavy lorries passing in close proximity; they can all set up unwanted vibrations for the photographer.

If the time comes when you really do need a firm support for the camera or lens and there is no suitable tripod or monopod to hand, the answer is to use your coat rolled into a pillow shape. In fact, when using very long telephoto lenses, this is often a far more suitable method than trying to tripod-mount a tiny camera with a yard or two of glass projecting forward. Many is the time I have used my anorak to support a long lens, rolled up under the lens on top of a wall, a car, a fence post or any other handy monument. Another trick is the bean bag. Bean bags are easy enough to make: two pieces of corduroy cloth cut about 23 × 12cm (9 × 5in.), sewn together and filled through one open corner with high-density polyurethene balls. It may add a few ounces to your already overweight camera bag, but the inconvenience will more than pay for itself on those occasions when a lens needs extra support. Similar bags are marketed in the US under the trade name 'Redi-Stedi' and will no doubt soon be available in Europe.

SLRs

The compact single lens reflex camera has reached a peak of design and versatility that would appear difficult to surpass. Innovations in electronic camera design have all been made possible by even more complex micro-chip technology and it would seem, if the pace continues, that the ultimate, auto-everything SLR is just around the corner. The burning question is, who needs or wants such an animal? Given that there is a very large area of the market drawn towards these instruments simply because of the pleasure acquired in ownership, there is another sector, albeit smaller, whose dreams and aspirations are purely functional: the all-whirring,

buzzing, bleeping machine is not an essential requirement of good photography.

For many professionals a hand-held light meter is considered *de rigueur* and, where a camera is frequently used out of doors in all sorts of climatic conditions, however revolutionary the age of the micro chip may be, camera manufacturers have yet to come up with an instrument which is not vulnerable to acid rain, snow, dirt and whatever other effluents fall from the skies. The most commonly reported fault in modern all-electronic cameras is that once the circuitry becomes faulty, there is no mechanical back-up system of any consequence - I mean, what can you do with 1/90 second?

Amongst my collection of battered mechanical Nikon Fs are two more frequently used models, the Nikon FG and the EM. For much of my work I find the meters very accurate; they are light and easy to handle with motor winders attached; in fact, virtually faultless for most of the time. What I don't like is their total dependence on electrical power. I have experienced only one or two shutter/meter failures, but both occasions were important. Two EMs I purchased when they were first launched, had to be written off after being drowned in an excess of spray. The circuits shorted and that was the end of that.

With particular regard to 'street photography', the compact motor/winder-driven SLR has numerous disadvantages, not least of which is its comparative bulk. But the biggest single problem is the noise made by the motor. Integral motor cameras like the Canon T50, the Konica FT-1 and the Contax 137MD have no traditional wind-on lever; one presses the shutter button for exposure and, as soon as it is released, whirrr ... clack. It is a very distinctive sound and one which people not familiar with cameras can immediately recognize. Accustomed to hearing these noises on television in a variety of different but frequently aggressive roles, people automatically turn away, hide or, alternatively, turn sour.

There is nothing wrong or immoral about candid street photography but the prospective subjects are more often than not likely to regard the act of being photographed without their permission as a blatant affront to personal privacy. Photographers engaged in capturing images of strangers should be considerate in their approach. This may mean being devious, artful, surreptitious, bold, kind, tolerant, gallant and compassionate, but least of all, aggressive. It may mean being only one of these things at one time; at others, it may mean being all.

There are various schools of thought as to how one should go about being a successful street photographer. Some say one should make obvious to all and sundry one's intentions by wearing the camera around the neck and accosting potential targets with a view to developing some swift and personal relationship. There are occasions when this tactic can be worthwhile. I seem to recall I asked permission of the ice-cream vendor in Manhattan while I was in the process of eyeing the picture through the viewfinder. While he was asking me what I wanted to do that for, I made the picture and then ordered an ice-cream.

Very often I am far more surreptitious: pretending to be fiddling with a camera when I am actually using it; shooting from my lap, or hip or leaving the camera on a bar table and letting the self-timer do the work, or releasing the shutter with one hand while knocking back a pint with the other.

In the street, I normally carry a medium-sized canvas fishing bag with a waterproof liner into which is crammed enough film stock for a day's shooting (up to 20 rolls of black and white and about 5 in colour), half a dozen filters, numerous lenses from 20mm up to 200mm and one spare camera body. Two other cameras, one an SLR and the other a rangefinder, I keep hung about my person, one round my neck and partially hidden in the folds of a jacket, the other to hand, with its strap wound around my wrist. Occasionally, I will stop wandering and take a break somewhere, taking time to change or clean lenses, sort out film I have exposed and make fresh plans for the next stage.

Rangefinders

For years I have used Nikon Fs, the now almost antique SLRs much loved by many professionals. I already mentioned the FG and the EM but my favourite 'street' camera is the little Nikon S3 rangefinder. I find the simple, bright line viewfinder a delight after the clutter of a modern electronic SLR. Focusing is fast and accurate, operated by a tiny knurled wheel on the top plate just in

front of the shutter release button. The lenses are very small, too, compared with the chunks of glass on an SLR. The design of a Nikon rangefinder is much like that of the early rangefinder Contax, but virtually all the components of the body are the same as the Nikon F, only smaller.

Aside from accuracy of focus and the general ease with which this camera operates, one other noticeable and useful asset is its virtual silence. There is no mirror to clonk up and down, just the 'shnik' of a cloth focal plane shutter. The standard lens is an ultra-sharp Nikkor f1·4 and I also have a 28mm f3·5 Nikkor which gets used a lot in trains.

Production of the S-series Nikon rangefinder cameras ceased many years ago and they are now a scarce commodity, mostly hoarded by vintage camera collectors and the like. Lenses are even harder to find. There is, however, a near copy of the Nikon/Contax in the shape of the Russian made Kiev 4 and 4a (one has a light meter on the top plate) marketed in the UK by Technical and Optical Equipment. A range of Jupiter lenses which are really excellent value for money, as is the camera, would make an ideal starter kit for anyone with limited funds.

In the higher price bracket there are any number of M-series Leica rangefinder cameras available off-the-shelf. The older types, like the M3, M3D, the M2, M4, MD and M5 represent excellent investment value for those concerned with that aspect but, perhaps more importantly to the creative photographer, these cameras epitomize superb craftsmanship in camera engineering. Whereas other camera manufacturers have seen fit to forge ahead with electronic hardware, Leica bowed to popular demand from the professional and amateur world by bringing back the M4 after it had ceased production, first as the M4-2 and later as the M4-P. In much the same vein as the Nikon S rangefinder, though vastly different in style and feel, the M4-P is a purely mechanical thoroughbred, unsurpassed as the ultimate photojournalistic tool.

The M5, introduced in 1971, was the first rangefinder camera to have TTL (through the lens) metering but, as a result of this innovation, the camera was quite a lot larger and heavier than its predecessors and, possibly because of this, was not so well received by aficionados. As if to remedy this situation a strange but wonderful deal was hatched by Leica and the Japanese Minolta Camera Company in 1973. The Leica CL (Compact Leica) was a sensation; measuring only 120mm in length by 78mm in height and 35mm in depth, the main feature of this little wonder was a vertically travelling focal plane shutter. The rangefinder base was slightly shorter than in normal Leicas and the shutter speed dial was mounted in front of the camera instead of on the top plate. Otherwise, the camera was every inch a Leica, accepting most of the M series lenses as well as having its own special optics in the shape of an f2 40mm Summicron-C and an f4 90mm Elmar-C. A light meter of the same type as in the M5 was also incorporated.

A logical development of the discontinued Leica CL was later launched by Minolta at Photokina in 1980 and, happily, it is still being produced today. The Minolta CLE is more conventional in appearance (see Fig. 138), having the shutter speed dial on the top plate with the release button in the centre. The polycarbonate body is somewhat longer than the old CL and the electronically timed focal plane shutter blinds travel horizontally in the normal way; but other features of the camera are remarkably similar, not least of which is the Leica M lens bayonet mount. The CLE has three lenses of its own: a 28mm, an f2 40mm as standard and the 90mm f4. All of these are matched with respective bright line frames in the viewfinder. What is perhaps really interesting is that this camera will accept most of the Leica M series lenses. Those that do not fit are the Noctilux 50mm f1, the Summicron 90mm f2, the Elmar 135mm f2, and the Tele-Elmarit 135mm f2·8. The only drawback by which users are likely to be hampered is the viewfinder, where the three bright line frames are matched to the Minolta lenses.

For the time being at least, the Minolta Camera Company has no plans to increase the range of lenses available for the CLE. In fact, it would be difficult to see how they could introduce other focal lengths without also producing a viewfinder accessory to overcome the nuisance of not having the matching bright line frame for each lens. An accessory viewfinder will give more accurate framing even if the eye does have to be displaced from the normal rangefinder position

to accessory at the last moment. In practice, I find that it is relatively easy to accustom one's memory to the degree of vision obscured by the lack of correct in-camera framing.

The angle of view of a 28mm lens is approximately 72° and that of a 35mm, 63°, a difference of 11° in total, or 5½° at either side of the picture frame. The Minolta CLE viewfinder reverts to the wide angle suspended frame when a lens other than the designated type is inserted. Say you wanted to use an M fitting 35mm Leica lens; then the angle of vision would effectively decrease by approximately 4° inside the 28mm framefinder. Alternatively, Leica M series camera owners may want to use the Rokkor lenses as they are such excellent value.

In addition to the TTL aperture priority exposure system, the CLE incorporates a manual override, enabling the full range of camera speeds to be used. All the necessary information is displayed in the viewfinder with LEDs.

One other rangefinder camera which should complete this list is the Canon 7. First marketed in 1961, this is now a very rare bird, although they do turn up from time to time fitted with an f1·2 50mm lens. The Canon 7 is a basic rangefinder camera of 35mm format, with a built-in selenium meter and a universal four-step viewfinder. At the time of its introduction, the Canon 7 was also available with the fastest lens in the world – f0·95. But it was a late-comer and, barring electronics, was about as sophisticated as one could get in rangefinder models. Some 140,000 Canon 7s were produced and in addition to the standard camera lens mount, the 7 featured an alternative Leica screw-threaded mount. Much sought after now by collectors, the camera is heavily overpriced but, if you are lucky enough to own one already, it's probably one of the best rangefinder cameras ever made – so hang on to it!

Pocket cameras

If you do not want or need a versatile rangefinder camera like the Minolta CLE, there are innumerable other full-frame 35mm pocket types from which to choose. This range, which is far too long to describe in detail here, includes 'clamshell compacts', so called because of the retractable dust covers

38 *The Minolta CLE rangefinder camera with TTL metering and electronically controlled shutter. Fitted with 40mm f2 Rokkor as standard, but can be fitted with most M series Leica lenses. (See text for details)*

which open and close over the lens and other optical parts, sealing the instrument from the elements when not in use. Lenses vary in focal length and performance: anything from 33mm to 39mm seems to be popular. Depth of field is usually very good but only a handful have coupled rangefinders. Others use distance scales or zone-focusing devices. Exposure systems are frequently fully automated by electronics allowing very little room for manoeuvre, except by fooling the system by resetting the ISO indexer. The Olympus XA and the Minolta AFC are both highly rated and capable of producing excellent quality.

Non-capsule-type cameras, but also with fixed lenses featuring infra-red focus and full automation are the Nikon L35AF, the Canon Sureshot II, Minolta Hi-matic AF2-M, AF2 or S2 and the zone-focus, all-weather Fujica HDS.

It is ironic that many of the design features of some of the compact clamshell or capsule cameras are reminiscent of a much earlier period of compact camera design: the folding 35s and larger format cameras of the 1940s and 1950s. Who knows, in five or ten years from now, these early prototypes of the 1980s will more than likely have become just as collectable as their predecessors. But I digress *(for more on street work see Chapter 6)*.

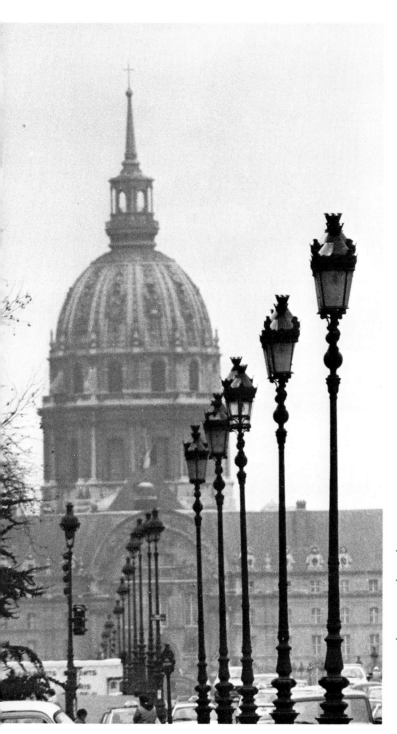

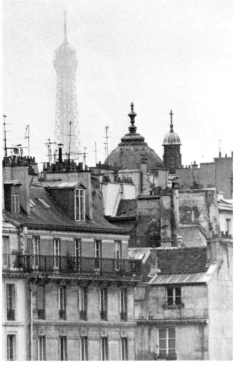

40

39 and 40 *Wherever possible, I always try to use a prime lens. Without an army of bearers, however, it is not always practical to carry all of your long lenses on a simple stroll around the city. Teleconverters are useful in this respect, but even the best are not really good enough for the discerning. Aside from loss of prime lens speed, teleconverters deteriorate the image quality. One way of making this lack of quality less apparent is to focus on an object which is nearer to the camera and chose a subject in which the bold foreground image helps to make the overall picture content interesting. In Fig. 39 I used the lampposts as the primary point of focus. In Fig. 40 there is no really pin-sharp foreground interest to attend the eye and, while the vague outline of the tower structure in back is in the correct proportion to the houses, as the eye would see it, nothing is clearly defined, or for that matter, very interesting. (Both examples in Paris with a TC200 Nikon converter on an 80-200mm zoom Nikkor; 1/60 second at effective f 8)*

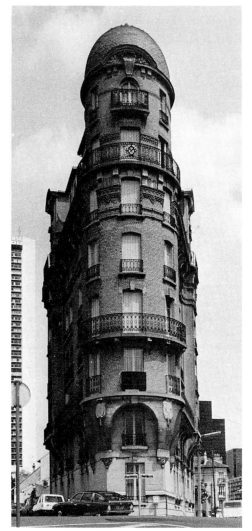
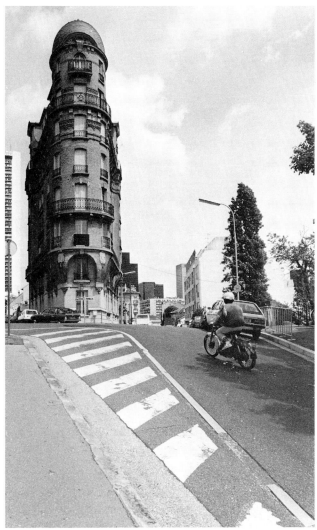

42

41 and 42 *Wedge-shaped buildings can present interesting and sometimes difficult aspects. Ideally, this building, in a suburb of Paris, would have been better photographed from a vantage point approximating at least the first floor of the building, but the immediate local area allowed only one view, not even a telegraph pole or a tree in the right place to gain a little height. As a record of architectural type it is better cropped as in Fig. 41, but both this and Fig. 42 compress the vertical proportion of the building. (Nikon FG; 28mm Nikkor; yellow filter on HP5)*

3 Visual Perception

Most of the pictures reproduced on the pages of this book were taken by myself; others are credited accordingly. Some were selected from the files because I like them and feel they are good examples of the sort of picture one can expect or hope to make within the subject concept. Many were chosen to illustrate specific points raised or discussed in the main text or caption material. There are some other pictures reproduced which I consider to be fairly ordinary but which also have a relevance in illustrating various points and, in that context, form an important part of the visual concept of the book as a whole.

The fact that these and other 'ordinary' pictures exist in my files at all has to do with a variety of circumstances prevailing before, during and after the pictures were made. Under the heading 'visual perception' I would list the following emotional activities: apprehension, excitement, tension, boredom, frustration, exasperation, exhilaration, timing, anticipation, tolerance, impatience, and so on. All, or any one, of these symptoms could be a reason for a potentially good photograph failing.

The human element should always be the first target for analysis in any post-mortem on why a picture failed, unless obvious mechanical instrument failures predominate.

The problem with any creative medium used to produce a two-dimensional image in the form of what we generally recognize to be a picture, is that there are no hard and fast rules about how the end result should be regarded. One person's taste is not the same as another's. It is, if you like, the result of a combination of emotions existent at the time of visual perception and later, when the picture is viewed, the subject of a different set of emotions.

In photography, simple guidelines exist around which each individual should be encouraged to work. These are: composition, lighting, perspective, mood, content, animation and context. In the following pages, these elements are discussed as they relate to pictures reproduced and to the way in which one, or a combination of all, can be used to produce good photographs. Before going further, however, there are a number of other points worthy of consideration.

THE STATE OF THE ART TODAY

It would seem to me, after spending several years engaged in professional photography and investing a great deal of time in studying the work of other photographers, that a demarcation line can be drawn somewhere in this century which shows where the good photography stopped and the quite ordinary began. While there is no doubt in my mind that many excellent contemporary photographers are hard at work, there are many more who are not producing much worth looking at. Arthur Goldsmith, in an editorial in the American *Popular Photography* magazine of April 1980 said, '... seeing, not the compulsive burning up of film is what photography is all about.' In the same magazine in an interview piece in August 1975, Sam Wagstaff, New York-based collector of photoprints said he found contemporary photographers on the whole woefully ignorant of their medium's history, compared with artists' knowledge of theirs. 'Ignorance of connoisseurship of the past, such as does not exist in the art world,' he maintained, was doing harm to contemporary photography.

What seems to be lacking is, firstly, the ability to recognize a picture when it is seen

for a fleeting moment by the eye and, secondly, the technical knowledge necessary to enable the photographer to put the image on film. Quite often, in discussions with other photographers and in helping to train young cameramen who have come straight into the business from school with perhaps only the briefest photographic education, it has been evident that, with regard to the first of these, a lack of understanding of what picture-making is about is the root cause of most problems. One can read and be taught all the practical and technical skills and have a thorough understanding of the chemistry of photography but, without an appreciation of composition, lighting and the ability to recognize, in pictorial terms, what is happening before your eyes, the bulk of what we shoot can be assigned to the rubbish bin. 'The grand delusion of contemporary photojournalism is that anyone can make great pictures,' observed Howard Chapnick in 1982.

The 'grand delusion' is not a phenomenon which has suddenly appeared in our midst; it has evolved, along with technical advances made particularly in miniature camera design and manufacture, over a number of years.

Looking back through 25 years of American and British photographic magazines it can be seen how, especially in the last two decades, many design features incorporated into modern cameras have become a major marketing point. Fierce competition between manufacturers for a healthy slice of the user market has forced designers to forge ahead with new concepts. Auto-exposure, auto-wind-on, auto-rewind, and auto-focusing are now as much a reality in camera equipment as the supermarket shopping trolley is to the housewife.

While some of these design concepts may have a significant effect on the sale of units, none of them can be said to be of really significant importance to the serious picture-maker. I have found the facility of automatic in-camera exposure systems useful on many occasions but, as a general rule, I still prefer to use a hand-held, off-the-camera meter. It gives me greater flexibility in ascertaining the correct exposure. Motor drives and powered winders also have their uses, if only to help balance certain camera/lens combinations but, rather like navigational aids in a boat, I do not rely

exclusively on their use as a means of firing the shutter. Auto-focus lenses have been on the market for some time now, but I cannot honestly think of an instance where I might have preferred to use such a lens instead of the usual mechanical type. There is no good reason why I should need any of these facilities to make good pictures.

The tendency is for the contemporary photographer to take all of these technological gadgets for granted, hoping that by making the monumental effort of squeezing the button, something equally memorable will be fixed on the silver halides. Concurrently, some camera manufacturers are not much interested in the end product their thoughtfully designed instrument might produce. The marketing emphasis is on knocking the competitor or a play on the psychological factor governing ownership.

While camera manufacturers virtually control, by way of advertising revenue, the well-being of magazines devoted to the hobby and profession, the reader's imaginative and technical horizons are being severely curbed. One or two journals are aware of this problem and make persistent attempts to ensure that their readers are well informed and encouraged by bringing to their editorial pages material which other journals would only regard as fit for the reject pile.

But, if one considers how many millions of photographs are snapped each year (20,000 million at the last count), some idea of the extent of the problem can be gauged. If only as many as one-quarter per cent of all pictures that were taken were actually viewed by the public at large it might be reasonable to suppose that only a handful of those would ever be filed for posterity as truly memorable pictures or socially significant documents. The very fact that these are selected and subsequently used to illustrate print or exhibited for the pleasure of millions can be seen as an indicator of taste. But how many thousands of disappointed, exasperated and frustrated photographers there must be, and do they know why their pictures never made it into the pages of published history?

Sadly, it seems not and it is partly the quality and content of many editorial contributions and partly the plethora of advertising statements by manufacturers extolling the virtues of one lumitronic camera or lens against another, which helps to perpetuate

43 (PREVIOUS PAGES) *Rouen, France. (Nikon FG; 80mm Nikkor lens with yellow filter on HP5.) Exposure and development were critical in order to retain both the atmosphere created by the mist and detail which could be seen through it. (See p. 59 for details on visual perception)*

44 (ABOVE) *In the little town of Montauban in southern France, the pattern and texture of a wooden fence plastered with political posters caught my eye, the vertical and horizontal (almost) planes making a simple graphic design. I waited a long time for the right human element. Having the man walking out of the picture, rather than into it, leads the viewer to wonder if the average Frenchman actually cares who wins the poll. (Petriflex SLR; 135mm Petri telephoto; Tri-X)*

the process of burying the visual perception of modern photography. '. . . if you know how great photography can be, you're not going to be satisfied with doing less yourself' Sam Wagstaff observed in the same interview with the late Jacob Deschin on the then current state of the art and the extraordinary standards which the past set for itself.

CHANGE FORMAT TO CHANGE VISUAL PERCEPTION

With no specific reference to a particular field of photography, Andreas Feininger once made the simple statement that for him 'light is everything'. The son of Lyonel Feininger, a well-known Bauhaus painter, Andreas first studied architecture in Paris and then moved to Sweden where he recorded some remarkable images of Stockholm using very long telephoto lenses. It was as much his understanding of what light is about as his experience in architecture and painting which, blended together, gave him the solid base on which some truly great pictures were made. In photographing city-

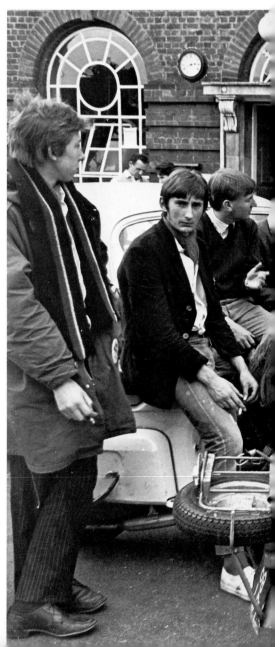

62

scapes for *Life* magazine and for much of his earlier work, Feininger made his own cameras to fit suitable lenses which he found by scouring war surplus departments and used-camera stores. One of his favourites was a 5 × 4in. instrument fitted with a 40in. lens mounted on a specially made tripod. His reasoning was simple: he wanted his pictures to create the same kind of awe-inspiring emotions as real sights sometimes do when seen with the eye.

The eye has a fixed focal length and maintains subjects viewed in rectilinear perspective. Taken individually, a skyscraper, a bridge or any other building can be recorded pictorially by the brain, but instantaneous or later recollection of those same images creates new impressions in the mind. With time, those images are gradually distorted. Using long lenses which retained the normal perspective when exposing over long distances, Feininger was able to be selective and make pictures which at first appear to be photographic distortions of reality. That they are simply dramatic, two-dimensional repro-

45 *As a group, isolated from the background, this picture would only have limited appeal and then would need the support of a long caption or story. As it is, the windows in the background look down on the group like giant eyes, adding balance to the whole; the eyes of the public gaze back and the group is caught between, as many teenagers often are (Petriflex SLR; 28mm Petri lens; Tri-X)*

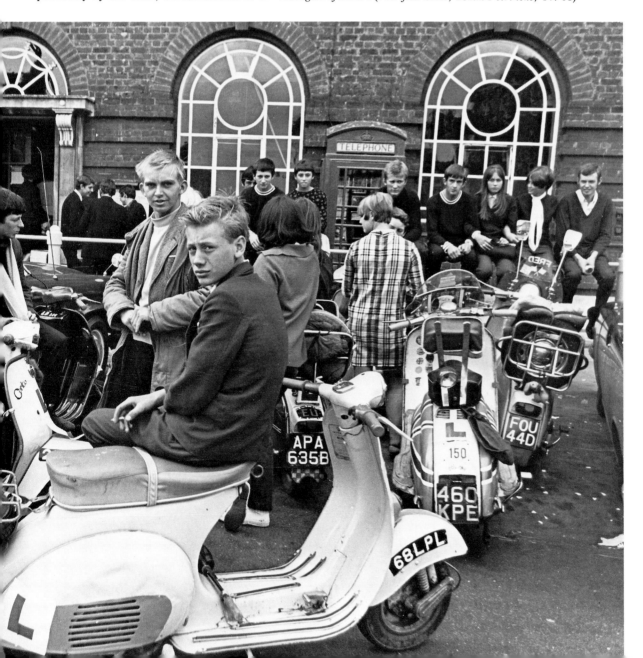

ductions of what was seen in the mind's eye is a credit to the man's ingenuity in finding an optical method of portraying those subjects in such a way that the viewer is compelled to look again and again, often seeing for the first time images within the image.

Consider for a moment: would today's photographer build a special camera in order to photograph the Empire State Building from a distance of seven miles so as to create a picture which shows the edifice in such a way that it relates in more exact proportion to other buildings around it? Feininger once said in a television interview that he knew exactly where to go in Manhattan at any time of the day to make the pictures he wanted. He was making reference to the way in which light affected his subject and it is partly the availability of that kind of knowledge which makes any picture so much easier to organize and execute: knowledge of the subject.

The answer also lies in a second area of availability, which can be found on the shelves of photographic stores. Since the introduction of the 35mm SLR camera some 30 years ago, lenses of all shapes and sizes have saturated the market. If a photographer needs a special lens for a special job, it will almost certainly be available, either for sale at reasonable cost or for rent by the hour or by the day. It is ironic that the availability of such a vast array of equipment still cannot guarantee that we will see and be able to commit what we see to film and paper in the same moving way as some of the early pioneers of photography. There are also now many other subjects which can be tackled easily and which photographers of 50 years ago would have struggled to arrest on film.

For the better part of its short history, photography has been practised utilizing large format cameras. That means anything from 6×6cm ($2\frac{1}{4} \times 2\frac{1}{4}$in.) upwards. Smaller formats were invariably resisted as instruments for serious use and it is only in the last 20 years or so that 35mm has come to be accepted by the editorial side of the industry and where it now rightly features as the most versatile mainstay; but there are still many areas in advertising where its use is not welcome. The reason for this usually has to do with end product quality rather than instrument sophistication. Carefully processed 35mm formats can give excellent results; the big problem is that, on a commercial level,

46-50 *The right choice of lens is as important to picture-making as the choice of subject matter. While the standard 50mm or 75mm lens is perfectly adequate for the majority of subject matter, wider and longer than standard focal length lenses give the photographer room to manoeuvre; to control perspective, proportion and elements of composition. Fig. 46 is of Volos: Sunday afternoon on the promenade (Nikon F; 300mm Nikkor; Tri-X; 1/500 second at f11)*

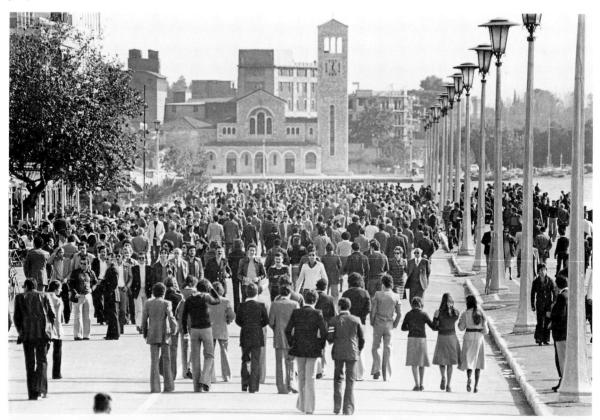

processing is hardly ever given the care and attention it needs in order to maintain consistent high-quality standards. Larger formats, because of their size, give significantly better quality under the same commercial conditions.

For the editorial photographer and photojournalist, compact cameras are ideal. Bodies and lenses are light by comparison with larger formats and can be carried with relative ease in a medium-sized suitcase or shoulder bag. A tripod is rarely needed and is frowned upon by those photographers who maintain that freedom of the body and mind and versatility of equipment are the key to successful shooting.

By working exclusively with one format, the photographer creates an involuntary restriction in the way in which subjects are seen. No knowledge or experience of the way in which other formats perform is as much a limitation on versatility and visual perception as the predicament of a painter equipped with paint but only one size of canvas.

Defecting from one format to another is often the result of a photographer's psychological battle, the reward of which is peace of mind. Some years ago, I wrote in *Camera at Sea* (Ajax Publishing 1975) that I could not see where a large format camera would fit into the everyday working routine, but that, in years to come, the situation might change.

Because photography is such a personal occupation, finding the right format to suit the task and the personality of the individual is not easy. For economical reasons it may make sense to use a smaller format camera, but the image which some photographers are compelled to present to the world is also a curious psychological factor and this may often take precedence over any other consideration. Because of preconceptions by the layman, ownership of certain types of photographic equipment can and often does have a profound effect on a less knowledgeable audience.

My first camera was a Box Brownie, given to me by my grandmother when I was ten years old. It had a single element meniscus lens and a portrait attachment. In spite of the camera's simplicity, I had a lot of fun with it for four years, when my father gave me a Chinese copy of a twin lens reflex. That I later swopped for a folding 6×9cm Zeiss camera which kept me company during my early days at sea. As soon as I was able, I invested in another TLR and, because 35mm SLRs were then available in a wide variety of marques, I purchased one of those too. I kept the Yashica 635 and added a Japanese 35mm rangefinder to the list. When I finally took up this career full-time, I added several lenses and two more Petriflex bodies to the collection. As if that were not enough, I also purchased a second-hand 9×12cm Van Neck Press Camera complete with standard Tessar, wide angle and an $11\frac{1}{2}$in. Dallmeyer telephoto. For a while, I took that camera with me everywhere. For the sheer exhilaration of seeing the colour transparencies it produced there was nothing to beat it that I could afford; they were like transparent post cards! Black-and-white 35mm negatives, no matter how carefully I processed them, could not compare with the incredible detail captured by the Tessar on a 9×12cm negative. Other formats had also entered the system and gradually I felt a sense of being swamped.

Sometimes, I would sit for hours prior to an assignment trying to make up my mind what to use. More often than not I would end up taking the whole lot, which caused the inevitable confusion of mis-matched lenses and fumbling for fresh films of one sort or another. I would forget to wind on the next frame, or remove a dark slide, the penalty for which was a higher percentage of missed pictures. Psychologically, I was over-equipped.

I sold all the big guns, gave some of the remainder back to the family and part-exchanged the Petriflex equipment for Nikons and a handful of lenses.

For a few years afterwards I managed to find some peace of mind and, I think, made some acceptable pictures with the 35mm format. Now, I am almost back to where I was at the beginning. The Nikon armoury has grown out of all proportion and I have added two Bronica 6×6cm formats with lenses and a 5×4in. Speed Graphic. But that is where the old habit stops. Various formats have their uses, but not all at the same time, though I may use a larger format camera for colour work on some assignments in tandem with 35mm. The 5×4in. is rarely used, but nevertheless has its moments.

Arguments for and against the large and small format are not important here; what is,

is an understanding of how various formats can be used to change the visual perception of a picture. In using 35mm SLRs exclusively, the photographer becomes accustomed to a variety of flashing lights, moving needles and various numerical scales cluttering the viewfinder. There will also be focusing devices: a split-image central circle, a slightly larger clear outer ring and the remainder of the fresnel screen. All of this clutter is supposedly designed to free the photographer's mind from unnecessary worry about correct exposure and focus. In many instances, it serves only to distract the operator's concentration. Rangefinder cameras are normally fitted with simple, brightline viewfinders, which although giving a smaller image size than the prism reflex system, leave the photographer free to concentrate on picture-making.

Granted the portability of small format equipment and the challenge it bestows upon the concerned photographer to obtain the very best that is possible from it, I have always felt that the end product, regardless of medium, leaves much to be desired. For a while, I managed to delude myself that with very careful processing, I could produce prints that were technically excellent so long as they were viewed from arm's length. Transparencies, particularly when projected, showed superb sharpness and colour saturation. When they were not superb – just a little shaken or blurred or fractionally out of focus – the faults showed horribly in magnification. Unless deliberately blurred for effect during exposure, anything shot here, in the agency, which does not meet rigid standards of sharpness, no matter how good it may have been, is rejected. Since a great deal less large format material is exposed, less is destroyed, but the ratio of success using the latter is probably higher anyway simply because a larger format encourages the photographer to think more carefully about all aspects of picture-taking and making.

For example, a chance picture of a golden sunset may use as many as 10 or 12 frames of 35mm, possibly more if the photographer is nervous. In anticipating the same scene, a large format user may employ a tripod, spend some time composing and focusing the picture on the ground glass, consult depth of field scales and make exposure adjustments

for shadow details as well as highlights, which are then recorded on the back of the film holder for use later in the darkroom. The large format user may be content with two exposures, knowing that each can be processed differently for varying effect. Very few 35mm users resort to short lengths of film, preferring to process a whole roll which may have as many as 36 differently exposed scenes and which theoretically, should all receive individual attention in order to obtain the best results.

Photographers tend to change camera systems several times during the course of a photographic career. The reasons for this may be the replacement of old and worn equipment or a change to a different format for one or some of the reasons already stated. Whatever the reason, every consideration should first of all be given to the capability of format with regard to its suitability as a tool for picture-making. If the changeover is one which only concerns format, don't go at it like a bull to a red flag. Keep some of the older equipment back because, even if you do not use it for a year or two, you will eventually see that it has its place.

Many 6×6cm users claim that one of the main advantages of that format lies in its square shape, a shape which, in practice, invariably utilizes only two-thirds of the total area for actual picture-making. Why this should be so only really becomes apparent when you begin to use the format. In practice, the square shape lends itself to an infinite variety of cropping styles both on and off the camera. It is possible to make several different pictures out of one square negative, but much more difficult to perform the same exercise with the smaller 35mm format or the in-between 6×4.5cm shape. Larger formats like 9×12cm also lend themselves to a variety of cropping procedures. But, of course, all formats can be cropped in printing. What makes one psychologically more attractive than another probably has more to do with the way a camera is used than what it actually produces in the way of a shaped negative.

At eye level, the 35mm camera becomes an extension of the mind's eye. What we see through the viewfinder of an SLR is pretty much what the mind wants us to see and is one reason, perhaps, why 35mm users have a tendency to shoot more frames of any sub-

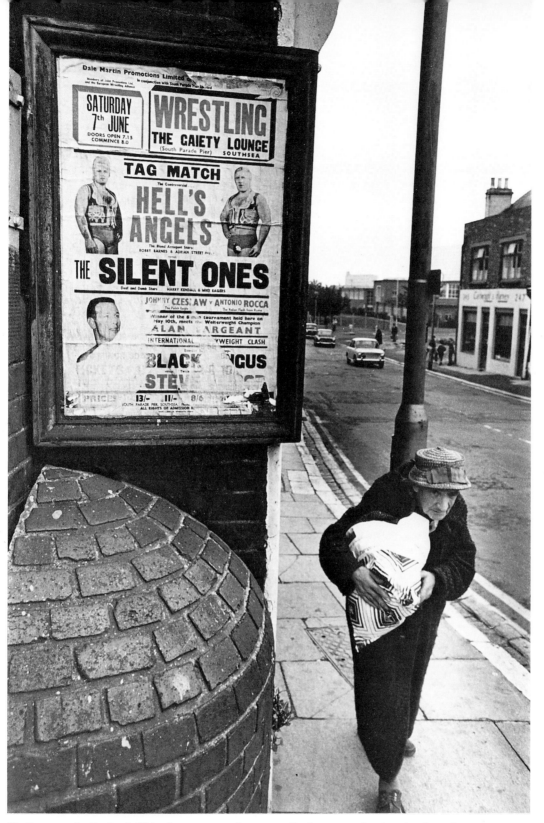

47 *Portsmouth, England. This picture was made as part of a feature on the changing face of an historic city. In fact, it's no longer the tatty place it once was but, at the time, the juxtaposition of old age and the youthful-looking wrestlers on the poster, with the rickety street scene behind, helped to convey the seedier images I had seen time and time again. (Petriflex SLR, 28mm Petri lens on Tri-X)*

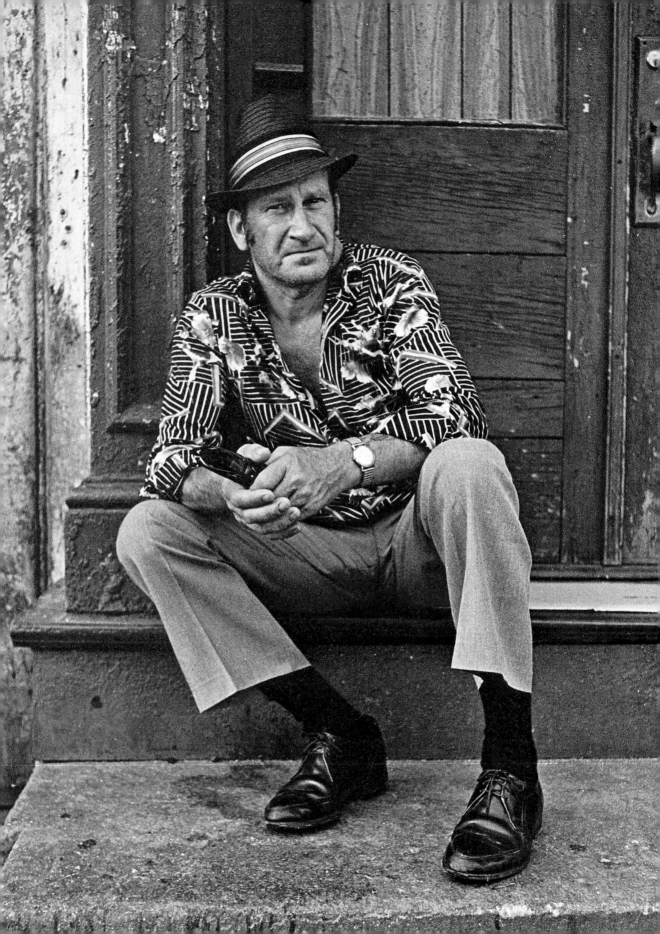

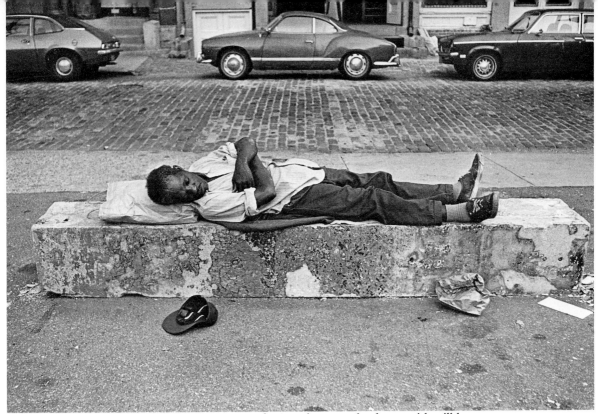

48 *Two examples of New York street life:*
(a) (LEFT) *Waiting for opening time. A face
full of character and interest. I asked the
subject if he would mind my intrusion. He
said he wouldn't and didn't move a
centimetre. (Nikon F2; 105mm Nikkor; Tri-
X); (b)* (ABOVE) *Off Wall Street. (Nikon F2;
35mm Nikkor; Tri-X)*

ject. Photographers using a larger medium
format camera, like a TLR, for example, are
restricted by a less instantaneous type of
viewing system. Most TLRs show the image
laterally inverted. Without the use of a penta-
prism, pictures are required to be viewed
at waist level; a fine focusing check may be
carried out by activating the image magni-
fier, at the same time raising the camera to
eye level. If the photographer is then still
uncertain as to composition, the camera will
be lowered back to waist level before the
exposure is made. While it is perfectly cap-
able of being used rapidly to record fast-
moving events, the photographer is auto-
matically persuaded by camera design to
approach the techniques of picture-making
more cautiously. On the whole, the same set

of comparisons can be drawn with still larger
formats.

None of this is to say that small cameras
encourage us to be less perceptive. On the
contrary, in talented and knowledgeable
hands, small cameras have produced, and
will continue to produce, memorable pic-
tures. Nor is it to say that more meaningful
work will be produced by larger format
users. What is important is that the photo-
grapher needs to recognize how seeing is
affected by the use of different equipment
and, consequently, how different formats and
different lenses can be utilized to make what
you want, not what you hoped you would
get.

COMPOSITION

In the same way that some people are af-
flicted by colour blindness, so there are some
who suffer from form blindness. In photo-
graphic terms, form blindness could be de-
scribed as the inability to assimilate real
shapes in the graphic sense. Shapes – the
form adopted by lines and curves in man-
made structures and nature – surround us
constantly. By glancing quickly from one
subject, or a number of subjects, to others,
it should be possible to pick out predominant
shapes. By placing these in our imaginary

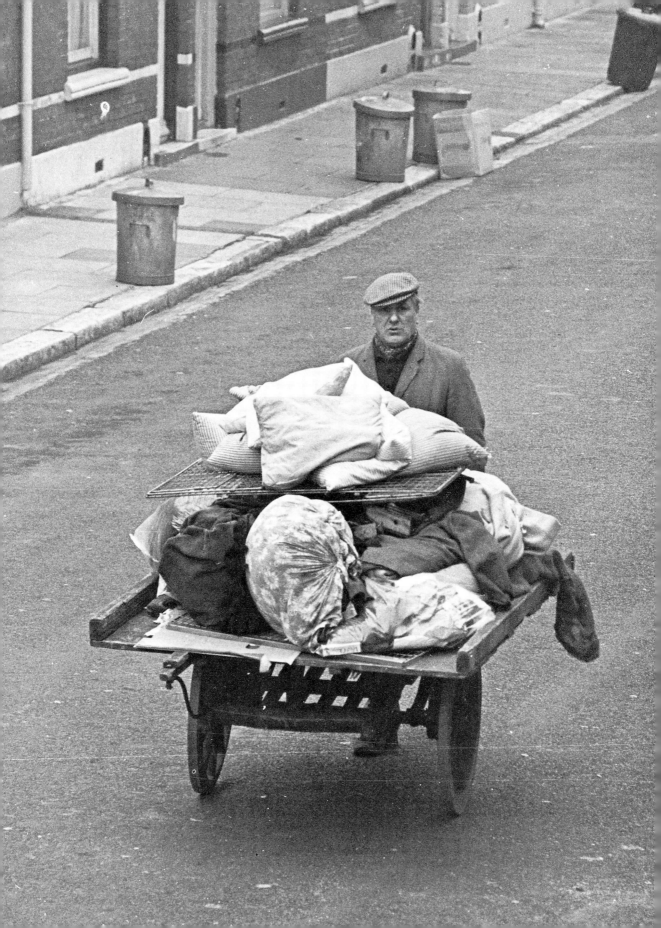

square or rectangle, the photographer begins to see how pictures can be formed.

With sufficient practice, the obsessed photographer will begin consciously to see life through 'square eyes'. It may also be possible that during the early period of learning, many other seemingly erroneous and irrelevent slices of life will be discarded along the way because they do not fit into our imaginary framework.

Good composition – the direction, balance and tone of light and form – is essential in good picture-making, but it should not take precedence when ascertaining whether a picture worked or failed. Under that heading we should look at the expression of content. Composition for the sake of it will achieve little, except perhaps a picture which is composed of ordered lines or curves, leading the eye into and out of the subject. If the content is expressed blindly, or if there is no meaningful content at all, the eye will quickly move on.

There are several schools of thought concerning composition. In one, the student is given to understand that certain formal shapes – the triangle, the division of a rectangle or square into thirds, the circle, or the 'S' configuration – are the basis of economical composition. We usually find that these 'rules' go hand in hand with other rules governing the technicalities of the medium: negative exposure, processing techniques, print gradation and finishing.

We should be concerned with all of these points, but as contributing factors and not as a set of rules guaranteeing pictorial excellence.

At the other end of the scale is the school which abhors rules of any kind; the 'shoot regardless' brigade, determined to succeed at the expense of self discipline. A photographer once told me that if he shot enough frames, the law of averages would dictate some degree of success, somewhere along the line. That is perhaps the saddest attitude, and one which I have seen practised time and time again by photographers whose only obligation is to get 'a' picture.

Both attitudes toward making pictures show obvious weaknesses: there is much more to making good pictures consistently

than simply pointing and shooting or fussing over much whether a picture is divided accurately into thirds.

In photographing the inner city, suburbia and industrial areas, the observer is confronted with any number of images that could make pictures of one kind or another. The question that should be asked is: how to portray what is going on in a way that the ordinary viewer who knows nothing about the skill or art of photography, will immediately understand? Should the photographer be concerned only with form, as in the shape of modern architecture, or with making comparative statements? What graphic statements can be made concerning environment and its effect on the residential populace and how are they interpreted to the best advantage?

In each case, there is a different picture or set of pictures which will effectively answer the question; but they will need thinking about, either before, during or, mostly, after the exposure has been made. All will become subject to the elementary rules – which are not really rules but guidelines – for composition, whether or not these have been thought about consciously. The more disciplined a photographer is about interpreting and using such guidelines, the more likelihood of success in making a picture that will stand a cut above the rest.

CATCHING THE ESSENCE
Learning to interpret the image

In attempting to record the buildings and streets of some cities, I have found that research into the past is essential; for it is from the past that much of the tradition of architecture and city life stems. In particular, the photographer is indebted to the painters of previous decades and generations who have documented scenes in such a way that, while also being impressionistic, are essentially accurate records of life as it was and, to a large extent, still is many years later. Even if the design of consumables, the style of clothing and method of transportation or shape of architecture have changed and even if the population per square metre has increased considerably, the essence of life remains the same. Using these painted impressions as a base for the application of photography, one begins to recognize certain aspects of framing and perspective which may not otherwise be easily seen.

49 One of a series on totters. (*Petriflex SLR; 135mm Petri lens; Tri-X*)

For example, a picture painted by Claude Monet in 1873 of the Boulevard des Capucines in Paris can be seen as a record not just of the place, but of the need which people have to congregate and promenade *en masse* along some elegant street. In the painted picture, only Hausmann's architecture gives a clue as to the place.

In the town of Volos in northern Greece, I found a bizarre interpretation of this theme one Sunday afternoon when the wide avenue leading around the harbour was suddenly filled with local inhabitants taking the air, perhaps in much the same way as Monet had seen in Paris over 100 years before. To capture the essence of the occasion I used a 300mm Nikkor telephoto and made the picture from on top of a parked Land Rover which gave me the necessary height for a long view of the parade.

Many other artists of the period all made paintings depicting similar scenes of cities around the world, in addition to countless more intimate expressions of life in the street, in cafes, parks and gardens, stations and dockyards – for example, Edouard Manet's *Bar aux Folies-Bergères* of 1882, *La serveuse de bocks* 1878 and Paul Cézanne's *Les jouers des cartes* 1890-1905. The photographer's problem is not that of recognizing that life *is* much the same today, but of how to interpret each slice with such technical and emotional competence that the viewer is only aware of the content. The technical ability should be of such quality that it only becomes obvious to the trained eye in the finished print.

The ability to see through a variety of different focal-length lenses without actually raising a camera to the eye is essential and, since each lens will have its own peculiarities with regard to depth of field, angle of view and distortion, it is equally important that the photographer knows in advance precisely how each image can be interpreted.

Being selective

The art of interpretation also raises another quirk in the way we see photographically: the difference of seeing with the aid of a lens and seeing without. Human vision is selective and frequently unreliable, subject to the emotions, feelings and senses of the brain. The camera is a mechanical extension of the eye only and, as such, is entirely objective and uncompromising in how it sees. The photographer must first begin to think like a camera before his or her own vision can become as objective. It is not only a question of constant use of the camera for viewing but an understanding of how each different lens will give an image which is different from the one which the brain sees. Artists and painters have one advantage in this respect in that because subjects are invariably viewed only through the eye and visually adjusted on to the canvas by the brain, each stroke of the brush helps to create the illusion of reality. Artists are not concerned in the same way as a photographer with the mechanics of selective focus, depth of field, compression or any other optical distortion which may result when a photograph is being made.

While the artist is also able to add or remove sundry objects to balance compositional elements at will, the photographer must be sure at the moment of exposure that the photograph has been given as much attention. All too often a photograph is spoiled by some niggling object or part of one that could have been omitted. This doesn't have to do with selective focus, it has to do with selective framing and timing.

Leaving out what is not essential is very often the hardest part with which a photographer has to come to terms. Some views are so all-encompassing, so magnificent, that they demand to be photographed in their entirety, and yet the result frequently disappoints simply because the scale of the two-dimensional print cannot in any way pretend to mirror the image of the real thing.

In seeing selectively, the human brain is able to take in grand vistas piece by piece and see them as a whole, even if subjects on the periphery are muted and out of focus. What we feel about this image is as much a result of seeing the way we do as what each piece of the jigsaw does to the sensory perceptors of the brain: smell of the air, colour of the sky, size of buildings and so on. Cameras cannot smell, or feel, or tell the difference between one colour and another without our help. Anything you leave in the picture will be faithfully recorded at the moment the exposure is made.

In all probability, a large proportion of the

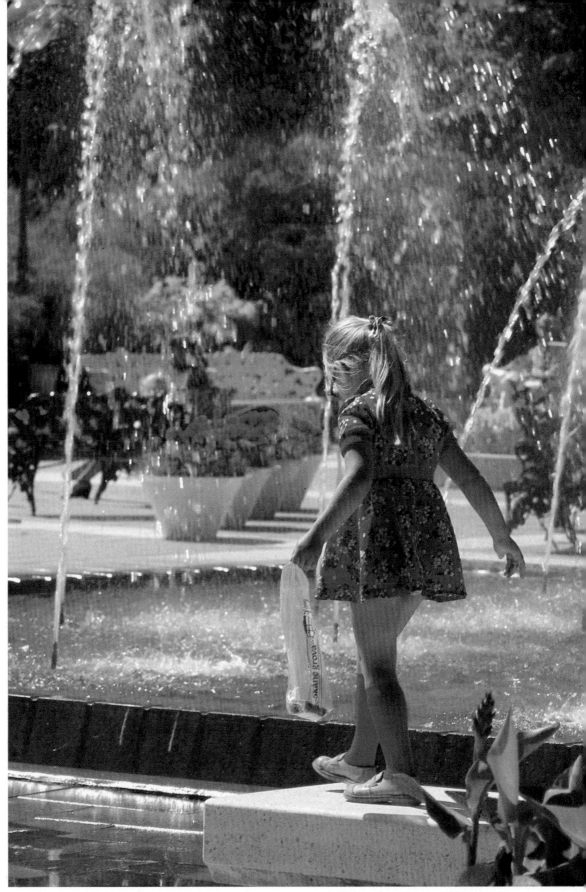

1 Stockholm (Nikon F; 200mm Nikkor; Ectachrome − X)

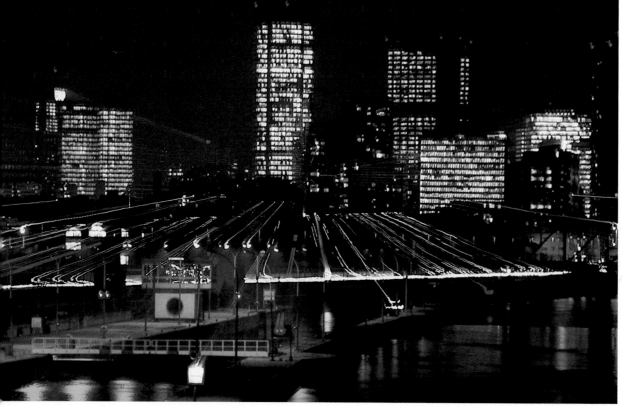

2 Night lights of La Défense, Paris (Nikon FG; 80-200mm Nikkor at f8; 1½ minutes, lens zoomed for part of exposure)

3 New York cab driver (Nikon F2; 24mm Nikkor; Fujichrome)

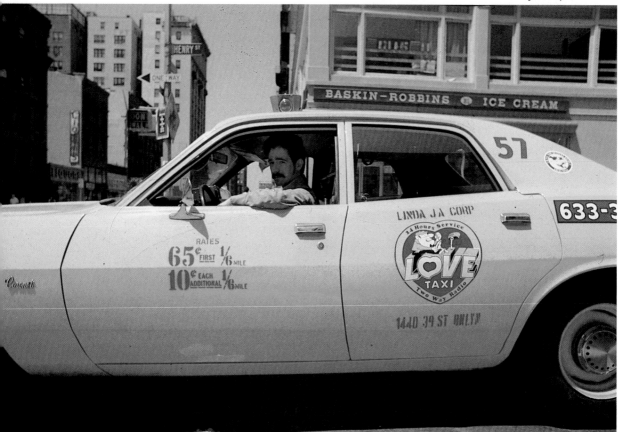

4 *America's oldest city, Key West, Florida (Nikon F; 24mm Nikkor w/a; polarizer; Kodachrome 25)*

5 *Underground station, Stockholm (Nikon F; open shutter; electronic and bulb flash; tripod; Ektachrome −X; 64 ASA)*

6 Montparnasse Tower taken through the trees of the Luxembourg
Gardens, Paris (Nikon F; 80-200mm Nikkor zoom; Skylight 1B
filter; Ektachrome 200; 1/60 second at f4.5)

7 The Glass Tower, Stockholm city centre (Nikon F; 24mm Nikkor
w/a; polarizing filter; Kodachrome II; 1/125 second at f8-11)

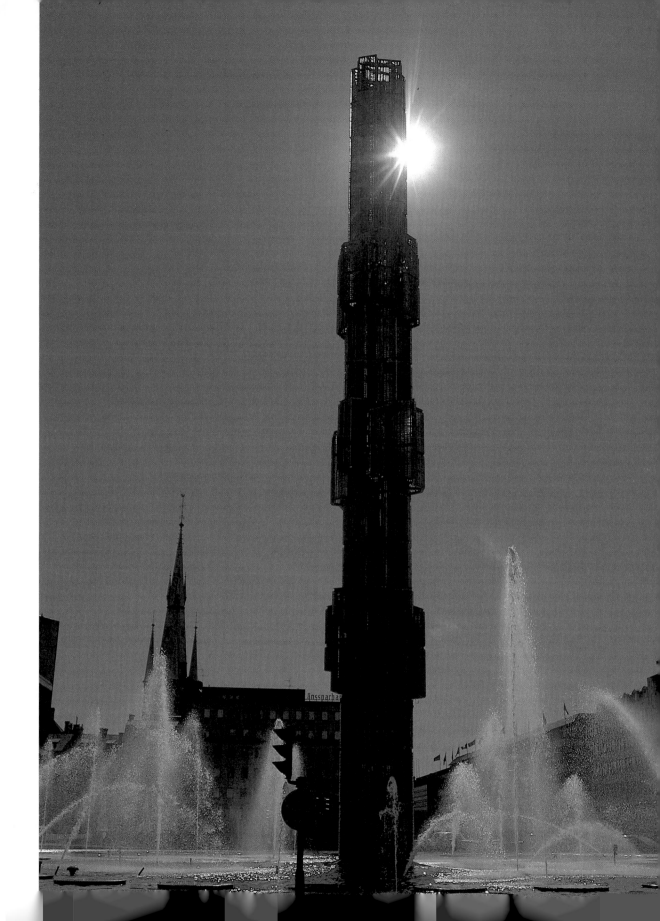

8 Montmartre, Paris (Nikon F2; 200mm Nikkor; Kodachrome II)

9 Stockholm (Nikon F; 200mm Nikkor; Ektachrome – X)

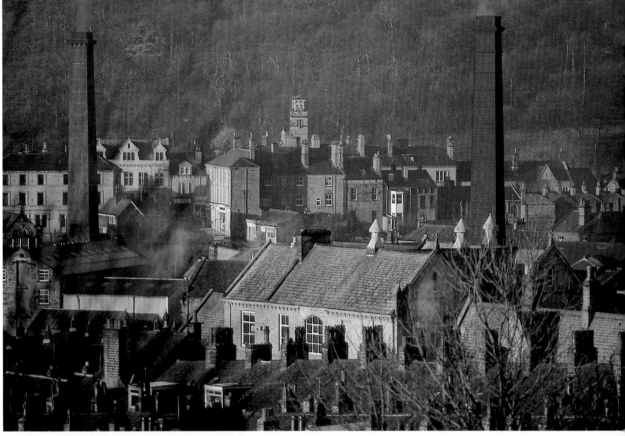

10 Yorkshire mill town (Nikon F2; 200mm Nikkor; early morning in
 March; Kodachrome II)

11 Port Said, Egypt, at sunset (Petriflex SLR; 50mm standard lens;
 Kodachrome II)

12 London, late November afternoon (Nikon Rangefinder; 28mm Nikkor; Agfachrome 50S; 1/15 second at f3.5)

subject matter which comes before your camera and which is ultimately committed to film will have very little interest for most onlookers, whether your audience be friends, family or spread over a wider field. What rivets the attention is not subject matter *per se*, but the way in which it is presented – impact. Impact is the result of clever and creative subject presentation.

A good photograph should be well composed, retaining essential detail for the viewer to identify clearly. Simultaneously, it should draw the viewer's attention easily through the picture to the main point of interest. Impact can be as subtle as it is often shocking, but that does not mean that you should deliberately set out to shock by photographing subjects in a distasteful way, or by using subjects solely for their horrific value – though a photograph can obviously contain elements of that nature.

Framing the subject

There are a number of devices which the photographer can utilize to present subjects in more interesting ways. Framing is one. The use of archways, foliage, balustrades, people, traffic signs. The secret is not to make an obvious habit of using the same or similar subjects. Be selective and try to find objects which fuse with the main subject. For example, in isolating a row of old miners' cottages from their general surroundings, the use of a frame employing contemporary street furniture would serve little purpose in conveying the message to the viewer.

Archways should probably be the last resort, since their use must be about the most hackneyed cliché there is in architectural photography, or views depicting 'olde worlde charm': the kind of thing that is frequently used for chocolate box lids, jigsaws or calendars. Not all archways are built of stone in the tradition of nineteenth-century architecture. There are many fine examples of industrial and contemporary commercial design which can be used to heighten a picture.

Placing horizons

Deciding where the horizon should be placed in a picture depicting a wide or long view is equally important. Traditionally, the painter uses a rule of thumb in which the canvas is composed of two-thirds sky and one-third land, very rarely is the division reversed. The very nature of photography however, allows one to be more daring. The traditional horizon used in the broad pictorial view creates less impact than the one placed lower or higher.

Low horizons used together with dramatic skies create a feeling of spaciousness and freedom; multiple horizons employing different tonal values – as in a view of receding rooftops, for example – create a feeling of depth, as do horizons placed higher in the picture, allowing more foreground to lead the viewer onward.

Used creatively, the low foreground can be made to emphasize (say) squalor in an area of urban re-development. What the viewer sees in the picture (*Fig. 71*) may be just a pile of bricks, but here the concluding piece of information to this mental puzzle is placed high in the photograph, confirming to the viewer that what he sees is not only a pile of bricks, but definite affirmation of some re-building project which will come after the demolition.

The illusion of depth can be created in a number of ways using high horizons or deep foregrounds. Controlling depth of field is one. Another is the use of *contre-jour*, or backlighting to emphasize certain objects in the picture while eliminating detail in others to create partially silhouetted effects. Correct exposure is the key to success here. Don't under-expose so much that detail in all of the highlight areas becomes too muddy. In effect, what you should be looking for is a balance between the pure black and white as may be found using lith film, as well as some retention of detail in all but the darkest areas. Extra treatment in printing may be necessary to obtain the desired effect, but the negative

50 (OVERLEAF) *This picture was one of a series for an article on pollution and required much travelling to various points up and down England. I had to expose two or three frames for the picture to ensure as far as possible that the horizon was level. The camera, a Petriflex V, was dangled by its strap to just above water level using the delayed-action self-timer to trip the shutter. (28mm Petri lens on Tri-X)*

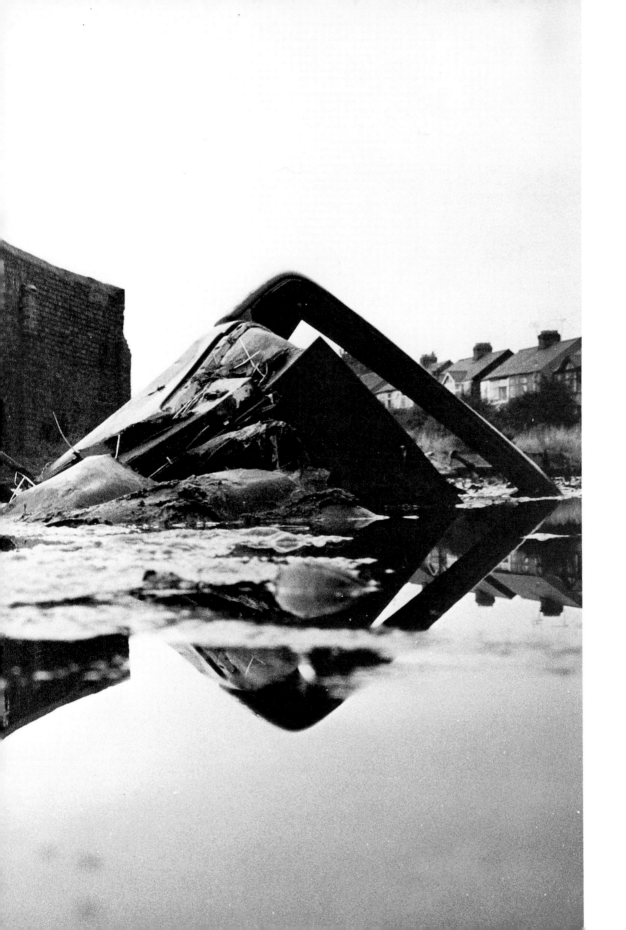

should already contain most of the information required for a first class print.

You can call it creativity if you like, but remember that all of these devices are the tools of a photographer's trade and, in using them to obtain a desired effect, there is always the risk that basic information may be manipulated into a two-dimensional rectangle which ultimately may give the onlooker a completely false idea of what is really happening.

51 *From a story on tattooists. (Nikon F; 35mm Nikkor; available light from bare bulbs hanging in the studio; Tri-X rated at 650 and processed in D-76 1:1 for 14 minutes)*

4 Light and Colour - Use and Abuse

THE QUALITY OF LIGHT

Individual photographers will have their own ideas about how light can be quantified. There are ground rules in terms of the pure mechanics of photography, but that is all. When it comes to pictorial interpretation – how light and shade are juxtaposed to capture the essence of mood, to create atmosphere, to give relief to one or a collection of buildings, to throw out details in architecture by using pools of light filtered through clouds, to silhouette form and shape, to illuminate texture, to present the colours of the world in such a way that the onlooker is shocked or pleasantly surprised – the only rules are those which experience has shown to have worked for similar subjects.

I have always encouraged a photographer to investigate the quality of work produced by others. In particular, the work of earlier lensmen and women, as well as painters and illustrators. Early photographic works need some study before any real understanding of how light was used to effect the peculiar charm inherent in many studies of the time. While there were many turn-of-the-century photographers intent on introducing their own brand of 'fine art' using controlled studio lighting and props, many photographs made in the great outdoors were the result of lengthy exposures on slow, home-made glass plates and, while normally moving subjects were often depicted rigidly fixed to the landscape, the intangible mood of epochs past has permeated early optics and been fixed on the plate.

52 *Dog at zebra crossing. I wondered whether it was thinking about the traffic or the lights or simply reflecting on the regimentation of human life. (Nikon rangefinder S3; 28mm Nikkor; HP5)*

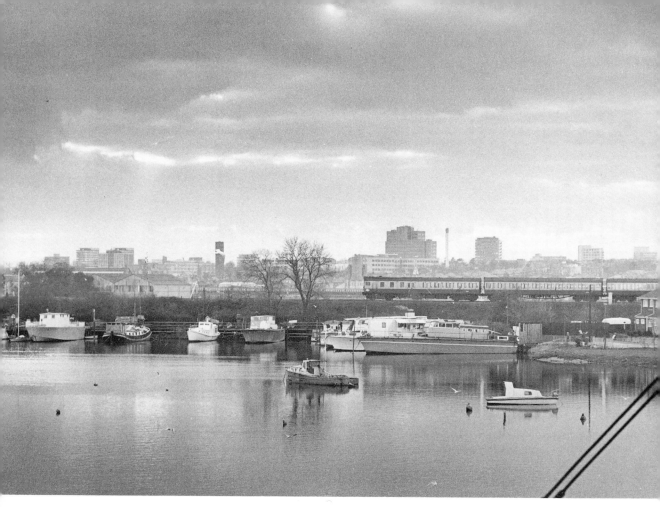

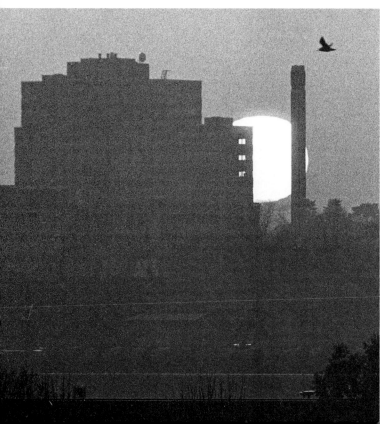

53 and 54 *The grand vista is often one of the most difficult subjects to photograph successfully, particularly when foreground interest is lacking. The effect of depth in Fig. 53 is retained by the use of aerial perspective. Used small, the picture becomes an indistinct blotch on the page; it needs space to allow all the information to be easily recognized and to maintain the grand view. (Fig. 53: Nikon F; 200mm Nikkor; HP5, through a yellow filter; late afternoon; Fig. 54: Nikon; 600mm; HP5)*

Even if the idea for a great picture comes only a few moments before the shutter is pressed, the majority of memorable works are invariably planned in advance. A photographer can spend hours tramping the streets of a city, shooting at random anything and everything which looks remotely interesting, but the fact is that a much higher percentage of success will evolve when the photographer knows more or less what it is that will make one photograph so much better than another.

Experienced photographers interested in their craft are able to collect, store and disseminate every single scrap of information in the mind which relates to subject matter, much in the same way as one might use a card index system or a micro-computer. Gradually, the scraps are processed to develop image-making ideas. These mental images are frequently incomplete but require only one extra piece of visual information before the idea becomes a usable commodity.

The missing piece of the jigsaw frequently falls into place instantaneously at the moment of exposure or immediately preceding it. One may not even be aware that the idea which had previously been fermenting for weeks, has actually jelled - a good reason, perhaps, why the analysis of a picture should take place as soon as a print is ready for viewing.

There are various schools of thought concerning picture analysis. One, which seems to be favoured highly among certain sectors of the fraternity, suggests that picture analysis is not only a waste of time and effort, but teaches the photographer nothing except how to look deeper into a picture for non-existent and meaningless points of reference. Photography being such an instantaneous process, one either likes the result for what it is, or not.

Allowing for an element of truth concerning the last sentence, the rest of the argument is tripe. The analysis of pictures, whether as photographic art or pure reportage, has been going on in a meaningful way more or less since the beginning of photography. In fact, it was the very idea that photography could even be held on a par with fine art which encouraged the criticism of photography by photographers. Anyone can press a button, but not everyone can make lasting images.

Light is the fundamental and most essential part of this jigsaw. Without it, we cannot see. In half light, the human eye is capable of discerning and distinguishing more than an average amount of detail. The camera sees all of this as a mass of grey tones which can only be separated and distinguished by using light as a mechanical device.

The late J. Allan Cash was a strict disciplinarian where the quality of light suitable for his kind of photography was concerned. Over many years, he and his wife Betty built a thriving business out of travel photography which ultimately grew into a picture library containing some 400,000 images. Virtually every negative or transparency held on file had one common denominator - they were all exposed in bright sunlight. Any that they may have inadvertently shot in lesser conditions were disposed of. This rigid discipline had the desired effect on picture editors worldwide, resulting in literally thousands of reproductions of their work.

We are not talking here about picture content, but with success in achieving a desired end result using a constant quality of light. What that quality is or should be will change through the eyes of every photographer; the important thing to remember is that, when other people see your work, whatever effect it has on them will be directly influenced by the mood of light in which the picture was shot.

Strong directional sunlight always helps to emphasize form and shape. When used for its sidelighting or backlighting qualities, textures of certain materials become more accentuated. Diffused sunlight, such as may be found toward late afternoon when weather patterns feature a series of passing fronts, or when a thin cloud veils the sun, is also useful for highlighting certain architectural qualities in a building.

Cloud formations, used as a back drop, help complement the flatter effects of diffused light, while light from a rising or setting sun is most useful for enhancing geometric patterns in black-and-white work and to add a variety of hues from gold through to red, purple and black in colour work.

In northern latitudes, where the climate is drier (and colder) than in our own, more temperate conditions, images illuminated in normal bright sunlight invariably record in the same crystal clear way as when seen by the eye. Moisture-laden atmospheres, however, even on what appears to be a fine clear day, can have a ruinous effect on colour balance as well as on apparent sharpness. Minute particles of water diffuse the light so that it absorbs more readily the hues of colours reflected from subjects in the immediate proximity.

Hazy conditions, however slight, always produce disappointing results in both colour and black-and-white stock, unless steps are taken to remedy effects. Some correction

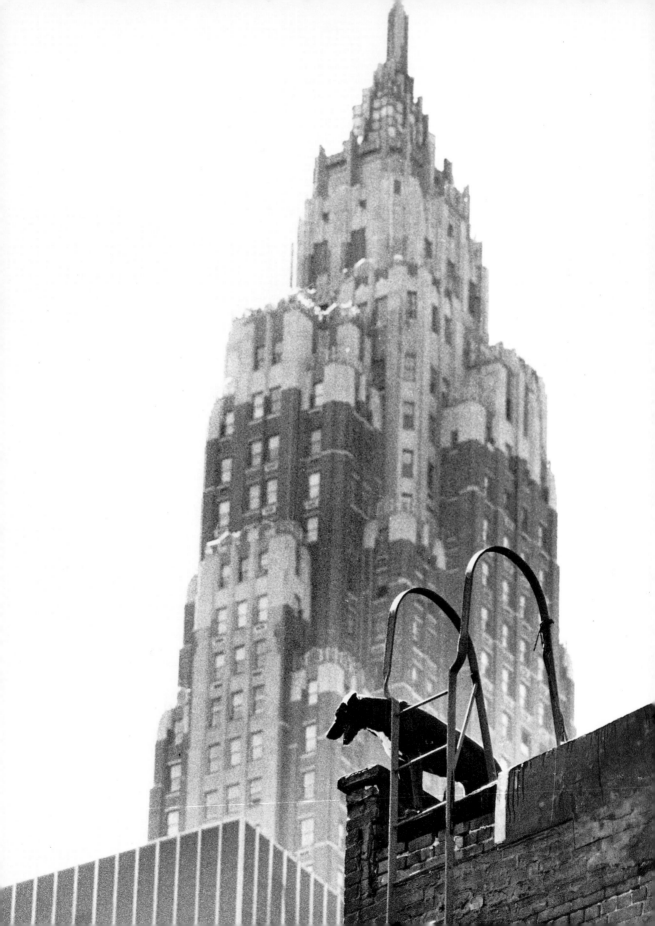

with filters is possible at the risk of increasing apparent grain in black-and-white film. With colour, resulting transparencies tend to look as if colours have been bleached. A reduction in the bluey/purple cast caused by ultra-violet light can be effected by employing an ultra-violet absorbing or skylight filter.

Moisture-laden atmospheres can play havoc with telephoto lenses because of the effect of air compression between photographer and subject. On a hazy day, this may result in photographs in which the tonal range is comprised of a series of greys. The use of foreground objects deliberately placed in the picture will help to improve tonal range and, at the same time, create a more representative aerial perspective giving greater depth to the picture.

WEATHER AND THE PHOTOGRAPHER

A constant supply of bright sunlight may not be the ideal of every photographer; indeed there will be many instances when this kind of harsh, coarse light will be almost useless for many subjects. Weather being the great determining factor where the quality of light is concerned, the photographer will benefit from studying that phenomenon and the effects which it can have on a day's shooting.

I discussed the subject of weather at some length in *Marine and Seascape Photography* (Batsford, 1983) and, with minor modifications, much of that text can be applied to more general outdoor photography.

Clouds

Clouds are a good short term indicator of the kind of weather likely to prevail over a 24-hour period. For the lay person, the infinite variety of cloud formations is probably the easiest part of meteorology to understand and recognize.

Clouds are formed when parcels of air reach maximum moisture saturation levels at certain temperatures (dewpoint). As soon as the temperature of the air parcel drops below its dewpoint level, the moisture contained within it condenses out into visible droplets as either cloud or fog. Heights and types of cloud formation usually depend on the altitudes at which a parcel of moisture-laden air has reached its dewpoint.

For example, high-altitude clouds are formed of ice crystals and are known under these headings: cirrus, cirro stratus and cirro cumulus; at intermediate levels they are described by the prefix 'alto' – as in alto cumulus, and at lower levels under the heading, 'stratus', as in strato cumulus. Cloud names are derived from the Latin and are categorized according to shape and height thus:

Cumulus: heaped clouds. As ground temperatures rise, clouds of small white tufts of cotton wool, known as fair weather cumulus, tend to rise and form the huge towering cumulo nimbus – the last word coming from the Latin, meaning rain. Occasionally, these clouds grow into huge monsters, having an anvil shape at the top which is formed of ice crystals; but the base of the cloud is usually full of water and indicative of a forthcoming shower, rainstorm or sleet and snow in colder seasons.

Stratus: layer cloud of which there are several different types. Cirro stratus is a high-level layer cloud formed almost entirely of ice crystals which sometimes gives a halo effect when the sun shines through it; such clouds are often indicative of the onset of rain within a few hours. Alto stratus, a lower level of cloud base, can also show that rain is likely. It is the kind of cloud formation which photographers often associate with superb sky colours during early morning and late afternoon near sunset.

Fracto: meaning broken, as in fracto nimbus or fracto stratus. The latter is a low-level cloud of dark grey colour often seen scudding across the sky at a very rapid pace and sometimes referred to simply as 'scud'. Scud often precedes cold front cumulo nimbus, clouds which are smaller than their anvil-shaped cousins. These frequently indicate a line of storms with heavy rain and this is often visible travelling only a few miles behind the cloud formations. After the rain, a bank of cool, clean air will follow until the next front passes through. Scud is also usually present after the centre of a depression has passed through and can sometimes foretell the onset of another one following.

55 Dog on skyscraper, New York. Change your approach to life; look up now and then. We all expect to see humans in the higher planes of life, especially on buildings. (Nikon F2; 200mm Nikkor; Tri-X ISO 400; 1/500 second at f8)

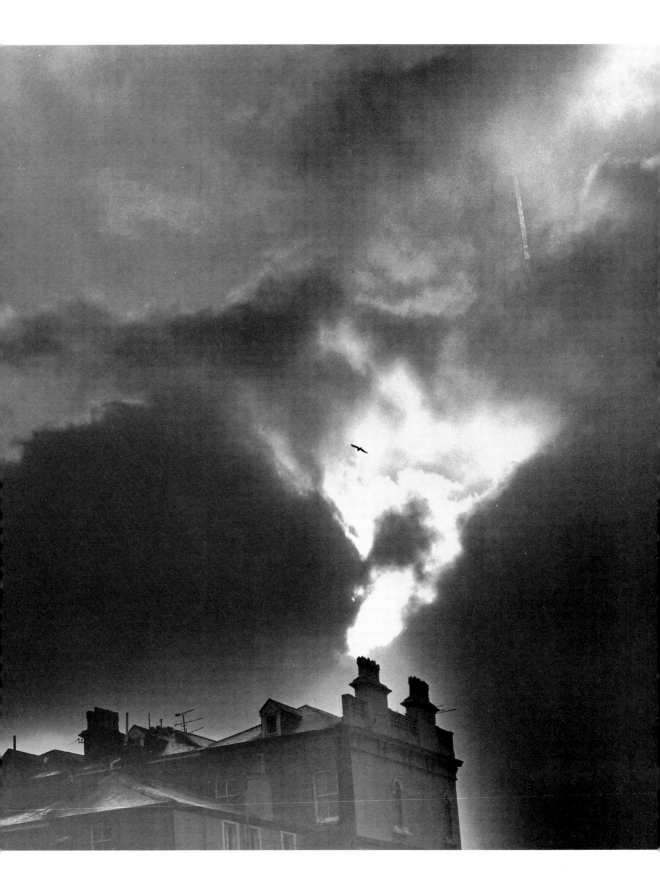

56 (LEFT) *Rooftops: (a) in the early morning;*
Worthing, England. (Bronica EC; 80mm
Zeiss Zenzanon; medium yellow filter; HP5
developed in HC110)

Air movement and wind direction

One other facet of weather prediction which
the photographer might find useful concerns
the movement of air and wind direction. In
the northern hemisphere, wind is deflected
to the right by the earth's rotation so, in the
case of a depression (low-pressure system),
the direction of movement will be anti-
clock-wise, the surface wind blowing out-
ward and away from the centre. The direc-
tion of rotation of wind is reversed in the
southern hemisphere. With a high-pressure
system, the direction of wind is clockwise in
the north and deflected away from the
centre. Using Guy Ballot's Law we find that
in the northern hemisphere an observer fac-
ing the wind will have low pressure on his
right and high pressure on his left. (The rule
is reversed in the southern hemisphere.)

In the very simplest of terms we can say

(b) midday: Paris. (Nikon FG; 28mm
Nikkor; red filter on HP5)

that low-pressure systems invariably bring
with them changeable situations which may
vary from being wet and windy to bright and
sunny with moderate temperatures. High-
pressure systems generally have a steadying
influence on conditions and are often asso-
ciated with cooler, dryer spells in winter and
equally dry but hotter spells in summer.

In the higher altitudes of the northern
hemisphere, particularly around the more
northerly areas of Europe and in Britain,
weather patterns tend to be similar from
month to month when averaged over a
period of years, though they may be infin-
itely variable from day to day. This is due to
the more or less constant flow of low-pres-
sure systems which are blown across the
Atlantic Ocean and which, in winter months,
bring frequent blizzards, gales, snowstorms
and rain and which, in summer, bring a good
supply of warm westerly or southwesterly
breezes, sunshine and, as we all know, a fair
amount of rain. Only when a high-pressure
system sits stationary to the north of the

83

Azores or over Scandinavia, do we find conditions stabilizing around the coast and across the country.

Depending on how strong these high-pressure systems are, meteorologists can forecast whether we are in for long or short spells of dry weather.

Satellite weather pictures are commonly used today in media forecasting. They help the viewer to develop a better understanding of synoptic charts and diagrams normally cluttered with figures, symbols and a miscellany of isobars. The creative photographer should make a point of storing meteorological information in such a way that media forecasts and natural signs can be used to predict reasonably accurately the kind of conditions most likely to be encountered on a shooting session. Whether or not you have an interest in meteorology, it would be a pity to ignore the preceding text, because weather prediction, albeit in a very elementary way, can be as much an aid to good and creative photography as a fistful of graduated filters, and possibly more so. With a little patience and careful study, you will begin to see how the photography of many subjects can easily be improved given the right conditions.

FILTERS AND THEIR USES

When my entire collection of filters was stolen a couple of years ago and I set about replacing them my eyes were opened (a) to the cost of all-glass, threaded filters – I had built my collection over many years – and (b) to the 'system' filters now widely available, not as a cheap alternative to glass, but as a system of creative aids to photography.

The square filter system is not that new however. Professionals have been using gelatin square filters in special holders for many years, but it took a Frenchman by the name of Jean Coquin to devise a system that could be adapted for use on virtually any modern small format camera. The Cokin filter system, now joined by Hoya/Hoyarex, Cromatek and a number of other brand names, comprises a threaded adaptor ring which screws into the normal filter thread on the front of the lens barrel. On to this slips the square filter holder which also doubles as a lens hood. Filters can be slid in and out at will.

These modern filters are made of dye-im-

pregnated optical quality resins which have good anti-abrasion qualities. They are easily cleaned and are usually supplied in their own plastic protective slip boxes. Literally dozens of different filter types are available, from the standard all-one-colour types, which most of us have used in the circular threaded type, to many variations of graduated coloured filters in which only half the filter is dyed; other types include multiple-image, prism-effect, star-burst, soft-focus, vignettes, neutral-density and polarizers.

Some systems allow combinations of these filters to be used – up to seven in one case. One filter holder/lens shade is all that is necessary for all but the largest front element lenses and, if you own dual formats, the only extra required is a lens ring adaptor.

The great advantage of the square filter system lies in its versatility and, to a certain extent, cost. All-glass threaded filters are, by comparison, very expensive and if you had one of each colour or density for two different formats, the investment would probably be as much as the cost of a new lens. Optical glass filters, on the other hand, are far superior in terms of resolving power than resin types so, probably, it will pay to have a selection of both types: a skylight 1B or 1A glass type which can be used as a lens protector for much of the time and which will filter out much of the ultra-violet rays which give the bluey casts to colour films shot without; a good-quality glass polarizing filter will be useful too. My own collection consists of various yellows, from light to deep, orange, red, skylight 1Bs for their warming tones, several neutral-density filters, green, blue and the polarizer. I also keep three graduated filters in the box and these are a blue-grey, light tobacco – which is the nearest to orange I could find – and a somewhat murky yellow.

I chose those three basically because I can use them with black-and-white stock to help liven up already leaden or overcast skies. Compared with all-glass types, they act more like graduated neutral-density filters, holding back the light in the areas which need to be darkened for effect. After some experiment, I found it just as easy and less tiresome in some instances to burn-in the sky in the darkroom. Much will depend on personal taste. With colour, I find the results using graduated filters very artificial when using the full extent of the dyed part of the filter

and so I do not very often use them for colour work.

As a creative aid in the studio, filter combinations can be very useful if one is trying to achieve a specific effect. Used very carefully in the field to complement existing colours or add just a subtle wisp of colour to an area that is lacking, they do have a place; but, as with most trendy gimmicks, they seem to be used quite indiscriminately in both commercial and reportage photography, to the point of turning natural beautiful phenomena inside-out by additional colouring.

While there are some of us who still use hand-held exposure meters and shutter speed or aperture dials which have to be set by hand, the vast majority of small and medium format equipment available features microprocessor, in-camera, meter-operated, stepless shutters and/or programmed aperture settings. Whichever piece of hi-tech electronic wizadry it is, it will have little trouble in compensating for the loss of light when filters are used. Most give accurate average exposures for 60 per cent of the picture area, but non-metered camera owners will have to learn all of the exposure factors for their filters in order to maintain accurate exposure. This is no great hardship and is a must for anyone who wants to find out what they can and cannot do with a filter.

Black-and-white film stock differs in its ability to record details at the extreme ends of the tonal scale, depending on stock used. Colours in the visible spectrum can be lightened or darkened easily using filters and the following table will be of help in determining which filters will provide the best results for a chosen subject.

Filter factors

Yellow: pale to medium or dark yellow filters have the effect of absorbing blue and green tones which help to render the sky darker and vegetable tones lighter. A medium yellow is normally used to obtain more correct tonal rendition in out-of-door subjects. It can also have the effect of emphasizing texture as well as helping to increase contrast.

Orange: helps to emphasize texture in natural materials; has a more marked effect in rendering blues darker and increasing contrast in aerial photography.

Red: the architectural photographer's standard. Renders stone, cement and other materials much lighter against really dark and dramatic skies. Ideal for use with infrared film; can be used for cutting through mist or haze; requires dramatic increase in exposure (*see table below*).

Green: could be useful for street photography if you are overly concerned with reproducing skin tones accurately. Ideal for scenes where different tones of foliage exist. Filter usage is very much dependent on the quality of light available as well as requirement. In black-and-white photography, filters are used either to improve tonal rendition of some tones or to emphasize the contrasting tones of colours in a more marked way. As a general rule, the paler the filter, the least amount of contrast improvement; the darker the filter, the more marked improvement in contrast. With the exception of clear, ultra-violet absorbing filters, all other types require some exposure adjustment to be made and these are usually shown on the rim of threaded filters as filter factors. Below is a table showing the amount of exposure increase necessary for each factor.

Factor	Increase in f stops
$1\times$	nil
$1\cdot5\times$	$\frac{1}{2}$
$2\times$	1
$3\times$	$1\frac{1}{2}$
$4\times$	2
$6\times$*	$2\frac{1}{2}$
$8\times$*	$3-3\frac{1}{2}$

*Bracket both $6\times$ and $8\times$ factors up to $\frac{1}{2}$ stop either side of f stop increase.

In-camera meters will give average exposure readings, compensated for light loss in optical transmission, when a filter is employed. In order to achieve a desired effect, some manual adjustment at the time of exposure may be necessary, together with a further adjustment at the processing stage.

For example, the aerial views of Paris on pp. 86–88 made from the top level of the Eiffel Tower needed just such an adjustment. It was a very bright, fine January day with the sun almost at its winter zenith, giving a good range of brightness between the lightest and darkest objects. However, it was evident that a certain amount of grey weather was approaching from the north-west which added a little haze over middle-distance

57-59 *For best aerial results, the photographer needs, clean, crisp light; the type normally associated with high pressure or anti-cyclonic weather patterns. Provided the camera support is firm and exposure correct, great detail can be seen in enlargements. Figs. 57 and 58 are two examples taken from the top of the Eiffel Tower with the light coming from behind but at 45° to the camera. In Fig. 59 the photographer's problems are more acute. Detail is required in both foreground and far distance where a certain amount of atmospheric haze has increased the light value at that point, rendering specific detail as a grey mish-mash. To retain sufficient detail in both ends of the picture, some allowance has to be made in exposure and processing. (Bronica EC; Zeiss 80mm 2·8 lens; Plus-X Professional; orange filter; exposure 250 second at f5·6; − 20 per cent development. The light meter reading was for an exposure of f8 in the foreground and f11 on the horizon)*

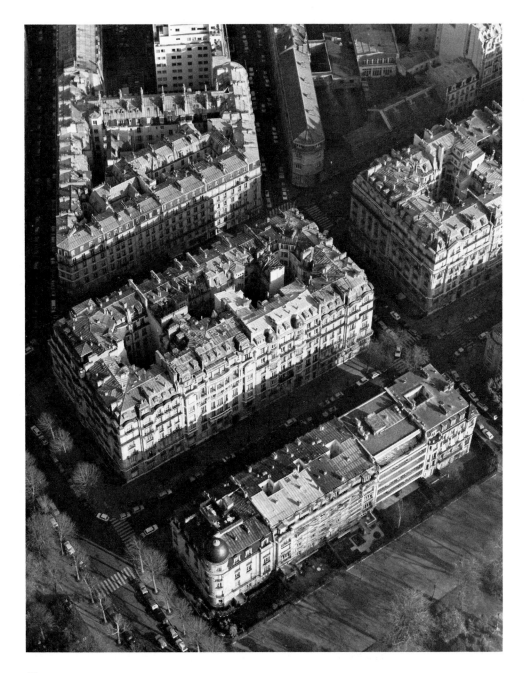

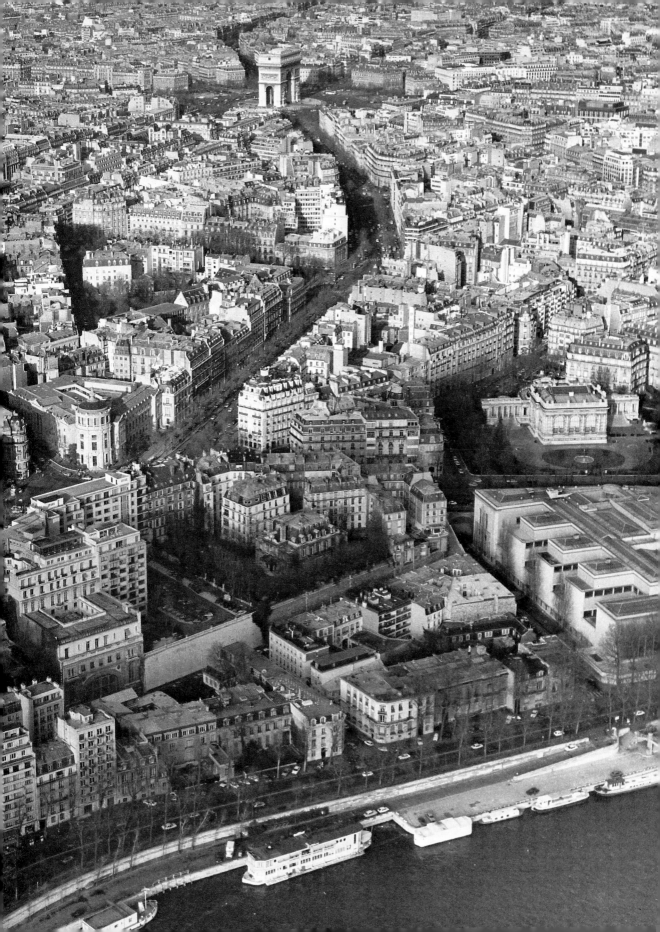

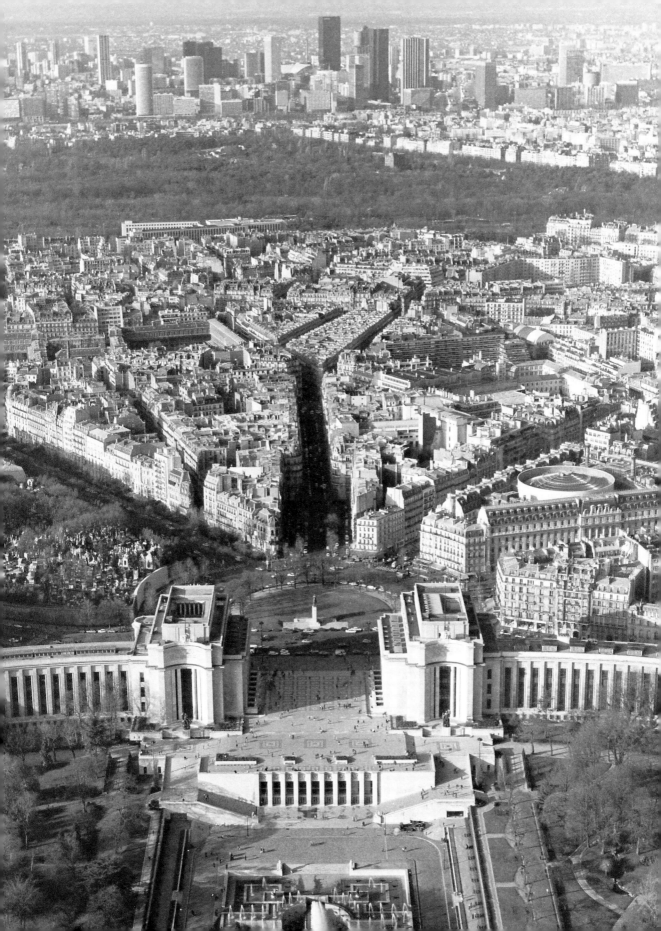

views. My meter reading indicated an exposure on Plus-X professional of 1/250 second at f8 with a medium yellow filter. This would be accurate for the highlight areas but not for subjects in deep shadow and would probably make printing the middle distance difficult. I opted for an exposure employing the same shutter speed but opening the lens to f5·6 instead of 8. This gave two full stops increase in exposure which I then adjusted in the darkroom by cutting the development time by a full minute on manufacturer's recommended times. The resulting negatives were almost perfect, giving a good range of tones throughout and easily printable on either a grade 2 or 3 paper.

In employing this technique, what you are effectively doing is improving the brightness range of the film and matching it to suit the subject, rather than allowing the meter to make a judgement using specified ISO ratings. In architectural photography, it is a technique used frequently to enable the photographer to bring out the full range of tonal values of certain materials, and with some practice is one of the simplest and most straightforward methods of achieving a desired result without having to resort to the more complicated and intricate details of zonal techniques. By decreasing exposure and increasing development times to match, the brightness range can be reduced, eliminating some of the middle tones; a complete reversal of the first method, which will result in negatives giving a more soot and whitewash result in print.

Further exposure/development modification details are given in Chapter 6, together with a table indicating exposure reductions or increases and matching development times.

Using graduated filters with black-and-white stock is relatively straightforward. In most instances, these will be used to darken skies, or immediate foreground and, normally, no exposure increase will be necessary. Filtered area of the film should be sufficiently under-exposed to obtain the desired negative effect for straight printing.

There are no hard and fast rules concerning the use of filters in black-and-white photography. Much is dependent on the individual photographer's requirements and only constant practice with different types will eventually show how to use them effec-

tively. Filters for use in colour photography are another matter and information about these you will find at the end of the following section on colour.

COLOUR PHOTOGRAPHY

Colour is the most used and, without doubt, the most abused medium in the world of modern photography. More colour material is shot than ever before and more demanded by users daily. Magazines and newspapers, which not that long ago could neither afford to print colour in such abundance, nor possessed the technological know-how to do so, now smother their pages with acres of it.

A few specialist processing laboratories still cater for the black-and-white worker; the vast majority, however, are equipped and geared to the computerized processing and machine printing of colour films; millions of miles every month of the year. Packet upon packet of uniformly processed negatives and enprints fall through the letterboxes of households daily. Perish the thought of anyone having to view the contents of a day's worth of packets!

All of us, amateurs as well as professionals, have at some time in our photographic careers, used colour for the sake of it. Most regular users of colour film shoot everyday subjects without even pausing to consider why or what effect the results of their indiscriminate and haphazard use will have on the onlooker. The world has become conditioned to the use of colour. We live in and are surrounded by a world of sometimes vibrant, sometimes dismal artificially coloured images perpetuated by advertising, television, cinema and the media, from which there seems to be no escape. Most of us are so conditioned that we expect colour to be used in the illustrative world as a matter of course.

There are dozens of reasons why colour photographs rarely work as well as had been hoped at the time of exposure. In attempting to reproduce the real world with its misguidedly dubbed 'natural' colours, the photographer's first hurdle is to overcome the limitations of the medium. And it is that - the fact that colour film is a medium, just as an artist's paints are a medium - which many photographers tend to forget.

Colour prints hardly ever reflect life's true colours as the naked eye sees them, and, as

is so often the case with black-and-white photography, there is always a tendency for the operator to try and cram as much of the scene into the format as possible in such a way that the resulting picture becomes a jig-saw puzzle which the brain must first iden-tify piece by piece before recognition takes place. In black-and-white photography, the brain is easily able to digest and understand a series of lines, shapes and grey tones and work out what it all means; colour in a pho-tograph diminishes the importance of form, texture, pattern and, in many instances, only serves to confuse the viewer's immediate cognisance.

If accurate rendition of hue is important to the photographer, transparency material is a more suitable medium. The subtle nu-ances of pastel shades and the vivid bright-ness of rich colours are immediately appre-ciated. Transparency materials are more easily able to convey the depth of colour present and, even when converted to prints using the reversal or Cibachrome process, the results are usually superior to standard colour negative processes. This is in spite of recent improvements in dye couplers which allow the great resolving powers of modern camera optics to be explored more fully through apparently finer grain structures. Prints are convenient for many purposes but they cannot match the luminosity of a well-exposed transparency and in publishing, the use of transparency materials is practically obligatory if adequate reproduction is to be obtained.

I use the word 'adequate' because in everyday publishing it is unusual to find good or even excellent quality colour repro-duction which nearly approximates to the fine qualities of the original. Only really superb intermediary colour separations combined with good-quality paper, inks and printing techniques can produce high-class work. Most run-of-the-mill colour reproduction is cost-effective and hastily produced, making no allowances for the special treatment of individual colour transparencies. Hence the result is frequently only adequate at best and proves a further psychological barrier for photographers who take pride in their work.

It is a rare thing for photographers to be good in both black and white and colour. Both media require a totally different approach. In one, we are concerned with form and content; in the other, with colour. Content and meaning may come a close second, but colour is the primary feature. This does not mean, of course, that you should stop photographing in black and white (or vice versa); the two media can be worked side by side, but the user should try and decide, firstly, which is the more important of the two media for any particular purpose and, secondly, which medium most suits the user's temperament.

In magazine and newspaper work, the photographer may be required to use both, even simultaneously, with cameras rigged electronically in pairs. An American agency photographer once told me that despite the huge demand for black-and-white photo-graphy by member newspapers, the board of directors would have preferred to see the same material going out on the wires in colour. A good case there for the use of high-tech colour negative material.

Given the choice, my own preference is for black-and-white. Aside from any purely business commitments where black and white has the dominating usage factor, I feel I can use black and white to say more of the things I want than I can with colour. Ob-viously, because the agency stocks a large colour library, a great deal of colour is also shot, but I am rarely pleased or inspired by the results.

Would fig. 12 on p. 23 have the same emotive effect in colour as it does in black and white? Come to that, what about the long shot of the Arc de' Triomphe (Fig. 1)? One could argue that since there is a lack of any real colour in the first example, the pic-ture would work just as well. But its com-mendable points lie in the simplicity of com-position of lines. The viewer immediately recognizes the contents of the picture and does not need colour to help identify either railway lines or the bridge. In a colour pho-tograph, the dark orange of the sky, colours of cars on the bridge and other subtle hues would have detracted immediately from the overall effect of shape and extremes of con-trast on which this picture relies for impact.

In the second example, I did take the trouble to shoot the same scene in colour, but the result is disappointing for several reasons. It is the hugeness of the Arc which dominates the avenue leading up to it. The jumble of cars is plainly visible, but does not

dominate the picture. In colour, a stream of red lights pock-mark the avenue and this becomes the dominant feature, overpowering the effect of the majestic Arc. In black and white, the brain is ready and able to add colour where necessary, a process which might be defined as the 'etcetera principle' in which the eye sees only a very small portion of the overall scene and is fed, if you like, only two-thirds of the information available in reality. Colour is added by the brain, but only in quantities and hues necessary for emotional identification.

In colour photography, all of the information is present, but on viewing the picture the brain must first eliminate some colour in order to reach a proper conclusion about content and form. Multicolour, used for the sake of it, on the other hand, may have completely the opposite effect in the process of analysis. In fact, on viewing some photographs in which bright, rich colours are the predominant and only feature, the mind will have no problem in recognizing instantly what is being presented and will look no further for an explanation.

So, in addition to the complexities of black-and-white photography, we now have two other criteria to contemplate. On the one hand, the colour photograph which contains meaning – a story to be told which requires an introduction in colour – and on the other, the colour photograph which has no concealed meaning and which relies for its effect on the compositional arrangement of colour.

We can of course take this one stage further, presenting a third dimension in which colour is manipulated in order that any specific effect may be achieved by employing optical accessories. These will take the form of coloured filters, split-image devices, star-burst grid defractors or techniques using zoom devices during the course of exposure. Most additive devices are invariably employed by photographers in an endeavour to create impact out of fairly ordinary and mundane subject matter which would otherwise be rendered as a collection of insipid and lifeless colours. There are, however, several photographers who have explored various techniques to create new and sometimes dramatic effects.

The man most likely to be held responsible for the widespread use of multi-faceted prisms which can split a single image into three, five, seven or even nine images of the same subject, is David Douglas Duncan: an American photojournalist and author of several superb books in which photography is used extensively.

Duncan's claim to fame as one of the world's great photographers spread through the pages of *Life* magazine in the 1940s and 1950s with reports on the Korean War, Indo China and later, the Vietnam conflict. But he produced other great works too, on the Kremlin and Picasso, the latter becoming the subject of several Duncan books. In between documenting war and for sometime after he and *Life* magazine had parted company, Duncan developed and then had made by Leitz, an optical device for splitting images which he called his 'bazooka'. The unique thing about this lens was that it could produce an infinite number of images of the subject in virtually any pattern or form the user demanded. If I recall correctly, Duncan had the lens made specially to carry out one assignment, though he did subsequently use it for other subjects. His series of photographs of Paris was sold to Collier's magazine in the United States for what was reckoned at the time to be a record five figure fee and, for that matter, probably still is. I apologize to readers for not being able to reproduce even one of those images here; as a small consolation, I would refer you to DDD's own illlustrated biography entitled *Nomad* in the UK (published by Hamlyn), and *Yankee Nomad* in the USA.

Colour in the real world is never experienced in isolation. There is always peripheral association with other colours. Under ideal conditions, the human eye is able to differentiate over 200 colours, though that is not the norm. The shape, texture and materials of an object are less important for the purposes of identification and, in photography, it is the composition and arrangement of colour which is the key to success.

Richness, sometimes also called 'saturation' by photographers, is controlled largely by exposure. Slight under-exposure of reversal materials produces richer but not necessarily correct colours. Over-exposure tends to produce insipid, washed-out colours. This is particularly noticeable in shots which include a lot of sky area. The result of over-exposure being completely translucent skies devoid of colour or cloud

formations. Projection quality materials may need to be accurately exposed but erring slightly toward under-exposure for better saturation. Reproduction quality materials may need even less exposure depending on which colour or part of the subject is to be emphasized in print.

Several other factors will affect the colours which are eventually recorded on film. Subjects photographed in isolation, where little other colour or very dark colours are present, may give a result which nearly approximates what was seen. Subjects surrounded by one or more rich colours may be affected by reflectance, giving a result on film which is partially contaminated and which went unseen at the time of exposure. The time of day, the colour of the sky and the colours of nearby objects can all affect the final exposed rendering. If your grandmother ever held a buttercup flower under your chin to see if you liked butter, you'll know exactly how the problem of reflectance can affect your photography.

Colour correction
Most of the problems of colour correction are easily solved using simple filters. Filters for colour work are different from those used in black-and-white photography, but other than a full pack of colour-compensating gelatin filters, there are only a handful which are essential aids to better colour photography.

An ultra-violet (UV) filter prevents blue casts by eliminating most of the invisible ultra-violet rays present on bright but hazy summer days. Ultra-violet rays, which are at the invisible end of the spectrum, will also affect focus so, if you want pictures which are as sharp as possible, keep a UV filter on the camera at all times. Skylight filters, the 1A and 1B, are also useful types to have at hand. Both can be used to suppress haze, caused by atmospheric dust and moisture droplets and some ultra-violet radiation. The 1B skylight filter gives a slightly warmer rendition to colours. Amber conversion filters can be used to subdue excessive blue casts and, similarly, the blue conversion filter is useful in reducing excessive reds, often found just after sunrise and before sunset. The polarizing filter, in addition to reducing specular reflection, enhances colour saturation. It can also be used in black-and-white

photography to absorb ultra-violet rays and blue (*see Fig. 27*).

The effect of a polarizer can be simulated with a pair of sunglasses. In absorbing reflections the polarizing filter also has the apparent effect of improving sharpness by increasing the colour saturation in each subject.

Subtle shifts in colour can be made using gelatin filters which are available in two sizes, 4×4cm and 7×7cm. These packs comprise varying values of cyan, yellow and magenta filters normally used in colour negative printing. They do however necessitate a thorough understanding by the photographer of the principles of colour.

Too many colours used haphazardly in a photograph tend to distract and confuse the viewer. Large areas of single colour as opposed to large areas of many colours will produce stronger, bolder images. Conversely, large areas of dark colour highlighted by a single bright and contrasting colour can be just as appealing. A profusion of colour may also produce a strong picture when it is the colour itself which forms the central theme of the picture.

Photographs which depend upon one single subdued colour spread over the whole scene are often referred to as being monochromatic. In fact, in colour, it is very rarely one, but several colours varying in brightness which give a monochromatic effect. This is a technique which can be used to great effect to produce evocative pictures which may depend largely upon form and shape, the colour being used as a sort of natural toning device to add atmosphere, depth or mood. Under these conditions, some care should be taken with exposure. Too little may spoil the effect being sought by deepening some colours in the scene. Normal to very slight over-exposure will help maintain the vagueness of colour and lack of specific detail which the eye expects to see. Side or backlighting is ideal for subjects shrouded in mist. Fog, on the other hand, is often so dense that the use of directional lighting is practically impossible and here you must rely on instinct to obtain the best result.

Patterns and texture in colour also proliferate in the world and can be exploited for their photographic qualities in much the same way as in black-and-white photo-

graphy. But be selective, do not use pattern for the sake of it in over-large quantities or the meaning of what you are trying to say will be lost in the maze. Try to remember that your subjective human vision is playing dirty tricks all the time. The camera cannot think and will reproduce, without trickery, the whole scene if you ask it to.

5 Planning an Assignment

BEING IN THE RIGHT PLACE AT THE RIGHT TIME

Various schools of thought exist concerning the pre-planning of pictures. On the one hand we have the devotees of spontaneity, where the photographer is expected to shuffle along blindly, tripping from one pavement to another in the hope that something extraordinary will suddenly be performed in front of, and for the sole benefit of, the camera. On the other side of the coin, the argument that while the spontaneity of life may exist in many different forms, it hardly ever comes to be seen by the ill-prepared. This does not mean that, in order to see, one needs to be equipped with specific items of hardware, although, obviously, having the right lens to hand could be an advantage. It has more to do with a mental awareness of what is happening all around you; what could happen and, when it does, being both mentally and physically equipped and co-ordinated to make the important exposure at the right time.

Being in the right place at the right time for many photographers comes as a result of meticulous advance planning. Quite frequently, more time may be spent in researching particular picture projects than actually shooting them. Many pictures are made on the spur of the moment which may appear to the onlooker to have no bearing or relevance to the assignment at hand. It is often the case that a certain scene will trigger off information previously stored in the brain and a picture imagined in the mind's eye suddenly becomes possible. It is also true to say that some pictures are indeed the result of instant recognition by the photographer and may, at the time, have no bearing on any information previously stored other than the most basic information pertaining to photographic composition and/or content.

A large percentage of the pictures reproduced in this book were planned. This does not mean that they were staged or that people were posed for the camera. What it means is that prior to each shooting session, each specific assignment, some thought was given to the result required. Many of the ideas I had prior to each session were vague. For example, in assigning myself to a day on the Paris metro, I thought about what pictures it might be possible to make given certain very low lighting conditions either in a train or in the subways and alleyways which lead to and from the station platforms. Because of the extreme light conditions, only static or semi-static subjects would be practically possible. I could look for people sitting, talking, reading newspapers, riding on escalators and so on. I could also look for underground musicians who, for the most part, would be stationary long enough for me to make several exposures. Where possible, I would use what light and lighting appliances there were to create atmosphere and mood. With a little patience and some luck, I would get all of that as well as the animation required to make good pictures.

My planning also took into account some existing knowledge of the metro system, at least in terms of how certain geographic areas of track appeared to the eye and whether it would be possible to make meaningful pictures whilst riding in trains that travelled on elevated sections of track above the city. Some trains traverse the Seine by bridge; perhaps that would be an area to look for pictures incorporating or using elements of engineering and architecture. Photographi-

cally, the riveted iron structures would add texture, pattern and form.

Studying a map of the metro system also gave me other ideas. By dint of careful routing I could travel all over Paris and take time out at certain stations for a quick look at the local architecture to see whether it would be worth going back a second time in order to shoot particular buildings or views.

In Stockholm, I spent so much time riding the underground system I was able to make plans for photographing the most modern stations there. It was quite a task. All of the new stations had been blasted out of solid rock deep under the city. The attraction, appart from the incredible cleanliness of the stations, was the roof paintings and scenic views painted straight on to the rock face. With the aid of a tripod, open shutter and large, hand-operated bulb flashgun, I managed to make a very acceptable portfolio of transparencies which were eventually purchased by the Swedish Tourist Board for their stills library.

Pictures in trains also need thinking out so one can keep a camera primed and an eye open for the occasional shot. One of the ha-

zards of most underground trains, particularly those in London or New York, is that they move very fast between stations, rocking and rolling with such frequency that standing passengers are often flung unceremoniously from one side of the train to another. In addition, lighting levels are terribly low. I dislike uprating film at the best of times and, therefore, usually make the task more difficult for myself by sticking to manufacturers' ratings. There is more about available light procedures in Chapter 7; suffice to say here that my normal shutter speed is in the region of 1/15 second with the aperture cranked wide open. In order to shoot at this speed at all in a moving train, one has to be very careful as well as patient. I try to find a standing position where I can wedge myself into a corner with an arm around a stanchion. The lens focus is set in advance to about 4m (12ft) and the shutter squeezed gently to synchronize as far as possible with

60 This one was taken through the windscreen of an ordinary saloon car with the front element of the lens jammed up hard against the screen to reduce reflection from the glass. The place is Boston, Massachusetts. (Nikon F; 35mm Nikkor; HP5)

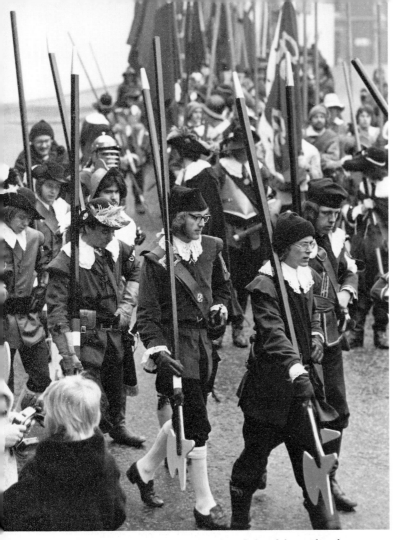

61 *Parade of the King's Army, London. Colourful parades always provide good material for the street photographer. A local What's On will give you details of forthcoming events. (Nikon F; 200mm Nikkor; Tri-X)*

the train movement. This is the most difficult part and is akin almost to obtaining one's sealegs. The slightest movement out of sync with the train will result in blurred pictures no matter what you do.

NEW LOCATIONS

Visiting a new city for the first time is a little like stepping out of reality and into a bioscope fantasy world. There are some things which seem familiar and you may have heard the language before, but many fresh images spring up like those in a pop-up picture book and, frequently, just as quickly, they disappear, lost in a maze of strange street names and the hustle and bustle of fast-moving

traffic. Often, I have arrived at a place, taken a taxi or a bus from the airport or station to my hotel and, in the space of half an hour, seen a thousand pictures along the route. When I go back to look for them the next day, they are hardly ever there or where I thought they might have been.

Usually, I am quite lucky with my travelling: I have at least a few days' advance notice. Apart from packing, much of the time is spent gathering information from a variety of sources. Tourist organizations are usually able to help with topographical information and street maps of most of the larger cities, and, if there are none in stock and there is enough time, they can always obtain them for you from overseas offices. Travel brochures and booklets, notable guides to well-known cities are all available off-the-shelf at the larger travel agents and good bookstores. The reference section of a local library is also a good source for illustrated books on many areas and major cities of the world.

Even if you have not the time to study all the works available, it is worth spending an hour or so just flipping through the pages to give you some idea of what to expect, though, I hasten to add, what you eventually see may be very different to the glossy illustrations. The whole point of this exercise is to give the photographer some knowledge of what he can expect to see and that may help to provoke ideas for certain types of pictures in advance.

Once I have checked into the hotel and unpacked, had a shower and generally turned my room into a complete shambles, I usually make a few quick written notes about anything I have seen in transit, from the arrival point to hotel, and then lay out the street map to try and identify where those areas are in relation to base. All of these places have to be visited to make sure that they are either worth photographing or if not, what lies in between.

This would be my first objective the following day and, in doing so, I would hope to familiarize myself with all available forms of public transport. Riding around in taxis is not only expensive, but completely isolates the photographer from real life. If no trains or buses exist, I prefer to walk however far is necessary in order to see what I would undoubtedly miss from a car. Even a hired car can be more of a bind than a treat unless

you have some specific project in mind and you know it is going to take half a day to travel there and back. In and around a city parking is always a headache and over the years, I have come to rely on public transport as by far the best means of moving around without restriction.

What I shoot on that first day will depend to a very large extent on weather conditions, but I would almost certainly pack a camera bag containing at least two camera bodies and a fairly large selection of lenses, from the very widest to a reasonably long 300mm telephoto. Rather than lumber myself unnecessarily with additional large format gear, I would rely completely on 35mm being able to accomplish all that I wanted. If I saw certain buildings or views which demanded more, or different equipment, I would then plan a morning, or whatever was required, to visit the location again.

'What happens,' you ask, 'when on the morning you have decided to return to that location, the weather deteriorates?' Well, remember that I have probably already shot a picture using the smaller format and, in the event of weather preventing a re-shoot, there would be other events planned as a standby.

Rain, fog, ice and snow, mist - all of these might prevent a re-shoot or work of any nature outside, for a while. In that case, I may spend part of the day visiting museums, an exhibition or an art gallery. Such occupational therapy might not seem the kind of thing on which a photographer should spend valuable location time, but there is a purpose. From museums one can gain a smattering of local knowledge. Exhibitions of old paintings and early photography, particularly in smaller provincial galleries and museums, depicting towns or cities as they were many decades before your arrival, are a great help in trying to make more meaningful contemporary images.

It was during just such a visit to a local folklore museum in the Swedish city of Gothenburg that I saw a wonderful collection of early photographs depicting the history of Scandinavian emigrants to the New World across the Atlantic. While walking through the narrow streets on my way back to the city centre I came across a construction site surrounded by clapboard hoardings on which were painted in primitive fashion, a series of pictures telling the same story. It is possible that, had I not seen the photographic display in the museum, I might have walked right past these temporary masterpieces without a second thought. I stopped to make several exposures which later inspired another idea for several features and another book on the subject of 'hoarded art'.

In between visits to museums and exhibitions I tend to amuse myself by watching the world go by from a convenient streetside bar or cafe window, gleaning as much information as possible from a local newspaper, even if the language is one of which I have little understanding.

It is a peculiar thing about newspapers. No matter where in the world you are, one can usually guarantee that at least one column will be devoted to forthcoming events. Such columns are a mine of information, giving dates and venues for anything from a local marathon to fancy dress parades, arrival times of visiting states persons and opening ceremonies for newly constructed skyscrapers. It all makes fascinating reading and gives the thinking photographer food for more pictures than there will probably be time for in one visit.

On several visits to Scandinavian countries, I have found the local tourist offices more than helpful, not only in providing pleasant guides for private sightseeing tours but, in some instances, also providing ticket vouchers for buses and tubes, special passes for museums and art galleries and introductions to people who were more than willing to allow facilities for more interesting pictures. All of this has made a great difference to the portfolios which I have assembled for various cities and which, I hope, will stand me in good stead whenever I visit some other far flung corner to begin another assignment.

Many photographers are self assigned and it is important for them to ensure as far as possible that film is not wasted on purely arbitrary shooting, in the hope that if enough stock is used something worthwhile and lasting will materialize. Plan your portfolio in advance by sketching out the rough outlines of pictures you hope to shoot. Doing this will also help you decide which lenses will be most suited for the effect you are after. There is absolutely no point in travelling half a mile or a hundred miles and then discovering that the one lens you need for the job

62 *Backs of rooming houses, Kenway Road, London, late afternoon. Petriflex V SLR; 28mm lens on Tri-X)*

has been left behind in a drawer. By being reasonably methodical – and this is where self discipline plays a large part in photography – you can be sure that time and money will not be wasted. My own experience has been that I find a great deal more than I ever hoped to find when embarking on a new assignment. My pre-planning keeps my visual senses aware all the time, helping to ensure that I get the pictures I had in mind and often adding many that materialize in the course of shooting those.

TRAVEL

Professional photographers in the employ of large newsgathering organizations or high-circulation glossy magazines are in the envi-

able position of not only having all their expenditure refunded, but also being assisted by numerous persons whose task in life is to ease the pain of travelling. The struggling freelance, determined to explore new ground at his or her own risk, and the dedicated amateur, interested in broadening his or her photographic horizons, are invariably loners, and at best have a girl/boyfriend or a wife/husband upon whom they can call for assistance when the going gets rough in planning an overseas trip. The time consumed in making preparations can often be halved with a little help and forethought.

The first item on the agenda should be to make the nature of the assignment clear. You will then be able to think rationally about what equipment you will need for the job and, if travelling to a country whose authorit-

ative traditions are somewhat vague, whether or not you will need a customs carnet for your equipment to facilitate its easy temporary importation and eventual export without having any of it impounded and subjected to hefty fines. You may also need special permission, other than a visa – if a visa is needed at all – to photograph in certain areas. On several occasions in the past, I have had to write to various embassies to obtain written permission to carry out what would otherwise be considered quite harmless and ordinary photographic touristic assignments.

Luckily, this problem does not exist in the majority of European countries but I have had to show immigration officials in the United States letters of accreditation from magazines or agencies to whom I would be supplying material, before they would let me in. In many countries, however, it is the problem of equipment which most bothers the inspecting officer at the (air)port of entry. Although I try to travel as lightly as possible since I do not have a battalion of assistants to carry my bags around, I rarely travel with fewer than two cases full of cameras and lenses and another which is packed with film. One can always use the excuse that one is a professional tourist and fanatical amateur photographer. Unfortunately, customs regulations in some countries forbid the importation of more than a few rolls of film and one camera with perhaps a couple of extra lenses. As a professional photojournalist, with sufficient identification to authenticate that claim if asked, I have experienced very few problems, but that is no excuse for not making sure of your credentials or overseas regulations before leaving base. Again, tourist agencies of various countries can be helpful in this respect and if there is any doubt at all you should contact the information department of that country's embassy for further guidance.

The customs carnet mentioned earlier is actually a sort of voucher system, operated by member countries of the exchange system. On application to your local Chamber of Commerce, and for a hefty £50·00 (in the UK) fee, your list of equipment will be itemized in a booklet containing sufficient vouchers for you to pass freely from or to other countries with the minimum of Customs aggravation. The carnet is valid for a year. All you do on entry to a foreign country is

present your vouchers to the control post. They take one piece of the voucher and match it with another piece when you finally leave the country. It's a sort of chain effect system which should eventually balance when you finally return home and hand in your stubs to the Chamber. You will also have to provide guarantee funds in the event of loss or theft of equipment as it is the Chamber of Commerce which will receive the bill for import duty – but, of course, you pay in the end!

And so to the more practical aspects of travelling. A long time ago, I spent several days travelling across parts of Europe on a shoestring budget. The upshot of walking half way across France and Spain, sleeping in ditches, riding with mad French lorry drivers and eventually, out of sheer exhaustion, collapsing outside a very famous cafe on the Champs Elysées, was that I made a pact with myself never to travel in a style less than I thought I should like to become accustomed to. When I could not afford to do so, I would stay at home.

This does not mean that I travel everywhere first class. On the contrary, I invariably travel on the least expensive budget, but I do spend a considerable amount of time investigating the various ways to reach my destination in relative comfort. For example, on the overnight steamer from Southampton to Le Havre, a proper bunk in a proper cabin with washing facilities is infinitely preferable to a semi-reclining chair, designed without due and proper regard to the ergonomics of the human frame, and the accompanying tatty blanket to which most cats would not give a second sniff.

On one occasion, when I was in a hurry to get to some small islands off the Greek coast, I thought everything had gone very well until I reached Athens. I had left home at rather short notice and taken the first available flight out, thinking that when I arrived at Athens international airport, I would be able to take the bus around to the domestic terminal, climb on an internal flight and continue my journey.

No such luck. All internal flights had finished for the day and there was not to be another, because one plane was out of service, for another 24 hours. Thus began one of the most gruelling and bone-shaking bus rides I have ever experienced. My taxi driver

from the airport knew exactly which coach I should take and even the time, assuring me, on one of the craziest drives through any city, that he also knew of a very good restaurant where I could eat and relax until the next departure several hours later. I was full of foreboding. We arrived in a cloud of dust at the empty coach terminal. It was quite obvious that there would be no more buses to Volos for at least four hours, the express having departed only minutes before we had skidded to a halt.

To make matters worse, I couldn't even buy a ticket. The booking office opened some half an hour before departure, but, I was told by the inspector, one should be in the queue at least an hour before that, to be sure of a seat!

Nine hours later and accompanied by what seemed to be an entire regiment of military returning to barracks, I stumbled out of the suspensionless bus in the middle of an empty street in Volos. I still had some 20 miles to travel to the coastal rendezvous with a charter boat that was waiting to take me on. It was 3 a.m. and I was in no mood for a mule ride; but it looked horribly like it would be that if I could not hire the one and only taxi most of my travelling companions now seemed to be shouting and arguing over. There was only one thing for it, but I would have to be quick in order to gain the advantage of surprise. Collecting my equipment from the luggage rack of the bus, I walked over to the dark green barrier of troops surrounding the taxi. The driver was still behind the wheel, engine ticking over. In the best BBC English I could muster, I calmly ordered the barrier aside with a stiff 'mind your backs please', opened the rear passenger door, hurled my gear across the seat and piled in after it, announcing to the driver as loudly as I could in Spanish that I wanted to go to the nearest brothel.

To this day, I am still not sure who was the more surprised - me, the taxi driver or the troops outside. Anyway, within seconds, the regiment had scattered, the driver dropped the big black 1949 Plymouth into gear and we were off. As soon as I thought it reasonably safe, I asked the driver to stop and in a mixture of pidgin Greek, English and German managed to tell the man where I really wanted to go and offered $20·00 for the journey. For a moment I had visions of

being unceremoniously bundled into the street by a very large and very unhappy driver, him departing into the night with all my equipment. Instead, he just chuckled, shook my hand energetically with both hands and launched the car off into the night, exclaiming that it would be the best job he had had all week and how was New York(?) and what wonderful people Americans were!

Dawn was already breaking over the little fishing village when we finally rolled the last few miles down a hillside track to the shore. I still had to wait another hour or so before I could hail a passing fisherman to take me out to the big yacht anchored in the bay and a real bed with sheets and blankets: I had been travelling for 22 hours.

The irony of this story is that if I had put in a little more thought before leaving home, I could have travelled by air from London via Geneva or Zurich and caught a connecting Swissair charter flight directly to the island I had come to visit. All in all, it would have taken only a couple of hours longer than my flight from London to Athens at much the same expense.

On another occasion, when it seemed that all and sundry were being herded like cattle into various flights across the Atlantic on cheap stand-by fares, I had a week or two to hunt around for the best ticket. My money eventually went to World Airways who conveyed me and about 150 other passengers in a 300-seat DC10 to Boston in relative luxury. Not only did all of us have the run of the seats but the food was served gratis on real china plates with stainless steel cutlery, and the flight, which I had had to book in advance to comply with regulations, cost only fractionally more than a low budget-wait-and-see ticket.

To some, this may all sound rather trivial but believe me, it is very important, if you want to start working fresh once you reach your destination, that the travel part of the operation flows with as few hitches as possible. There is nothing worse than arriving at the other end and feeling as if you have just been dragged through a bush backwards and in desperate need of a week's physiotherapy before you can begin the assignment.

I suppose that in this age of relatively inexpensive air travel and the speed with which one can be whisked from A to B, other methods of reaching new locations are sel-

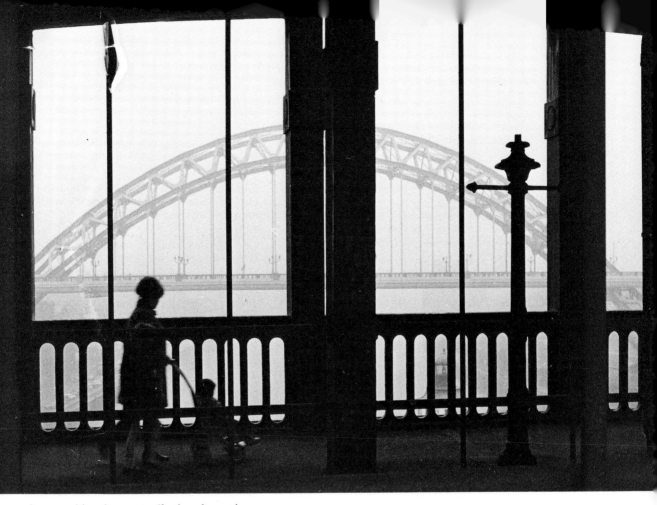

dom considered as cost-effective alternatives. For the self-assigned freelance with a tough budget and deadlines to meet, speed is often of the essence. There are however, occasions when speed may not be of such great import.

Road or rail? The latter is perhaps the most comfortable and has one added advantage in that whatever the distance covered, rail travel allows its passengers a great deal of sightseeing. For the photographer constantly on the search for new picture ideas, this can be a great asset, opening windows on the world which are not visible from the air and frequently missed when travelling by road. On the other hand, in spite of the feeling of 'isolation' which automobiles instill in their occupants, driving does have the advantage of convenience for exploring hitherto unseen areas at leisure.

I did manage to operate very successfully without a car for many years, but I have to admit that owning one has taken the strain off the logistical problems of carrying trunk-

63 Everyone has their pet subjects. One of mine is bridges, I suppose because they are often elegant and evocative. This is the prototype for the Sydney Harbour Bridge at Newcastle-upon-Tyne, England, photographed by my brother Peter using a Zorki rangefinder camera and 50mm lens. (Photograph Peter Eastland)

loads of equipment and reaching locations that neither planes nor trains seem to go to. Provided time allows, when excursions to other countries in Europe are planned, I would almost certainly take the car on an overnight Channel ferry, making an early start on the roads in order that some other areas of interest might be explored before the eventual destination is reached.

Travelling in this way is usually a leisurely affair, but it does require much more planning. Hours are spent pouring over road maps, making notes of route numbers and so on, planning not one but several itineraries and constantly referring to old notebooks in which I have kept records of places of photo-

101

graphic interest and to which, I had someday planned to return.

Apart from trains, I always find that a long journey by car inspires much more of a feeling of adventure than at any time when I have travelled by air. I suspect however, that this partly has to do with the fact that my four-wheeled companion is long past the age when most contemporary vehicles would have been retired. So in addition to photographic equipment which piles up in the passenger compartment, I have to think about a boot-load of car spares and engine oil; all items which are either expensive or virtually unobtainable on the Continent. Luckily, the car is big enough for all of this excess baggage as well as one or two passengers. Its most important feature perhaps is that the spacious interior converts easily into an overnight sleeping compartment, a facility which I have enjoyed on a number of occasions when staying on the road has become a necessity.

While on the move, I keep at least one case of equipment accessible on the rear seat, plus a camera at my side in the front. It is surprising how many pictures can be missed when all the equipment is buried in the boot. The psychological barrier of having to stop the car and get out of it in order to find the right piece of equipment is easily overcome by having the tools to hand, even if it still means leaving the car to find a more suitable vantage point. In the passenger dashboard locker I keep several spare rolls of film, plus an alternative lens and cleaning equipment; also the light meter. These are all items which can be conveniently carried about one's person when arriving at a place *en route* where the vehicle has to be parked some distance from wayside restaurants, bars, etc.

If you are planning a journey that is likely to take several days, there are innumerable other things that you will need to pack in addition to a change of clothing. These include: documents for the car and a first-aid kit, which should include sizeable pieces of elastoplast, bandages, various liniments for scratches and bruises and a roll of heavy-duty carpet tape – the latter is used to make splints in the event of a bad accident on or off the road. Insect repellant is another useful item and, if travelling in winter, extra blankets and some form of heating for forced night stopovers. A number of good-quality

camping gas heaters are small, efficient, relatively inexpensive to run and use readily available refills.

A portable, high-wattage mechanics lamp with extension cable fitted to the 12-volt vehicle supply is another necessary tool. If you have room, a fully charged spare battery can be carried in the car boot, provided it is firmly strapped in place. In the event that you manage to drain the main battery, at least you will have some means of getting under way again without having to call out the emergency services.

TRAVEL ACCESSORIES

It is always possible to take things to the extreme, of course. You might, as one American citizen did, customize your car for long distance photographic adventures. This could include building in extras like a chemical loo, automatic washing machine, mains AC generator and portable darkroom, to mention just a few! On the whole, it is perfectly possible to manage with only a handful of essential accessories, the important thing being to take only what you will definitely need, and not a long list of items which really are just excess baggage.

Why bother to go to all this trouble when you could just as easily take a caravan or one of those space age mobile homes, I hear you ask. Well, you pays your money and.... From a purely personal viewpoint, I prefer to travel as lightly as possible and, more importantly, since a great deal of my work takes me into large metropolises rather than the countryside, I would rather not risk the hazards of parking a caravan somewhere on the outskirts of town. I do not habitually sleep in the car out of choice; only when it is necessary. I much prefer the comforts of a moderately priced hotel to anything I might be able to arrange conveniently on a moonlit roadside. I have, however, thought of the possibility of converting a big diesel coach, but that is another story and for a journey which is still some way in the future.

The major consideration, whichever way you ultimately chose to travel, should be equipment. Some photographers limit themselves to just a couple of camera bodies and a handful of lenses, usually the ones most frequently used. These, together with enough film for the assignment, a few filters, cleaning equipment and a couple of maps

and notebooks, will all fit easily into a soft carrying bag or shoulder bag.

Although I find that much of my work around suburbia and city centres is adequately covered by perhaps only one or two lenses, ranging in size from 35mm to 200mm, I always feel ill-equipped if the big 'guns' are inaccessible, packed away in their cupboards at home. The problem is that, however well you may plan ahead, the unexpected always jumps out at you when least expected.

I decided some years ago, after travelling too light on a number of assignments, that, whatever the consequences of excess baggage, I would take as much equipment as I could reasonably expect to carry, even if it meant that a large proportion of it would end up being left in a hotel room somewhere. Being caught short just didn't pay, and I could not afford to lose pictures when the budget was all in my pocket.

Film is another factor often underestimated. I try to average out how many rolls I might shoot in a day and then add a couple of spares; so if I am going for seven days I will probably pack 35 rolls of black-and-white stock and about 20 of colour. This will be a mixed bag of 35mm format, 120 and more if I take the 5 × 4in. as well. If travelling by air, all of this film is packed into lead-lined film bags for those odd occasions when foreign customs officers insist on passing everything through the X-ray scanner. In large international airports, additional security checks are made by hand and I always insist on giving my film bag to the inspecting officer to make sure that he doesn't try to pass it through the scanner when I'm not looking. In spite of large notices displayed above scanners which maintain that film cannot be fogged, there are still many reports of photographers having their film ruined by X-rays. So far, I have not experienced these problems but I suspect this has to do with the fact that I make sure all my film is packed tight and sealed in those lead bags.

64 *The Arc de Triomphe photographed from an open top car on Etoile. I used the little Nikon Rangefinder with a 28mm f3·5 Nikkor lens for this, but note how, although there is an indication of scale in the apparent size of automobiles, all of the huge proportions of this massive structure are lost in the acres of space surrounding it. Compare with picture of the same building on p. 10.*

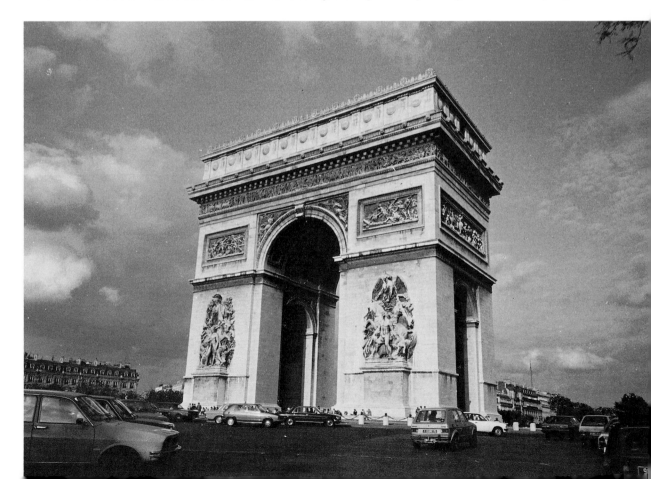

One always hopes that equipment will not break down, but it quite often happens and, while some malfunctions may require the assistance of a professional service engineer, others can be fixed on the spot. I carry a selection of fine instrument screwdrivers with standard and Philips type blades; a pair of long-nosed pliers and a small magnet for picking up tiny grub screws when they fall off your knee and are lost in a maze of carpet pile. Also, a small jar of vaseline, lighter fluid, insulating tape, a packet of electrical connectors and a standard electrician's screwdriver. I have found all of these items useful on more than one occasion, even when it has necessitated sitting up half the night with the diaphragm of a lens dismantled all over the hotel room dressing table.

All of this extra gear has to be packed, of course, and it is not much use pretending that delicate instruments travel well when they are badly packed. On a number of occasions, I have had to consign some of my baggage to aircraft cargo holds and this means that once you have checked in at the ticket desk, your precious equipment disappears down a conveyor belt tunnel, and somehow, miraculously reappears on a similar belt (hopefully at the same airport as you), thousands of miles from where you last saw it. I hasten to add, that I try to avoid letting this happen as often as possible.

Proprietary aluminium cases are fairly strong but they do not like knocks on the flat panels, which are constructed using thin sheets of plywood covered in nothing more than aluminium foil. The panels can be strengthened by tearing out the foam packing and adding a layer or two of glass fibre to the plywood. This material, together with sufficient resin for the job, can be purchased in most good motor accessory shops. It is best applied in the open air on a warmish, dry day, or in a heated but well-ventilated workshop - the garage will do. Once the resin has cured, the pieces of foam can be put back in place using a contact adhesive. If the case is consequently given a sharp knock, the plywood may break, but it is unlikely that the glass fibre, if properly applied, will give way.

And now that you are so overloaded with equipment and baggage that a three ton truck is needed to move it all, one final item which should be on every photographer's check list: the torch - a small pocketable type with rechargeable battery, or a penlight. For those infrequent occasions when photographing the night-lights becomes a must, a torch is an invaluable asset.

6 Cityscapes: Practical Workings

RESEARCHING THE SUBJECT

Photographers attempting to document every aspect of a large town or city will have their work cut out. Some form of shooting schedule for a project of such immense proportions needs to be well thought out before the first exposures are made. Whether such an assignment is a full-time or part-time commitment is immaterial, the essential factor which will ultimately decide whether or not the project is going to work, is a list of potential subjects which will give the portfolio a structure.

Any list of this nature is bound to be incomplete, as it will be altered frequently with additions and deletions as shooting proceeds. Neither is it necessary to work rigidly to the list; it is, after all, only a continuing working memorandum for the photographer and some subjects will often be selected on the spur of the moment for their instantaneous pictorial appeal. Obviously, you will not hope to fulfill all of your assignments in a short space of time, but gradually the portfolio will grow and begin to give a more overall picture of the whole project. If your lists have been properly researched, there should not be too many glaring holes, but gaps are bound to appear now and then.

For the photographer with unlimited time, a little research in the library reference section will sometimes turn up nuggets of early illustrated information which can be used as a basis for contemporary photography. For those on professional assignments working in cities with which they are not at all familiar, a variety of other informational sources can be explored. It is not uncommon for professionals to make several lengthy visits to a city in order to obtain sufficient and meaningful coverage, and this is particularly necessary when picture requirements might include shots showing religious or festive celebrations which take place at different times of the year. During these visits, interviews with local trade organizations, planning and development departments, tourist offices and local newspapers, will all be useful in sorting the pictorial wheat from the chaff.

Some subjects might lend themselves to more in-depth coverage. For example, in addition to the architectural qualities of specific areas, you may want to include local characters, businesses or trades peculiar only to a certain area, building detail, and so on. Light engineering and small industrial site complexes often exist within the city, particularly where planning and redevelopment has not progressed very far into the twentieth century. In addition to general vistas that graphically depict the locations of such areas in relation to familiar city landmarks, you may also find a wealth of human interest stories hidden away in the cells.

Underneath the familiar 'railway arches', another world exists. The cobbler, candlestick maker, scrap merchant and car mechanic exist side by side in these seldom seen backwoods. On one occasion I found the home of a local band of *totters* (rag and bone men; metal merchants and dealers, roaming city streets in search of scrap items, either on foot or using horse and cart) only a stone's throw from a city guildhall. Every morning, come rain or shine, this little backstreet with its row of shuttered wooden gates would suddenly burst into life as stables were opened and horses run out and shackled to waiting carts. I spent a week or so working with these people just to get enough material for an article before the demolition experts moved in to tear down their premises.

In another district of the same city, I found a pair of tattooists hard at work in a studio housed under a railway arch. A chance meeting developed into a lasting friendship and produced many fascinating pictures, some of which are still selling through the agency library today. Elsewhere, a backstreet garage that was once used as a stable for coaching horses, houses a thriving carriage restoration business.

Picture stories like this will only work well if there is a good variety of material from which the editor can chose. In order to create an adequate balance, I try to make sure that each assignment includes equal proportions of general views, close-ups of work in progress and some interesting portraits of the artists and craftsmen involved. Some of these workshops are very small, so working space for the photographer will be at a premium. If possible, I prefer to use a 35mm lens for the bulk of the pictures. My Nikkor f2 is fast enough for most naturally lighted situations, focuses down to several inches and, when used properly, will not give any noticeable distortion in portrait work. If the angle of view is too small for general interior views, I would then switch to a 24mm or 20mm lens, taking care to ensure that the camera is at all times as level as possible.

For most of these picture stories I relied on available light, using subdued daylight from windows, or tungsten and strip lighting, and sometimes a mixture of both. Apart, that is from the tattooists' studio, where the only available light came from a pair of bare bulbs; the totters' stables were fitted with large barn doors which could be easily adjusted for just the right effect.

SUPPLEMENTING AVAILABLE LIGHT

Conditions are not always as one would like them, however, and I have frequently had to supplement the existing available light with small electronic flashguns placed strategically and linked to the camera with extension leads. If you do not want the inconvenience of miles of wires everywhere, electronic slave triggers are perfectly adequate for most purposes, but you must make sure that each flashgun is so angled that light emitted from it is not obstructed on its path to the slave unit.

Ideally, when using several flashguns to light the scene, your camera should be firmly mounted on a tripod. Using the camera self-timer, you can then walk away from the camera position to get a better idea of how the scene has been lit. If you are using extension leads to each gun, make sure that everything is working before plugging into the co-axial socket on the camera. The simplest of tests can be carried out manually by firing one or more flash units by shorting out the electrical circuit using the writing end of a plastic biro; alternatively, use an electrician's screwdriver.

If you do not like the quality of direct flash, whether used on or off the camera, bounced flash makes a reasonable substitute for daylight that would normally be filtered through a door opening or window. Umbrella reflectors are normally used to reflect the flash beam over a wide area. The efficiency of such equipment is largely dependent on the quality of cloth used in the umbrella; some inexpensive types are covered only with a thin layer of cotton and, instead of actually bouncing the light back in the direction of the subject, a large percentage is transmitted through the fabric, reducing the efficiency of the flash by more than half. As flash light bounced off a reflector only gives half its full power for a given distance, using a cheap reflector rather defeats the object of the exercise.

Simple reflectors can easily be constructed by the enthusiast. Large pieces of white card, purchased for very little outlay from an art materials' dealer make useful temporary reflectors when all else fails. Another cheap method which can be used for even larger reflectors requires a roll of silver aluminium cooking foil and a sheet of hardboard. For ease of portability, the hardboard is cut into two pieces, each measuring 4 × 4ft. The glossy side of the silver foil is used as the light reflecting surface and can be glued to the surface using a proprietary contact adhesive, but you need to be careful, when applying the glue to the foil, that it does not tear before you have had a chance to fix it to the board.

When using reflectors with flashguns, the photographer should remember to make due allowance for a certain amount of light loss as well as for the fact that the light emitted from the flash unit now has to travel twice the distance to reach the subject. While

many flashguns are now computerized to match dedicated camera flash metering systems, experience may show that the exposure given automatically is insufficient to light the subject properly. Exactly what your flash and camera metering system is doing can soon be established by running half a roll of film through the camera using the automatic mode, and then in the manual mode for the remaining half of the film.

In the manual mode, calculate the correct exposure using the flash guide number for any given ISO. Bracket the exposure either side of the given figure by several full-stop and half-stop increments. You will find that, in order to retain the atmosphere of a dimly lit workshop, reflectors must be placed in natural positions – i.e. where a door might be or a window light which would normally give sufficient backlighting to the subject. A small amount of frontal lighting is then used to highlight sufficient areas of the subject for easy recognition by the viewer.

In areas where surrounding walls are predominantly light coloured, a great deal of bounced light will be bounced further, resulting in a somewhat flat picture. Move the reflectors closer to the subject and, using the manual flash synchro shutter setting on the camera, select a correct aperture for the light available but, instead of using this figure, select an aperture which is one or two stops wider. Develop the film giving 20–30 per cent less development. Do not despair if you cannot get it right the first time. Exposure will largely depend on the subject-to-reflector distance but, in any event, if you already know what the correct exposure should be, over-exposing by one or two stops and reducing development time will give crisp negatives with sharply defined tones and a lot of depth.

Remember also that when using colour film reflected light will add colour casts if it is bounced off coloured walls or ceilings. Over-exposure should be avoided when using transparency materials as this will only burn out details in light-coloured objects. Use the camera in its automatic mode for a selection of frames and then revert to the manual settings which you have calculated. Err towards slight under-exposure, bracketing each frame by a half or quarter stop.

In combining both available daylight and reflected flash with colour materials, I would normally use a hand-held meter to establish as accurate an exposure as possible from the available light. This done, flash reflectors are placed strategically to give just enough light to parts of the subject I wish to show in detail. I may even turn the flash power down to a half or quarter its normal output, so that I can retain the metered exposure but still light the subject efficiently. Going in close to the subject will normally mean that any available light will then play second fiddle to the flash reflectors which are now used as the primary light source. If you do not possess a flash meter, one of the easiest ways to calculate the correct exposure is to treat the flash as you would normal subdued or diffused daylight. Take a reading outside whatever building you are working in and use that as your main guide, bracketing if you think it is necessary either side by half and quarter stops.

Whether or not you decide to use flash to supplement existing light will very much depend on the effect you wish to portray. If atmosphere is what you are seeking, be very careful not to allow the flash to be used harshly; it will only extinguish the subtle nuances of daylight or available light which already exist.

CAPTURING DETAIL

Cityscape photography is not just about buildings, motorways or all encompassing extensive vistas. The observers amongst us will find a wealth of fascinating material for the camera at street level – the miniscule detail which is far too often taken for granted and passed by without a second glance.

Door handles

Door handles, for example, exist in a million different designs and materials. It would not be difficult to make a fascinating study of the more unusual ones. A macro standard or close-focusing medium telephoto lens of about 80–105mm would be an ideal optic for the hand-held SLR small format camera. Use a fine-grained, fairly slow ISO film to retain as much detail as possible, or a larger format. Exposures need to be read carefully and adjusted for personal printing requirements. Be careful in choosing an angle of view; many handles and opening devices are made of brass or stainless steel and if highly polished,

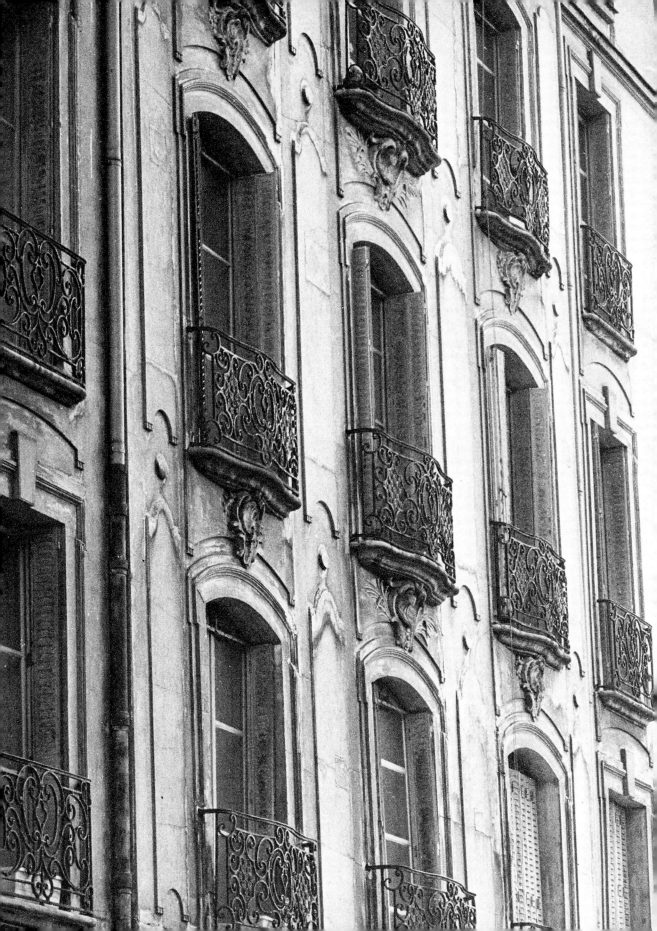

as they often are, will reflect the large open areas of bright light from above.

Bright, sunny days are not ideal for photographing these objects since the brightness range will often be so long that any latitude the film might have will be over-extended; much better to wait for the more diffused light from an overcast sky and even then there is bound to be several stops' difference between the prime subject and the background. If it is not necessary to show large areas of the door on which handles are mounted, the use of a larger f-stop to throw the immediate background out of focus will help in concentrating the point of interest. In those cases where it is important to show the design of a door, exposure adjustments will have to be made to allow sufficient detail to be retained in both primary and secondary subjects.

This can usually be accomplished by giving more exposure for the darker areas of the picture and reducing film development accordingly. One full stop less than recommended exposure is equivalent to approxi-

65 (LEFT) *Here, I used a 200mm zoom Nikkor to make a balanced graphic design of the windows and wrought iron balconies seen in a building in Versailles. (HP5 with an exposure of approximately 1/60 second at f4; late in the afternoon)*

66 *Totally unsuitable as a record of architecture but ideal as one of a portfolio of pictures on a particular area or the building in question; the Royal Pier at Southampton. (Nikon FG; 80–200mm zoom; tripod; yellow filter on HP5; late autumn afternoon)*

mately 15 per cent reduction in normal development (*see table on p. 113*). This technique will still allow sufficient highlight to develop to a printable level while the additional exposure will improve rendition of detail in the darker parts of the subject. Alternatively, exposure for the highlight together with normal development will leave shadow detail at the lower end of the density scale. Similar exposure and development techniques can be applied just as easily to other subjects: windows, window frames and things seen through windows, doors, archways, manhole covers, drains, street signs, shop signs, lattice work, stairways, steps and stairwells, flags and flags flying, and so on. All of these items can provide interesting themes around which the creative photographer can work, either using the subjects themselves to form the focal point, or as an introduction to a broader meaning.

Windows

Since people are an essential ingredient in much of my own photography, I was quite fascinated to discover while editing a number of pictures of windows that, in nearly every case, people had been introduced to give scale, animation and a point of reference for the viewer, who might not otherwise have understood why the picture had been taken. From a purely architectural point of view, window designs can certainly be interesting, but usually much more so to the student of architecture. While some of us not so well versed in the values of good or unusual design can appreciate graphic form to some

extent, much closer personal relationships are needed in order to recognize elegance or ugliness, humour or tragedy.

The problem with adding the human dimension to subjects which are in themselves fairly straightforward and uncomplicated, is that one has to be both patient and lucky. Window-watching can actually be great fun, even if the photographer is sometimes frustrated in an endeavour to make the right picture. People living in European cities, for example, spend much of their time watching the world go by from a window or balcony. They are usually reluctant, because you are intruding on their privacy, to stand still while you make your pictures. The photographer, therefore, needs to be sharp-eyed and fairly deft in manoeuvring a chunky lens in the direction of interest, ideally managing to shoot whatever pictures are required without being noticed. If you make your intention plainly obvious to all and sundry, the chances are that people or persons will rapidly disappear behind the shutters, or worse, re-appear angrily from an unnoticed doorway with the clear intention of chasing you off.

An American photographer travelling in Mexico once told me that you could get away with anything if you asked first, '?Puedo tomar una photografia, por favor?'. I did try politely several times in many different languages, including English, and on each occasion promptly consigned the picture I really wanted to memory instead of film. I am quite certain that the discreet approach has been more fruitful than the head-on confrontation; not only is the spontaneity of the moment lost forever, but on more than one occasion I have been threatened with grievous bodily harm!

The window pictures illustrated here were shot expressly to illustrate one or more of the aforementioned themes: humour, environment, confinement, boredom, and the more pleasurable moments in life. Indirectly, each photograph uses the window or windows in a graphic sense to draw the viewer's eye more easily and quickly into the picture; frames within frames, a more subliminal approach where one or other of the different subjects, or both together, may be viewed with separate emotions but in which each has equal importance.

Reflections

A glass window is one of the many media through which life is frequently viewed. Other reflective media include metal, paint, water, polished wood, plastics and so on. From elementary lessons in physics at school, we know that the distance of the reflected image from the plane of the film, is twice the distance of the camera to plane of the reflector.

Two problems that the photographer will encounter in photographing reflections are depth of field and focusing. In the first case, adequate depth of field is obtained simply by employing a relatively slow shutter speed and small aperture. In the second, only a reflex camera or view camera are the ideal instruments to use; both types allow the photographer to see the exact depth of focus as well as the exact area to be framed and the degree to which lenses must be stopped down for best overall effect. Rangefinder or zone-focusing type optical viewfinder cameras can be used, but much more patience is necessary to obtain the right effect, and it pays in most cases to shoot a slightly larger area of field than that actually required, so that more accurate cropping can be achieved in the darkroom. Ideally, a tripod should also be used and with non-view or reflex cameras you will need a tape-measure to obtain the exact focusing measurement.

Exposure and filtration need the same critical attention as most ordinary subjects if the very best results are to be obtained from photographs which are primarily reflections. Because most reflective media absorb fairly large quantities of light, the actual exposure required to make a true rendition of tonal values in the reflection will always be more than that required for a non-reflected view. In cases where reflection forms the major part of the photograph, allowances for

67 *The smaller details of building construction can make interesting pictures, especially when a complete portfolio of a particular area is required by the client or historian. There is nothing special about this door fronting a derelict terraced house in Portsmouth, England, but weather and time have given the wood and bricks as well as the glass name plate an interesting photographic texture. (Petriflex V; 28mm Petri lens; Tri-X)*

68 This might have gone down in history as one of those 'classic' view pictures so sought after by social documentary archive-hunters in years to come. Unfortunately, it suffers from an altogether common problem. The negative is riddled with reflections of the window through which the picture was taken. The only way to overcome this is to ensure that the front element of the camera lens is pressed firmly against the glass pane, preferably fitted with a polarising filter (see p. 120 for further details).

extraneous matter around the reflection need not be given but, where the reflected image forms, say, only half the overall picture area, the photographer must try to calculate as accurately as possible the best exposure to give detail in both parts of the negative.

It may be that emphasis is desired only in the reflected part and, in this case, the remaining area of non-reflected subject will more often than not suffer from over-exposure, and any real effect through tonal contrasts of reflected and non-reflected subjects will probably be lost if a straightforward normal meter reading is used.

In the beginning, a certain amount of trial and error is necessary to establish a method of exposure which will allow sufficient detail to be retained in the shadow areas as well as in the highlights. Remember that any deviation from normal readings will mean that some adjustment will be necessary in film

processing to counter increased or decreased exposure; further, it may also be necessary to carry varying film processing techniques over to the printing stage in order to produce the desired effect through burning in or holding back during print exposure.

COMPENSATED DEVELOPMENT

In most cases of reflection, we are looking for photographic effect rather than actual record, so some leeway in exposure, processing and printing is desirable in order to obtain that effect. As a very rough guide, the following table may be found useful in helping to determine certain tonal values and negative densities. The figures are based on techniques used by the author over a number of years to obtain predictable results from certain light situations. The film developer is Kodak's HC110, a general purpose developer which can be used in a variety of dilutions for rapid or medium speed processing with a variety of different film types. This table provides only a basis of figures from which the individual can work to obtain desired negative densities and tonal ranges. Similar figures for other film stock can be easily calculated using simple formula of percentage reduction increase over manufacturers' recommended times.

EXPOSURE COMPENSATION DEVELOPMENT TABLE								

Times are given for a working solution and tank temperature of 68°F (20°C)
Film: Ilford HP5 rated at 400 ISO (slight variations for Kodak Tri-X at same rating)
Stock solution of HC110 diluted to a working strength 1 part stock developer, 9 parts water

Development Time in Min/Sec
increase/decrease development %

Exposure	0%	10%	15%	20%	25%	30%	35%	
−3 stops							9·78	I
−2½ stops						9·4		N
−2 stops					9·06			C
−1½ stops				8·9				R
−1 stop			8·34					E
−½ stop		7·97						A
								S
								E
Normal	7·25							
								D
								E
+½ stop		6.5						C
+1 stop			6.16					R
+1½ stops				5·8				E
+2 stops					5·4			A
+2½ stops						5·08		S
+3 stops							4.7	E

I should emphasize that this processing technique is not a true 'Zonal' system as used in a variety of ways and developed originally by Ansel Adams. Over-exposure or under-exposure systems geared to percentage increase/reduction developing techniques simply allow the photographer more control at the printing stage. Normal meter readings should be used in most instances where the light is even or diffused, except where more, or less, emphasis is desired in the point of interest. In bright conditions, where extreme brightness ranges exist, averaging exposures geared to normal development will usually result in negatives which are too heavy to print successfully on normal grades of paper. Using the above table, you can see that brightness ranges can be extended or shortened at will, providing negatives that can easily be printed on all but the hardest and softest grades of paper.

In extreme cases, mostly where the brightness range is so long that only a slower ISO speed film could cope with it efficiently but that stock is not immediately available, under-rating high-speed film can sometimes provide acceptable results. This applies mainly to 400 ISO films, like Tri-X or HP5.

Rate the film at half its normal speed and process for 40 per cent less than recommended times. The problem with very short development times, particularly with roll and sheet film, is even development. With miniature and roll film, even development is best achieved by slow but constant rotation of the tank throughout the development process. Vigorous agitation in the first 15 seconds is essential to dislodge any air bubbles which may be present on the film. With sheet film which is dish processed, the operator must keep up a steady agitation by raising and lowering each corner of the dish in strict rotation. Tap the film sheet gently against the side of the dish to dislodge bubbles. Pre-wetting in a solution of correct temperature water, to which a spot of mild household detergent or photo-flo solution has been added, will help lessen the risk of uneven development and delinquent air bubbles, especially on roll film and sheet film processing. Even for longer development times, there is no harm in adopting the pre-wet system as normal procedure.

ON THE WATERFRONT

Name virtually any great city – London,

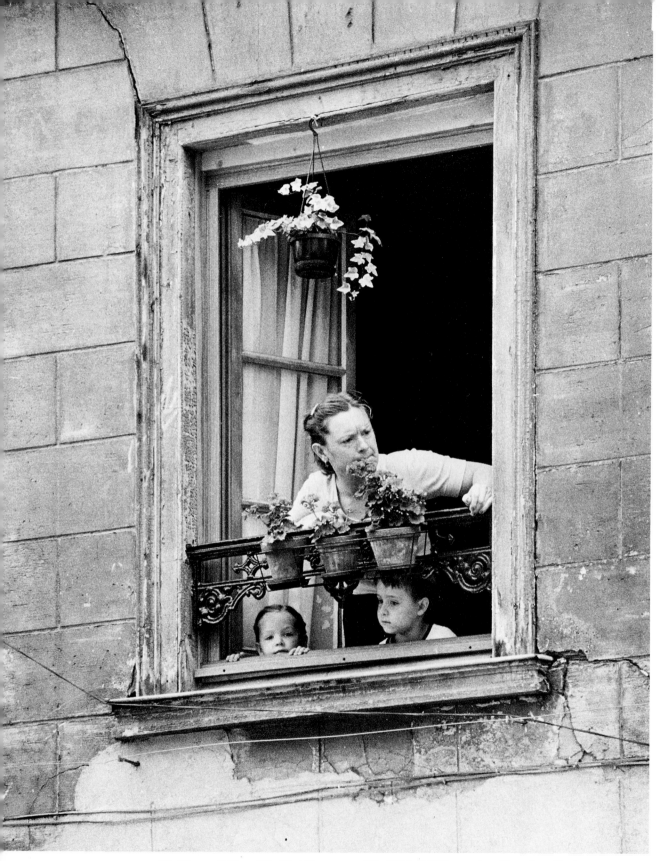

69 *Dieppe. (Nikon FG; 70–150mm zoom 'E'; HP5; 1/250 second at f8; yellow filter)*

New York, Amsterdam, Hamburg, Sydney, Stockholm; designs in architecture may change from place to place; people will speak a different language; but there is one thing all of these great meeting places have in common: docks and waterfronts, for it was around these watering holes that the vast sprawling masses we know today first came into being.

In a way, I suppose, it is a sad reflection on life's rapid technological advances that so much of the charm and vitality has disappeared from the huge areas of dockland. In London, for example, where commerce once plied its trade into the heart of the city, today's spectator is faced with acres of vacant wasting wharfs and echoing empty warehouses. The piers of New York – once jammed solid with freighters and liners from around the world, their derricks dipping and dunking in harmony with hissing, steam-driven winches – are mostly derelict, decaying into the hungry Hudson or murky waters of the East River. Many areas have been turned into leisure centres, incorporating marinas for small boats, or static floating museum pieces, praying on the public's insatiable appetite for a dose of maritime nostalgia – history . . . roots.

In England and the rest of Europe, similar things are happening little by little: the general demise of scheduled ocean travel and the amalgamation of once familiar names in shipping to form consortia, has left the dockland devoid of life, though that is only part of the reason for closures. Big ships still come and go, but invariably to obscure pipelines far away from the public gaze, or to container ports built on reclaimed land where acres of space are the key to rapid handling. We hear and read about new ports, new freight services to far off places, of the visits of giant tankers, but only rarely do we come face to face with life on the waterfront.

There was a time when hotels and stations were built as one. Travellers would ride in elegant boat trains down from London and overnight in Southampton in a hotel terminus just a few minutes walk from the Ocean Terminal Building. After an early but comprehensive breakfast served in style on the best crockery on solid wooden tables laid with the finest linen and plated silverware, passengers would once again board their trains to go the last few yards to the foot of a liner's gangway. Tugs hustled and bustled,

whistles blew and great ships, with sirens blaring, moved out into the fairway for another voyage south or west. If you worked in the city, this dockland life became a part of you, there was hardly any way to avoid it. I remember travelling on the upper deck of a bus with my grandmother while being given the grand tour of Southampton when I was barely old enough to stand up. From the Civic Centre you could see all the great mail ships tied up in the Western Docks and maybe one of the *Queens* in what was then the world's largest graving dock over a mile away. Down to the Town Quay, the Royal Pier and, further east, Cunarders stood resplendent towering over the little banana carriers that filled the inner docks. Cranes clanking up and down the wharfs, tiny tank engines hauling wagons piled high with best Welsh steaming coal, puffing along the road that divided the waterfront from the city proper.

People will argue no doubt, that the demise of waterfront life has made many of our cities cleaner and safer places in which to live. Be that as it may, our lives as photographers are less rich because of it and that may give a clue as to why I find photography around today's waterfronts such a challenging occupation. It is not often rewarding, but when it is, it is worth all the waiting and the walking.

In *Creative Techniques in Marine and Seascape Photography* (B.T. Batsford, 1983), I described in some detail the process necessary for gaining access to dockland areas, since most of them are either private or State owned. Passes giving restricted access are usually obtainable by bona fide photographers from the public relations departments of most commercial ports. Local papers often list arrivals and departures of the more important larger vessels and, occasionally, you will see more page space given over to impending arrivals by foreign vessels or extraordinary types. Quite often, such an arrival provokes an unusual amount of activity in the port with other vessels being moved

70 (NEXT PAGE) *Grain elevators, Southampton. Industrial and waterfront scenes are just as much a part of city life as buildings and street life. Choose your light carefully to emphasize areas you want to show as the key picture elements. (Nikon FG; 80-200mm zoom Nikkor; yellow filter on HP5)*

115

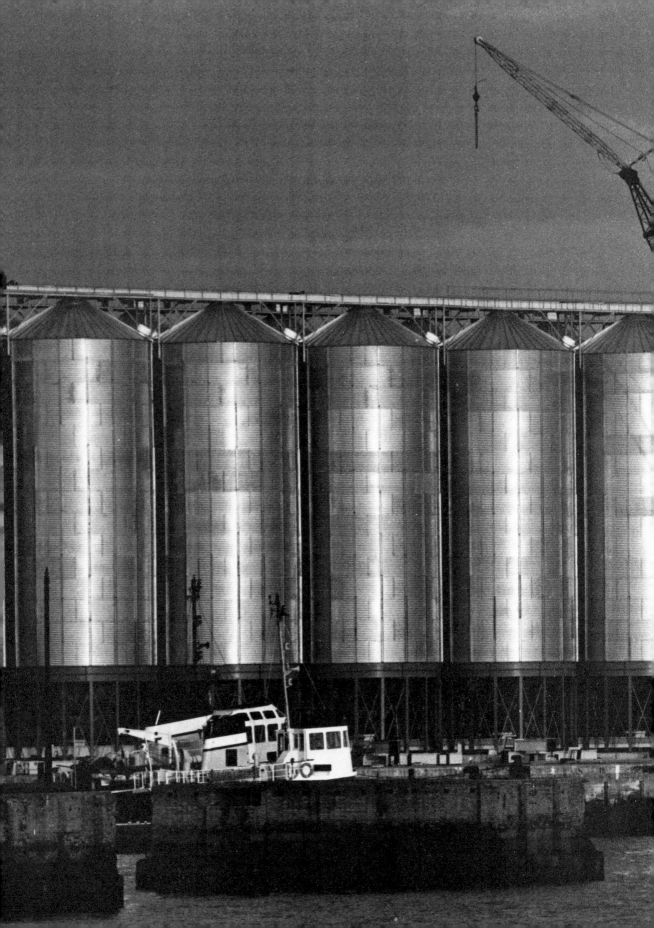

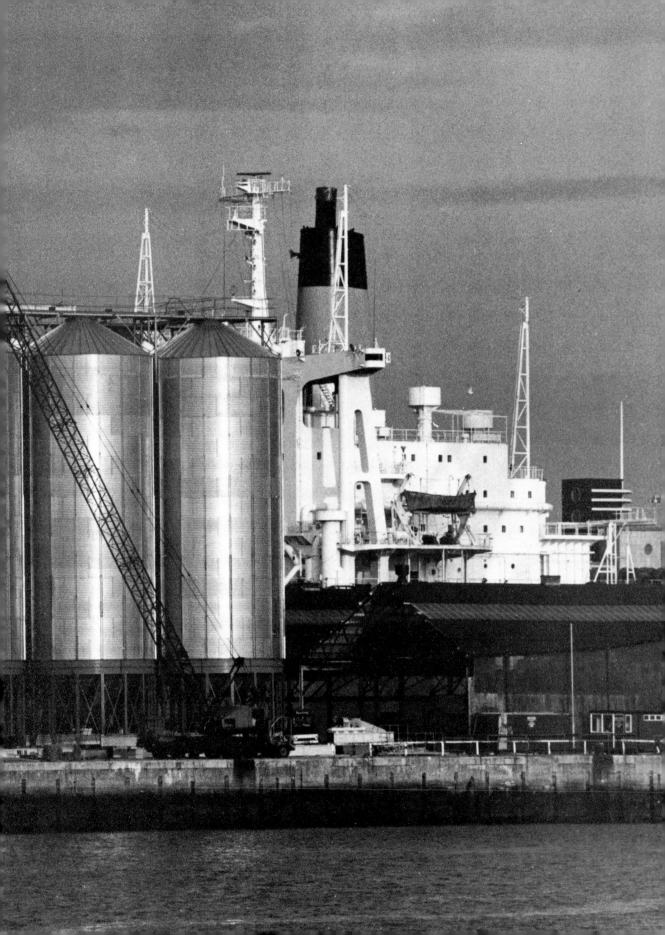

around so that the visitor can be accommodated, and you may just happen on a picture.

I had been visiting Rouen in northern France on and off for some years to cover the annual powerboat race held there. It is a very beautiful city, situated deep in the heart of Normandy and built on the banks of the river Seine with rolling limestone hills all around. The spire of its famous cathedral jutts boldly into the sky and the city also has a thriving commercial deep-water port. Ships large and small sail up the river from Le Havre, over 100 miles away on the Channel coast, to pack the wharfs and grain terminals.

My first visit left a great impression. There is a long tunnel on the train route from Le Havre through the hills surrounding Rouen and, as we shot out of the darkness, I was immediately struck by the grandeur of the city, buildings and ships in harmony, all highlighted by superb shafts of early morning spring sunshine. Consequently, on following visits, I tried to arrive before breakfast just so that I could savour the delights of the trick of light – as well, of course, as freshly baked croissants and rich black coffee served in the sidewalk cafes overlooking the Seine. Because the powerboat racing took place on a public holiday, all the barges of France seemed to be moored along the quay wall, enjoying a couple of days' respite from their inland voyaging. I pondered ways to get this atmosphere into a photograph and, after several visits to the city, I still had not managed to find the right location from which to make a picture.

One year, I decided to drive there, thinking that I would perhaps have a little more time to explore locations around the city. It was pitch dark as I drove off the ferry at Le Havre and made my way south on the old Route Nationale. Gradually, daylight dawned and, as I came over the brow of the hill leading down into Rouen, I spotted a gap between the trees. It gave a perfect view of the great bowl in which Rouen lies: ships and wharfs and the cathedral spire looming mysteriously out of a layer of mist which mostly obliterated the city. Luckily, a turning off the main road gave me more or less immediate access to the place from which I wanted to shoot; someone had even sited a park bench on the very spot, so I guessed a great many people had already sat where I now stood, enjoying this enormous vista. Ironically, neither light nor weather conditions were at all reminiscent of how I had ever seen the city, shrouded as it was in wetness and fog, but everything I had sub-consciously thought of during those previous visits was now spread before me; a city full of legends and mediaeval history, of interesting and sometimes beautiful architecture, dependent on the life blood of the Seine for its well being. I don't look for the picture any more, but I still see the shafts of sunlight and maybe, one day, there will be another place and another road with a gap between the trees.

Seemingly inanimate objects like ships and warehouses appear all the more lifeless when they are left unused and derelict. However, the sheer immensity of some objects is often enough to form the basis of a good picture.

What else is required? Well, huge objects need comparison with smaller objects to emphasize scale. This could be effected by incorporating one or two people or some other subject with which the viewer can readily identify, such as a car. Equally important is the apparent, or real, animated content. This can be achieved in a number of different ways and is mostly dependent on the movement or apparent movement of ancillary subjects: cloud formations, wisps of smoke or belching smoke or steam, static or flying gulls and, if it is important to the story content of the picture, the physical attitude of people. The photographer should consider carefully various lighting conditions and note what is likely to give the best overall effect on film, avoiding where possible full frontal effects, which invariably lack modelling and are devoid of atmosphere.

Viewing positions which give the photographer height are to be preferred over the ordinary ground level position. Height helps the photographer to delete unwanted background, or add an interesting background which may not be visible at ground level. Further, height often provides a more interesting viewpoint for the onlookers who are familiar with the subject at ground level. Subjects seen from ground level and photographed with standard or wide angle lenses are frequently diminished in scale, resulting in photographs which rely on print size for impact; the smaller the print, the less impact. Whereas subjects photographed from a

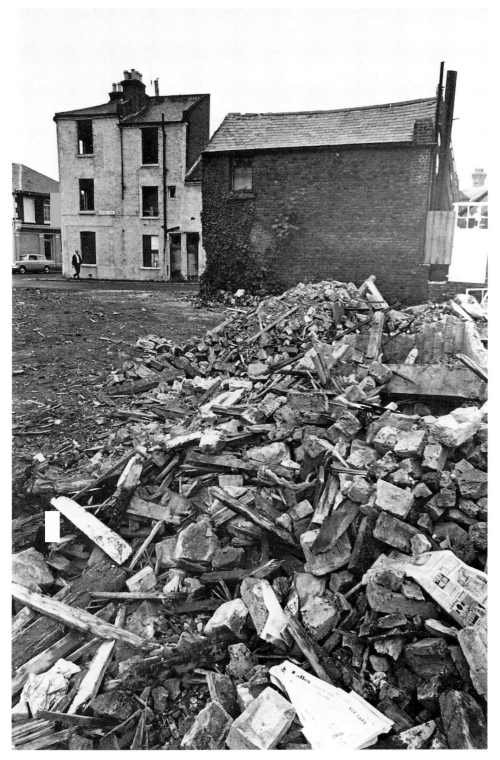

71 *As in any other field of photography, certain subjects need special treatment. This is obviously an area undergoing change, either by complete demolition or re-development. The caption would explain where and why, but the meaning should be clearly evident in the picture. (Petriflex V; 28mm Petri lens; Tri-X)*

higher viewpoint from a distance with a medium (or longer) telephoto lens, frequently have immediate viewer impact irrespective of print size.

The amount of extra height required for a different view may vary from several inches - say the height of a metal equipment case - to several feet or meters. Often, it may mean approaching the owners or landlords of specific buildings nearby whose windows or rooftops look as if they could provide the right viewing location. In my quest for unusual angles, I have found hotel managers and office tenants more than happy to oblige with a rooftop view or an open window here and there; polite requests to private households can sometimes open a door to a new view on an old subject and the provision of a good-quality print to the houseowner will always be remembered, even if never hung!

Things do not always go according to plan, however. Some years before I launched into my current profession, photography was only an occasional but fervent hobby. On a visit to Sydney, I was so impressed by the waterfront area around Circular Quay that I managed to persuade the owners of a then important and modern skyscraper to allow me access to the top floor. For some reason which I never discovered at the time, access to the roof was barred, so I had to make my pictures rather hurriedly through an enormous plate glass window.

A secretary who had been assigned as my guide kindly held the Venetian blinds while I managed to expose half a roll of film on a super scene in the harbour below. The liner *S.S. Canberra* was departing slowly, being turned by a handful of bustling tugs; crowds of well wishers lined the Ocean Terminal Building, launching hundreds of multicoloured paper streamers into the air. In the background, Sydney harbour's magnificent bridge made a majestic backdrop for the activity. Even the Manly ferry had stopped mid-stream for a few minutes. I could not have had better luck. Then a few days later, I saw the processed film. Running across all the superbly exposed negatives were neatly focused reflections of the Venetian blind the secretary had so patiently held out of my line of vision. Still being relatively inexperienced, I had photographed the scene while standing away from the pane of glass instead of pressing the front element of the camera lens as close as possible to it. That day, I learned a lesson about reflections and another about the benefits of owning a polarizing filter.

Waterfronts have always been traditional hunting grounds for artists and photographers. In spite of commercial recessions and depressions, life does go on. We may never see a return to the golden age of travel when mammoth leviathans jammed the piers, but we can learn from those older pictures of the past, both painted and photographed, to see ordinary life in a different, and perhaps even exciting way.

All of the photographs in this section were made over a period of several years and, with one or two exceptions, all were made using a prime telephoto of some 200mm or an equivalent zoom lens. In one or two instances, the idea for another, possibly better picture, developed from attempts to photograph certain subjects, but this often entailed waiting several months for the right weather conditions or until I could find a new viewpoint. At other times, a picture idea was born out of a snippet of news carried in a local paper or in the columns of trade journals devoted to commercial shipping. In one case, a new idea was inspired from a cutting found in a 30-year-old South African newspaper, and some others have come from painters whose works have been around much longer than that.

If you are working very close to large areas of water, you will find that, as a general rule, the light level tends to increase. This is caused by light being reflected back on to subjects by the water. It is even more apparent when large amounts of cloud are present. Colour photographers will need to watch for abnormally high levels of haze and the effects of ultra-violet light. These will be particularly noticeable on reversal materials which have been exposed more or less exactly as the camera meter indicates. If you are not already using tinted or special-effect filters, always carry a UV filter or plain skylight type. Soft-focus and light-diffusing filters will also create more light-flare, which will require more than the usual half-stop under-exposure if the results are not to be washed out and totally devoid of detail.

7 The Human Element

The excitement of visiting a new city for the first time can often play havoc with the photographer. You realize after only a matter of minutes perhaps, that there is so much to see and do and, bar spending a considerable time there, you have not a hope of recording everything that flashes momentarily in front of the camera.

Consider the ordinary eccentricities of city life that so differentiate it from life in the countryside. In the great western jungles of civilization, the pace of life is fast: people hurrying to and from their places of work, hailing taxis, crossing roads and playing dodgems with the traffic; commuters in and out of trains, every carriage window at rush hour a silver screen of life inside; lovers in parks and gardens; tourists rubbernecking or soaking up the world from pavement cafes; writers, and readers; waiters; models parading; clowns and actors; musicians begging for a dime – it's all there before your eyes.

72 *Candid street photography – Rouen during a May Day Parade.* (*Nikon F, 105mm Nikkor lens; Tri-X*)

73 *Thousands of pictures like this, of people camping out on the streets of London while waiting for 'stand-by' airline tickets, were pushed around the newspapers at the time. This one is not special; it would have benefited considerably from a little height, a narrower angle looking along the pavement, so that the viewer could have seen more tents, more people and more parking meters compressed into the view. Since the only vantage point was from the middle of a busy road and I did not have a step ladder immediately available, I had to settle for this. Now see Fig. 76.*

74 (BELOW) *Travelling through time: an effective picture which relies on the attitude of the girl and the compositional elements of the carriage used as a natural framework for the main subject. Movement is depicted in the window to add necessary mood and atmosphere. (Nikon Rangefinder; 28mm Nikkor; 1/30 second at f5·6; HP5)*

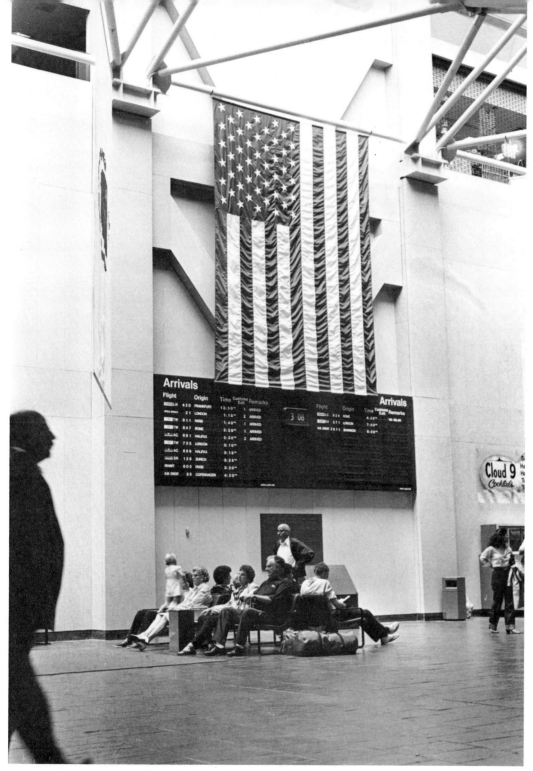

75 (ABOVE) *Logan International, Boston.
Note how the effect of both depth and height
are retained in this relatively simple shot of
the arrivals area. The Hitchcock figure at
extreme left is an important yardstick,
allowing the eye to move freely over the whole
picture in one sweep; (Nikon F; 35mm
Nikkor; HP5; from a sitting position)*

76 (NEXT PAGE) *Here I found something
which conveyed to me the occupational
hazards of flying 'stand-by'; a great deal of
discomfort and an almost impossibly long
wait. A row of polythene tents on the
pavement cannot show the human element so
vividly. (Nikon Rangefinder; 50mm 1·4
Nikkor used wide open; exposure 1/15 second;
film agitated continuously in processing)*

ANIMATION

Animation is probably the single most important key to the successful photography of people; the ingredient which adds life to a picture. There are innumerable ways in which animation can be expressed. These require complete understanding and recognition by the photographer, an advance visual awareness, if you like, of the many moods of the human being; seeing what is about to happen and knowing the precise moment at which to release the shutter. We are concerned here only with making pictures; visual moments in which content, composition and context are all gathered together as a complete unit. A secondary benefit is that the picture may also tell a story which, in turn, will have different meanings for different people.

Human emotions and moods are manifested physically in many different ways. Anger, joy, sadness can be expressed by the body in any number of attitudes, but there is a moment when limbs, torso and facial expressions are clearly delineated and this defines exactly the emotion or mood being experienced. Picture agencies are frequently called upon to supply television news and current affairs programmes with selections of head and shoulder shots of politicians or heads of state in which various moods of elation (winning a poll), anger (parliamentary leak/scandal), concern (hi-jacking) can be back-projected behind the head of a newscaster as the story unfolds verbally.

In candid photography of people on the street, we are not concerned with why people are expressing a particular emotion. Moreover, it is far more difficult to capture these everyday expressions and the context to which they refer. The news photographer has the advantage in many instances of having the subject in a fixed position. The subject is also likely to be used to popping flashguns and the glare of publicity.

The ordinary mortal going about his or her everyday business is, generally speaking, not used to being photographed. On the other hand, many people are prepared to oblige a photographer's specific request for a picture, contrary to views already expressed in Chapter 6. In the event that certain situations make it apparently normal for a photographer to be present, people will usually continue with whatever it is they are doing and ignore the camera. In working on the street, the photographer has to be able to size up each occasion and decide very quickly whether the situation is 'safe', or whether some more formal approach should be made. Very often, if a scene is to be captured at all, there is not time to ask questions. If in doubt, shoot first and ask afterwards. How successful you are will also depend to a large extent on your own personality and how that is manifested from day to day.

BODY LANGUAGE

Eadweard Muybridge made pioneering photographic history in the 1870s when he used batteries of cameras to photograph the many movements of men, women, children and animals. By modern standards, his techniques would be considered archaic, but that is of no matter. The important thing is that his 'electro-photographic' investigation of consecutive phases of muscular action vividly illustrate human motion and anyone concerned with the subject should make a point of studying his pictures.

There are few moments when the human body reaches its most aesthetically pleasing form when tremendous exertion is in the process of being unleashed. Initially, the photographer is looking at the whole body and trying to choose a moment when movement of limbs and trunk adopt a co-ordinated form which expresses the meaning of physical exertion in graphical terms. If the chosen moment is successful, the viewer will be able to recognize in an instant exactly what is happening and be able to interpret this in the way desired by the photographer. In many instances the onlooker will only need to see parts of the body or face in a picture to be able to recognize which movement or emotion is being portrayed.

The successful animation of a picture is complex. Action or movement is useless without meaning, context and composition. It is form which draws the eye to a picture and fixes attention on the content. A simple test of whether or not a picture works, assuming all other requirements are met, is to turn the print upside down; disregard the subject matter and concentrate the eye on continuity of form. If it is interrupted, even in the tiniest way, by a reflection, a gap too wide, tones too similar, a hat out of place, and so on, continuity will be spoiled.

77 a and b *Two superb examples of photographic control in anticipation of the moment. In Fig. 77a a family takes a siesta in a small town in southern Spain. The photographer stood off and used a 200mm lens, at the same time acting the fool for the children in the group whose animated expressions make the picture what it is. (Nikon F; 200mm Nikkor; 1/250 second at f 5·6; Tri-X, late afternoon) In Fig. 77b the photographer had spotted these two youngsters playing in a back alley. He approached quietly and asked them if they would pose for a picture. While they were asking him what for and so on, he was able to make half a dozen exposures. (Nikon F; 50mm Nikkor on Tri-X; 1/60 second at f 4·5)* (Photographs Peter Eastland)

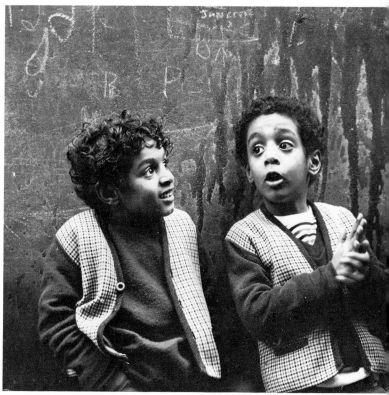

78 *Market place in Louveciennnes just outside Paris, one time home of Renoir and other Impressionist painters. This scene struck me as one which had probably changed little over the years. (Nikon FG; 28mm Nikkor; HP5; 1/250 second at f6·3)*

79 *The world is full of little old ladies crossing streets: this shot of a nun on her way to the post is not particularly special other than in capturing the effort of the moment. It was made with a partly extended zoom lens, and is only a part of the negative, since I could not put myself in the right position to shoot what I really wanted at the time. The car in back is ugly and detracts from the overall effect of what might have been a good, simply composed picture. In this print, I burned in a lot of the car to subdue it, but the fact that it's there at all is a nuisance.*

Assuming the requirement for composition to be met, the photographer next needs to examine content and decide how that can best be portrayed within the compositional framework. It is not enough simply to take the framework of a picture and dump people into it, hoping that by doing so, the picture will suddenly spring to life. Even if animation is present, it may be entirely irrelevant to the context, leaving the viewer wondering, not about what the subject is doing, but why the photograph was ever taken.

Some photographs may be self explanatory, but they may also leave the viewer demanding to know more. Normally, that extra information, which may confirm the visual content, is added in the form of a caption, explaining in more detail precisely what is happening, or not, as the case may be. If the picture works well, it should be capable of standing alone without caption. It is important, therefore, that the photographer be sure that all requirements are met at the moment of exposure.

AVAILABLE LIGHT

One of my favourite haunts is the central railway station; any city will do. And riding in trains and undergrounds is another favourite occupation. Here you will find a wealth of material for the camera and an opportunity to test your skills with available light photography.

What is available light? Simply defined, it is light which already exists but which is much lower in exposure value (EV) than normal daylight found in large exterior open spaces. Low light, existing light or available light sources can be filtered or diffused daylight through a window or other opening, electric light sources as found in large communal gathering places such as railway and underground stations, shops, theatres, etc. or a mixture of both daylight and electric sources. Shooting under these conditions excludes the use of flash, on- or off-the-camera, portable photofloods, or any other kind of illumination imported to the location for the purpose of lighting the subject. Available light includes the twilight periods which occur at dawn and dusk, but not total darkness. Night photography is a separate subject which normally requires the use of longish time exposures for acceptable rendition of the subject (*see Chapter 8*).

Low light levels in certain areas will sometimes present problems. These include flare – which can be caused by overhead electric lights, street lamps or other point sources, such as daylight filtered through windows – and extremes of contrast between light and shade, which make the rendition of detail difficult for some black-and-white and colour films. Fast-moving subjects in juxtaposition with stationary or slow-moving subjects may also pose problems, which even up-rated films may have difficulty in coping with. None of these problems are unsolvable and the experienced photographer will have come to terms with similar situations. Allowances will be made for each factor as it pertains to the subject matter.

80 *The feet at left walking toward the camera present a threatening attitude toward the subject at right, even though there was, in fact, no real connection, and helps to make the point that, irrespective of town or city, the world is also full of those who are socially unacceptable or discarded on the wayside for whatever reason. (Nikon Rangefinder; 28mm Nikkor; HP5; 1/60 second at f3·5)*

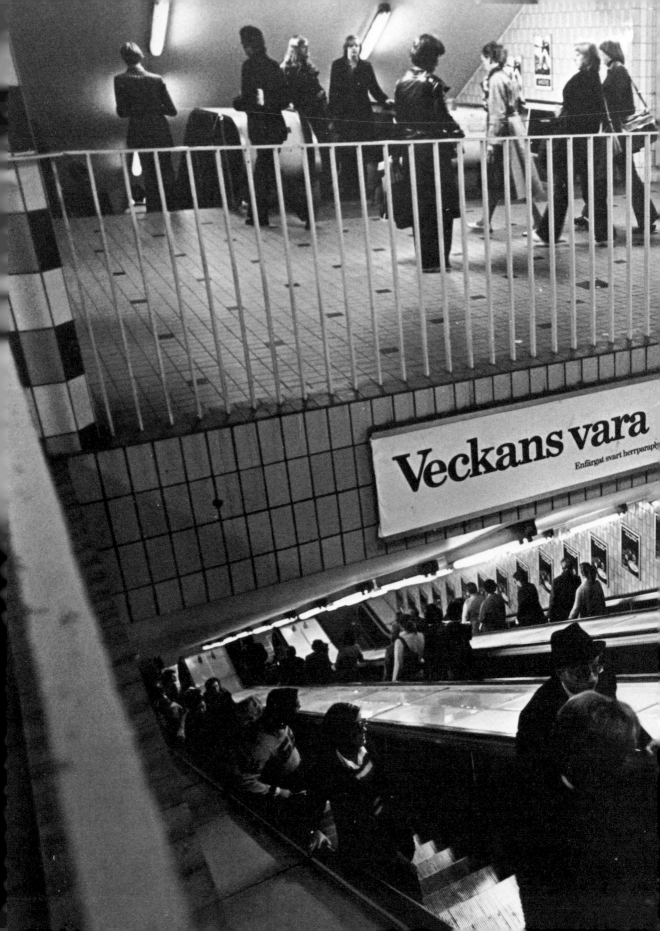

Veckans vara

Enfärgat svart herrparaply

Modern emulsions are capable of rendering minute details when properly handled. Fast films, much preferred by professionals for a variety of lighting conditions will not produce any significant increase in grain or, to be more accurate, in the clumping of grain when given ISO speeds are doubled. There are photographers, however, who may prefer the technique of up-rating film and processing in a fairly coarse developer to bring out the granular structure of emulsion so that the effect may best be seen on a very high-contrast printing paper.

However good the anti-flare coatings of modern camera optics, they cannot completely eliminate the effects of incident or oblique light bounced internally through all the elements of a lens. Keeping a lenshood on at all times is good photographic practice, especially when using lenses which are wider than 50mm. Wide angles have a great tendency to pick up unnoticed extraneous reflections which can ruin an otherwise good photograph. Again, some photographers use flare deliberately to add atmosphere to a picture taken in low light conditions, or to emphasize the fact that overhead or street lighting exists.

One of the best lenses available for Nikon users in low light conditions is the Noct-Nikkor 58mm f1.2. The lens has an aspherical surface, giving maximum coma correction at full aperture, which enables maximum detail to be retained in shadow areas without the impingement of light scatter often present when using normal lenses. But this is very much a specialist lens and not one I would use for much of my own work. I much prefer the wider angled 35mm and 28mm lenses.

Black-and-white users will not notice any particular difficulty when working under artificial lighting, such as that which may be found in a large store. But photographers

81 (PREVIOUS PAGES) *Available light: underground station, Stockholm city centre. Z-shaped composition helps to retain the continuity of this picture, even though there are literally two levels of activity. A slower shutter speed would have introduced too much blur into the picture. Nikon F2; 20mm Nikkor; f4; 1/30 second; Tri-X)*

82 *Available light: window dresser. Reflections of fluorescent lamps neatly intersect the eye of the dresser (no, it's not dust in the enlarger), adding something to the mysterious gaze of the mannequin. Photographer's image is caught nicely in the plate glass of the shop front. (Nikkormat FTN; 50mm Nikkor lens; Tri-X)*

83 and 84 *Available light: people in trains: commuters, not travellers. These two pictures are used to illustrate several aspects of picture-making and the approach to subject matter. In Fig. 84 horizontal and dispersing overhead lines combined with contrasting bright highlights against the darker tones help to produce a nicely balanced and simple picture of a train standing in a station. However, its strongest point is in the graphic design and tonal values. A meaningful picture conveying interesting information it is not.*

Fig. 83 on the other hand, while using similar subject material, conveys a more powerful picture. This is achieved by using the window as a natural frame and a sort of one-way mirror on life inside the train. It's a scene familiar to all who commute home at the end of a day's work from the big metropolis and one which those who don't would rather avoid. Fig. 84: Nikon Rangefinder; 28mm Nikkor 1/15 second at 3·5; HP5/400ISO; Fig. 83: Leica M2; 50mm Summicron; Tri-X 40Q ISO; 1/15 second at f4.

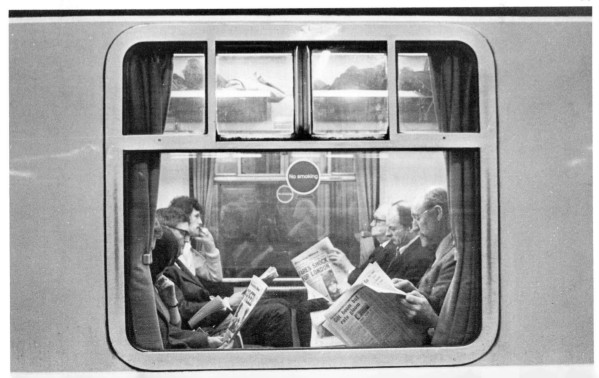

using colour film, whether transparency or negative, will experience abnormal casts in the processed film. The cast is normally green but this can be corrected by employing one of the standard types of correction filter. Colour tints resulting from exposure under fluorescent tubes will vary slightly depending on the type of tube in use but, unless an exact rendition of colours is of paramount importance – in which case a combination filter pack should be used – the normal filters designated FLR/FLD for daylight stock and FLT or FLB for artificial light type films will give quite normal rendition. In some stores there will be a mixture of artificial light from fluorescent tubes and normal tungsten light which may make it necessary to use a conversion filter for the daylight stock (80A or 80B) in addition to the fluorescent light filter. Alternatively, use tungsten film and the single FLT/FLB filter.

Personally, I like the yellowish tints rendered by tungsten light on daylight stock, so would only consider the possibility of using a fluorescent light filter. As light levels will already be low, the addition of further filters will only reduce the operating range of shutter speeds and aperture combinations.

Most available light conditions allow reasonable exposure on ISO 400 black-and-white film stock (or colour emulsions with the same rating). Only occasionally do I find that I have to up-rate film in order to obtain good results. This is usually accomplished by pushing HP5 to an ISO of 650 and processing in HC110 diluted 1:9 for seven minutes and fifteen seconds. Normally, I can obtain the results I am looking for to match my particular printing techniques by using the same dilution with a maximum of six minutes and fifteen seconds. I may also cut development time further by a few seconds in order to obtain a negative which is slightly on the thin side and which I feel will print with better effect on a harder than normal paper.

There are a number of film/developer combinations which can be used for available light photography. There is no reason at all why slower ISO rated stock may not be used, but in doing so you will probably find that shutter speeds are lowered to below a hand-holdable level; this rather defeats the object of the exercise – to make the best use of the subtle nuances of available light. I like to be able to vary my shutter speeds between 1/125 second and any fraction of a second below that, together with usable aperture settings of between wide open and about f5.6. In photographing people, I rarely go below 1/125 second, because while it is easy to hand hold the camera at this speed, there is never the guarantee that the subject will remain still for the same length of time. In underground stations, some lighting situations have become very poor, making it necessary to up-rate the film stock in mid shoot. Normal practice in doing this is to fire off a few blank frames, make a note of the new frame number on the exposure counter and begin again. In the darkroom, film can be cut to length fairly accurately for processing using simple stick gauges which have been cut to 10, 15, 20 exposure lengths, or customized to particular lengths.

For this type of work you will need a fairly fast lens with full apertures of not less than f3.5 and preferably f2 or f1·4. Shutter speeds can then be selected in the 1/30–1/125 second range which give a much better chance for shake- or blurr-free pictures. Some photographers may argue that fast lenses are not necessary. Under normal daylight conditions where f-stops are in the region of f8 upwards, that argument would hold ground, but, if like me, you spend a lot of time searching out subjects in less than ideal conditions, the faster the lens the better. Old-school reactionaries who delight in handing out the theories of full-aperture definition loss need look no further than modern SLR lenses. After all, why bother to make fast lenses in the first place if their fast, wide open apertures cannot be made use of. Even the old Canon f0·95 was a superb piece of glass. Better look first to your enlarger lens, for that is invariably where many problems begin and end.

With regard to film stocks, the available light aficionado has a wide range of choices in both black and white and colour. Eccentrics may prefer the results obtainable from 2475 Recording film which can be up-rated to 10,000 ISO. Royal-X Pan 4166 film for medium format (120) users can be exposed at 4000 ISO. Both types are capable of reasonable shadow detail if exposed as per manufacturers' instructions, but rapidly fall off at that end of the scale as the ISO is pushed up, resulting in very grainy images.

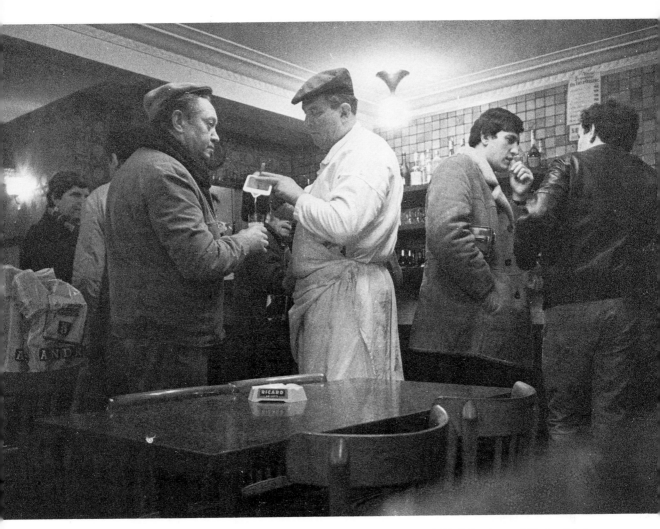

Chromogenic films in the black-and-white range which use colour chemistry for processing, like Ilford's XP1 400 and Agfapan Vario XL, yield excellent quality negatives when exposed in the ISO range 100 to 1600, though do not expect perfect quality in the higher ends of the scale. These films are quite capable of being used for consecutive exposures over a wide-ranging ISO scale with no detrimental effect. Grain structure is excellent and emulsions of this type are capable of retaining great detail at both ends of the density scale. With the latest introductions of T-grain structures for some colour negative films, it is likely that this new technology will soon be incorporated in black-and-white chromogenic stock.

Twin lens reflex and single lens medium format users will need to pay special attention to focus under low light conditions, as the depth of field of most larger format lenses is somewhat impaired by use of larger apertures. Maximum aperture on larger format equipment is rarely more than f3·5 and many 50 mm lenses are f4. One of my Bronica SLRs has a 75mm f2·8 lens as standard and most medium format standard lenses of that focal length are ideally suited for available light work.

The other Bronica has an 80mm Zeiss lens of the same maximum aperture. Even if it

does have a slight edge on sharpness, I find the focal length just a trifle on the long side. The 75mm lens, equivalent to about 39mm on a 35mm format, tends to give a more correct perspective and wider angle of view of events with fractional improvement in depth of field at wider apertures. Longer lenses have even less depth of field and this is one instance where I would almost certainly double the effective rating of HP5 or Tri-X in order to retain as much depth as possible. The increased grain factor will be hardly noticeable when using the larger formats.

86-92 Most photographs are taken from eye level looking horizontally at the subject. Often however, subjects are seen more impressively from another point of view and, in some cases, it is impossible to make a picture without first of all moving the camera physically upward or downward. In Fig. 86 this muddy-looking fellow appearing out of the manhole is in fact a bronze statue in the centre of Stockholm. In colour, the viewer recognizes that the man is not real because of the inherent colour of bronze. It looks like a false being. In black and white, the viewer is persuaded to look twice because the tonal value does not actually give a clue as to the species. In this instance, the juxtaposition of real being, slightly out of focus in back glancing curiously at the subject not only adds to the mystery but also helps to focus the real point of interest for the viewer. From eye level, the angle of view was too great to achieve the correct balance. Camera had to be low down and a medium telephoto used to pull subject and onlooker together. (Leica M2; 135mm f 2·8 Elmarit; Tri-X; no filter; 1/500 second at f 8)

UNUSUAL VANTAGE POINTS

During an afternoon spent walking the streets in Providence, Rhode Island, I had been looking for something to photograph that reflected my feelings of euphoria and nostalgia for similar scenes in other American cities. There was a lot to see: broken lamp-posts at crazy angles juxtaposed with abandoned and obviously dying automobiles, a mixture of traditional and modern architecture, pawn shops side by side with beer halls and, everywhere, the noise of moving, hooting traffic. I shot a lot of film, from street level and motorway flyovers, from high-rise multi-storey car parks, but there was nothing eventually which struck me as being anything more than a fairly sophisticated snap shot. Perhaps it was just one of those days; I had gone out looking, convinced I would find something.

In a way, it was an exercise in observation, never mind the film wasted. The lesson I learned yet again, was that nothing about making pictures out of nothing is ever easy. Simultaneously, how easy it is for the brain to overreact to sights and sounds – the old problem of thinking subjectively and not objectively as a camera sees. Spontaneity does exist, but this often follows hours of concentrated mental effort in trying to establish just what it is we, as photographers, are trying to communicate to the viewer.

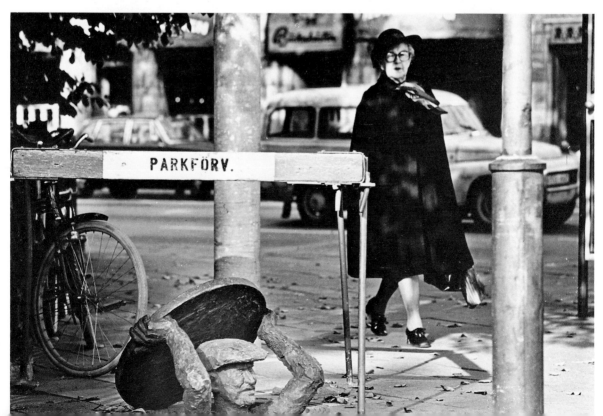

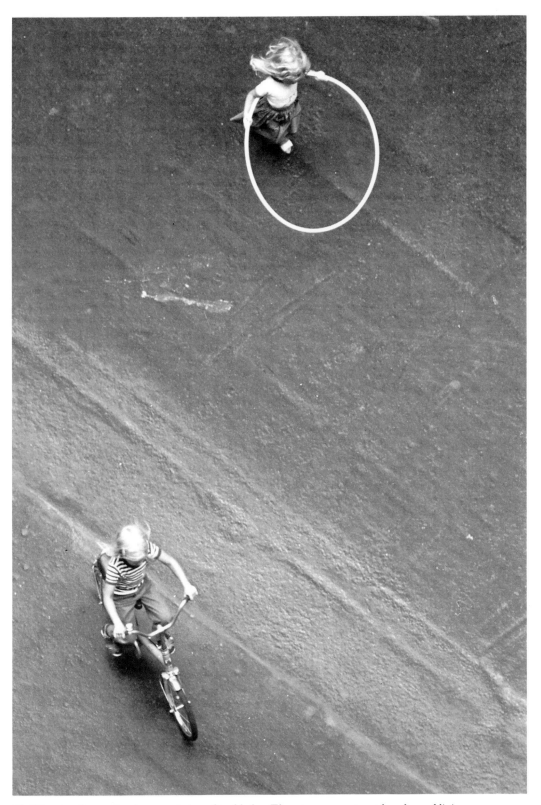

87 *The view from a hotel room window, Stockholm. These two youngsters played on, oblivious to my observations from four storeys up. An intrusion at ground level would have been fruitless, not only because of the loss of a pure slightly patterned background, but also the overall effect of design would have been lost. (Nikon F2; 200mm Nikkor; 1/125 second at f4 on Tri-X)*

88 *The point of view here is from a sitting position. If the camera had been at eye level at normal standing height, the subject in the background would have been lower in the picture and in completely the wrong place for a successful balance. (Nikon F; 35mm lens; HP5; 1/125 second at f 5·6)*

89 *Here extra height, a matter of inches, from a higher walkway, has helped to compose a tight picture with a relatively uncluttered background. If I had been lower, the skyline would have interrupted the overall effect. (Olympus OM1; 70–210mm zoom; HP5; no filter; 1/500 second at f 5·6)*

I had been in America to cover the finals of the America's Cup and most of my time had been concentrated in that direction. Several days later, during the ride back to Boston to catch a flight home, I pondered over the susceptibility of the brain to sentiment and the realization that for a while at least I had not been reacting objectively to my strange environs.

Making allowances for myself, I sat back to enjoy the passing scenery, watching the skyline of one of America's oldest cities loom ever larger in front of the heap of cars jamming the expressway ahead. It was about this time that the idea for a picture slowly took shape but, as usual, much would depend on timing, composition and viewpoint. It was late afternoon; the light was low and strong, throwing up the city's towers against an almost purple skyline. As I could not stop the car, I decided to make use of those on the road ahead by shooting through the windscreen.

There were two elements for a picture; cars on the road and a city skyline. With a big telephoto lens from the top of a stationary truck two miles back, I could have made a picture, possibly. But with a 35mm wide angle lens through the windscreen, I needed more and the only thing in sight was an overhead gantry giving lane indications. Several of these notice boards had already been passed. What I needed was one that would frame the two main subjects, but there was no need to worry about missing the moment; the traffic was moving so slowly, I could have walked faster. Using a Nikon F SLR with a motordrive, I removed the lenshood and placed the camera lens against the inside of the car windscreen to cut out as much flare and extraneous reflection as possible.

Pictures having little or no point of reference for the viewer are invariably meaningless, so the photographer should always try firstly to obtain a clear unobstructed view of his subject, and having done that, decide

whether all the necessary elements for a well-composed and interesting picture are still available. Will the viewer still be able to recognize the subject? Does the new vantage point make the overall concept more pleasing or less? Has the spatial effect changed too dramatically?

Unusual vantage points for the camera are those from which the result envisaged first will be the same, only better; more concise, clearer, more simply defined, less cluttered and providing the viewer with an unexpected angle on what may be an old and hackneyed subject.

One very simple way of seeing the difference that a few inches in height will make is to take a walk through a crowded pedestrian precinct. Use a medium telephoto lens on your camera to give some compression of space. A sturdy aluminium camera case can be used to stand on once you are in the middle of the melée. This will give just enough height to allow row upon row of people's 'faces' to fill the frame, adding depth to a picture that would otherwise be simply a muddle. If no case is available, you will have to look around for conveniently placed doorsteps, balcony windows, sturdy litter bins, anything that will provide a little extra elevation.

At any great event worthy of pictorial record you will still find the odd photographer who has gone to great lengths to transport a set of step ladders to the scene. He may be regarded by his/her colleagues as something of an eccentric, but, at the end of the day, the industrious photographer will be able to produce an interesting set of pictures while those of everyone else might be a fairly mundane record. Some aspects of city life are no less frenzied than the scrum of special eventing and anything which will help the pho-

90 *Crossing the road in London. A pedestrian barrier adjacent to the crossing gave me sufficient extra height (about 6 inches) to make an effective picture out of an ordinary every minute occurrence. It could easily be improved upon no doubt, but as it stands all the elements of composition and movement make a coherent whole. (Nikon Rangefinder; 28mm Nikkor; HP5; 1/250 second at f 8)*

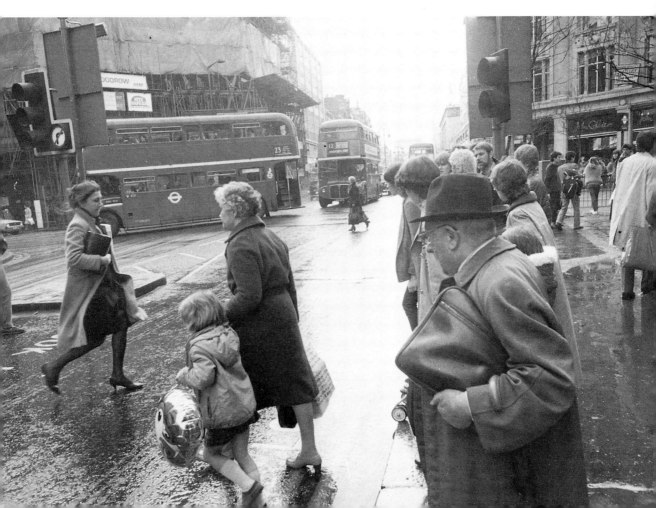

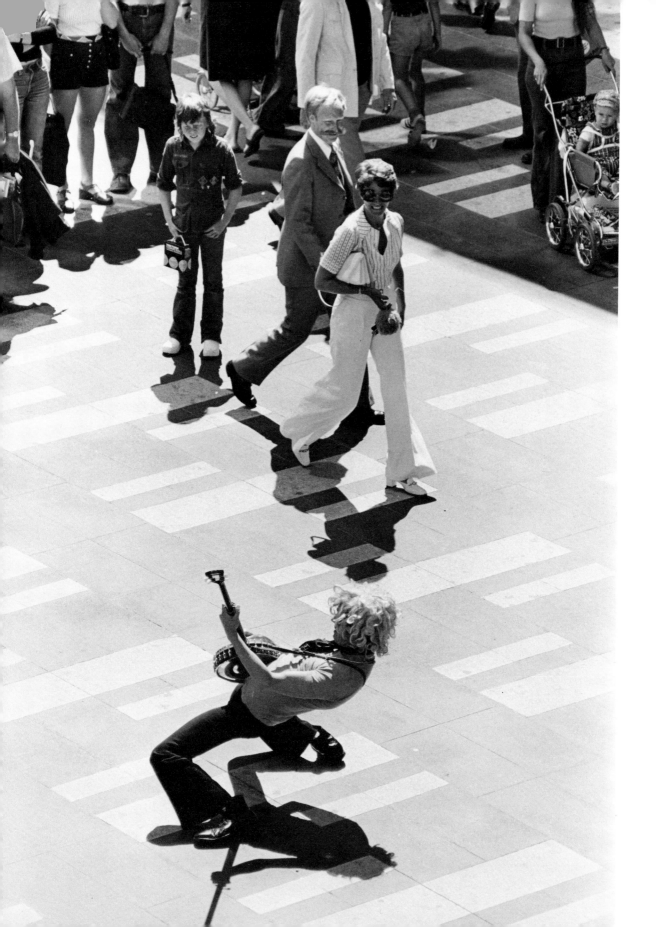

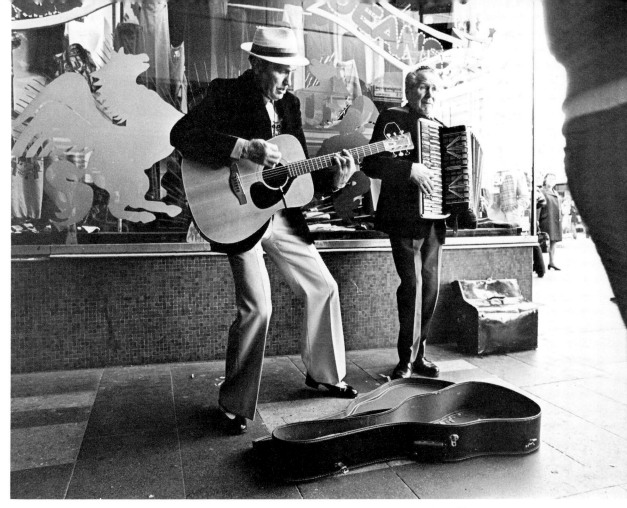

91 and 92 *Buskers in Stockholm. Two
extremes of point of view and two different
lenses. Nikon F2 and FP4 for both. (In Fig.
91 200mm Nikkor lens; yellow filter; in Fig.
92 24mm Nikkor lens; polarizing filter)*

tographer to achieve that little bit of added
height should be considered.

Large subjects which cannot be photo-
graphed in their entirety because of re-
stricted access, may require severe cropping.
This invariably means that the camera has to
be placed in fairly close proximity to the
subject, necessitating wide or ultra wide
angle lenses if the frame is to be filled. The
mistake often made here is that the impres-
sion of grandeur will be maintained in the
picture. This is invariably not the case, as we
have already seen. Big things in life need big
lenses if the illusion is to be maintained at
all.

But try looking up! Confront the viewer
with an angle of view which is altogether

familiar; instead of using the whole subject,
take just a part of it. The essence of grandeur
can be retained and, because certain aspects
of architecture are familiar, the imagination
will feed the rest of the picture into the
brain, providing instant recognition in awe-
inspiring proportions.

SEEING PICTURE POSSIBILITIES

Some years ago I was asked by one magazine
to supply photographs for a feature article
on pollution of the country's waterways.
Since my library of pictures was very much
in its infancy, I could only supply a handful
of images from stock, the rest would have to
be purpose shot. This meant first of all, ori-
ginating a list of possible subjects and trying
to decide in a very short space of time what
was essential and what was simply 'extra'.
My diary shows that the assignment was ac-
complished in a little under a week with visits
to locations on the south coast and venues
further afield in the Midlands.

141

In Coventry, I found two significant pictures for the article after walking for an hour along a stretch of the towpath on the Birmingham/Coventry canal. Although much had been cleaned and restored, I was fortunate enough to happen on a small cut where the scene confronting the camera epitomized the ill-treatment of Britain's canal system. Literally everything from the car to the kitchen sink, had at one time been dumped into this cesspool. Local residents could afford themselves the vantage point of a nearby footbridge for a better view of this squalor and after shooting several frames from the towpath, I lowered my Nikkormat on its neckstrap almost to water level to obtain a wide angle view of the scene.

The footbridge with its daubed graffiti gave depth to the foreground composition of junk resulting in just the picture I wanted to emphasize the problem facing canal restorers everywhere. One interesting aside to this picture came about shortly after I had made these exposures. From the footbridge, there was also a view of the main canal, but it lacked any real meaning as far as the story was concerned. I stopped an elderly gentleman and, during the course of conversation, discovered that he had lived in the neighbourhood most of his life. His comments regarding the decline of local canals were, I thought, essential to the main story. Two more frames were exposed with the main canal going to vanishing point behind a super portrait of a local. His comments formed the basis of the picture caption and both were ultimately used in the article.

Back in Boston's International Logan airport, I had been contemplating the possibilities of a cleverly designed roof structure in the main check-in area. A huge American flag hung vertically on the facing wall above the heads of seated travellers. From where I was squatting, my back to someone's desk, I was able to make a number of exposures using the Nikon rangefinder fitted with a standard 50mm lens. The resulting pictures were interesting and led on to speculation about the way in which people wait. From my low viewpoint, I was able to make several more exposures of people in various stances, the intention being to try and capture something which interpreted graphically the image often presented by people waiting for trains, boats or planes.

During the height of the early days of 'stand-by' travel, people often waited for days for a ticket. Some camped on pavements, others dragged mattresses and bedding into back alleys and basement car parks. Very little light permeated these dingy holes and I was hard pressed to make anything worthwhile, even rating the film at 1600 ISO and shooting wide open at 1/8 second. After a morning spent mostly watching the comings and goings of dozens of people, I had exposed half a roll of film. It was the picture (*Fig. 76*) of one family which finally epitomized the occupational hazards of stand-by travel.

The light was so bad in the part of the basement I was working in, that I had to work on at least $\frac{1}{4}$ second for exposures. A concrete pillar in just the right place gave a solid support for me to lean against while I gently squeezed off three or four exposures.

Aside from the problems of low light levels and lack of camera support, slow shutter speed also brings to mind another matter which can sometimes curtail any hope of obtaining the required picture. In confined spaces, acoustics can carry the sound of a whirring shutter some distance. To be as unobtrusive as possible, I had deliberately selected the rangefinder Nikon.

8 Night Photography

THE USE OF FLASH

Early in my photographic career I set out to try and teach myself some of the techniques I could not find written about in books. In setting these experiments, I also hoped to make a little extra money from the end result. But it was not always easy; in fact most of the time it was just plain hard work trying to make a picture which was in theory a relatively simple operation. From time to time, I would enlist the help of my two brothers, one of whom was then at an art college and possibly knew more than I did about certain photographic techniques, and the other, who although still at school, was later to follow in photography with a flair for picture-making that often made me wonder whether I was wasting my time.

A newly constructed apartment block set me wondering as to whether I could photograph it at night. Perhaps the local newspaper or the builder, or both, would find a night picture a little different from one produced under normal conditions. I decided to make a picture of the rear elevation of the building as it backed on to a large open car park and was relatively uncluttered by the vacant ground floor shops which fronted the high street on the other side.

I had seen some photographs by an industrial photographer in which he had used car headlights to make a night picture of a new cross channel ferry in port. I did not own a car in those days, nor did I have access to a mobile searchlight which would have done the job admirably. My lighting equipment comprised one tiny electronic flash gun which hardly gave out enough light for portraits, let alone anything else; in addition, there were a couple of ancient collapsible bulb guns.

While the electronic gun was left on charge for a few hours, I went in search of the largest flash bulbs I could find and tried to work out what sort of exposure I would have to give the subject.

A street lamp placed strategically near to one end of the building would probably burn out that part of the picture if the exposure was too long. But it would take a little while to paint the building with light from flash guns, especially since access to the first floor balcony was restricted.

With my two brothers armed to the teeth with flash bulbs and the fully charged electronic gun, the tripod was set up in the car park and the camera, a 9 × 12cm Van Neck, secured firmly on the pan and tilt head. I had loaded Tri-X into the cut film holder having decided to work to the standard ISO rating of 400. Once the image on the ground glass had been focused and framed, I set the shutter to T, clipped on the film holder and withdrew the slide. I had selected an aperture of f8 as a starting point for this experiment based on approximate exposures detailed under unnumerable night pictures made by others on a long time exposure. Anyway, it seemed a logical place to start. My two assistants were placed one at each end of the building, the idea being that they would walk slowly towards one another firing their flashguns in arcs from side to side and angled upward so that the upper part of the building would receive sufficient light. From the camera position I could see clearly which parts of the building were being lit and after the first round was complete I pointed out areas I thought had been missed and these were filled in as effectively as possible with the little electronic gun. Luckily, there were not too many 'holidays'; the gun took ages to recycle its charge.

143

The actual exposure time was about five minutes, due to the length of time it took to fire and re-load each flash gun with a bulb; but each part of the building had only received a fraction of a second of light. I didn't think this was enough, so the whole process was repeated. The shutter was closed in between each operation and this is where I hoped that the tripod would be sturdy enough not to move when the shutter was cocked and re-opened for a second session. We must have used nearly 60 bulbs that night and there were none left for a second frame when the job was finished.

In processing, I decided against my earlier judgement and effectively up-rated the film to 650 ISO, using neat D-76 for just over eight minutes.

To be fair, the result was slightly disappointing. Not because I had made a mistake as to the general assessment, but simply because I could not throw enough light on the upper part of the building at roof level. While it was fairly well outlined by the glow of street lamps on the other side of the building, only the ground floor and garage doors had been sufficiently illuminated. Also, I did not allow for light reflecting back onto my assistants and so there were ghost images all over the place.

I was somewhat exasperated, but aside from the cost of the operation, I learned a lot from the exercise and still recall the picture to mind each time I go out to photograph another building at night. The buildings change of course, but the problems are essentially the same: how to throw enough light on the subject without under-exposing important areas and how to highlight essential parts without burning them out of the negative.

93 *The traditional agency picture of New Year's Eve celebrations in London comprised a stock composition of revellers washing themselves in the fountains of Trafalgar square; different people, same picture, almost without fail, every year. I wanted something different and something which could be wired simultaneously with the 'jubilation' picture as a total contrast. Luckily, I found this gentleman of the road, complete with all his worldly goods and chattels not far from the AP office in Farringdon Street. The picture was made at 2359 precisely on a Nikon F with a 35mm Nikkor and direct electronic flash on half power on Tri-X at f8. I heard later that several newspapers across America had used the picture big*

Not very long afterwards an advertisement in a popular American photographic journal described how an enterprising cameraman had photographed the entire Mexico Olympic stadium using some 2000 flash bulbs, all fired simultaneously! None of my assignments using flashlight ever had subjects quite as grand as an Olympic stadium, but quite a large number of them required extensive lighting arrangements.

From time to time, I was commissioned to photograph the interiors of restaurants, the occasional engineering factory and, frequently, boat building factories in various parts of the world. Since the subjects usually required multiple flash set-ups, I became quite adept at making them work properly, preferring to use long extension leads to link the guns rather than slave units which would often fail to trigger the main light when the light path was slightly obstructed or when the slave was more than 12m (40ft) from the camera. I had also obtained a large hand-operated bulb gun which accepted the larger

94 *Bar in Pointoise, France. Nikon FG; 35mm f2 lens; 1/8 second at f2.8; HP5 rated at 650 ISO and processed in HC110*

No. 2 and No. 1 bulbs (PF100s and PF60s). Nicknamed 'Gilbert' (after its trade name), the gun became a constant companion on my forays into the world of industry and I still use it today whenever the occasion demands.

Depending on the available light, my exposures work around a shutter speed of about $\frac{1}{2}$ to 1 second at between f8 and f16. The camera is firmly bolted to a solid tripod and the delayed action device is used to open the shutter and fire the electronic flashguns which are strategically placed around the subject, hidden in doorways or windows. Gilbert is loaded with a pre-wetted bulb – the contacts are run over the tongue – and fired at the scene from as high as my arm will reach while the shutter is open.

This technique requires a little practice; you have to learn to listen for the tell-tale noise of the shutter opening, watching at the same time for the camera-linked electronic flashguns to go off. If I think the scene needs the main light from another angle, I can take Gilbert to whatever part of the frame edge is required and my cue then comes from the automatic flashes as the camera shutter trips on the self-timer.

Shots like this take a little while to set up properly and you have to be absolutely certain that all electronic guns are tripping when the camera shutter trips. Extension leads do not last long and after a while I found it was easier to make my own using a much heavier gauge cable. The co-axial connectors can also be a nuisance and I usually carry two or three spares, plus several packages of high-powered new batteries for Gilbert. Why flash bulbs? I can hear little voices in the dark squeaking with glee. . . .

You may have noticed the incredible quality of flash shots of earlier decades. Particularly the 1940s and 1950s when most photographers still used bulbs in preference to those enormous early electronic units. The richness in a bulb flash shot has to do with two things. One is the choice of shutter; a focal plane shutter synchronizes to the flash bulb in much the same way as a compur type leaf shutter, making use of the peak output of the bulb but, because there is a slit in the focal plane type which travels across the film plane, it usually only picks up the last part of the peak. The exposure tends to be somewhat uneven, but not as noticeably under-exposed in some areas of the negative as when an electronic flashgun is used in conjunction with a focal plane shutter. The second and probably more important factor which makes such a noticeable difference between electronic and bulbs has to do with the power of illumination. A flash bulb burns for considerably longer than the short burst of an electronic gun and this helps to expose silver halides more efficiently than electronic flash. It is a phenomenon which introduces a reciprocity factor into the exposure, resulting in negatives which are beautifully exposed in the shadow areas. This makes it possible to produce negatives of excellent quality and prints with a superb range of tone.

Successful flash photography is an art based on sound practical experience. There are no set rules, only guidelines which have been handed down, or along, from one photographer to another. Usually, the problems experienced by photographers have more to do with under-exposure, especially when lighting large subjects out of doors at night. Difficulties are also frequently experienced inside for the same reason, and this nearly always has to do with equipment inefficiencies.

Most modern electronic dedicated flashguns are really not tough enough for this kind of work and, at best, can only be expected to light the subject while working at full aperture over a distance of some 18–22m (60–70ft), using 400 ISO film. Some flash manufacturers producing fully automatic guns maintain that distances up to 45m (150ft) can easily be covered when using a telephoto lens. However, these lighting units are still a long way from producing really efficient amounts of light suitable for large scale indoor or outdoor subjects. Some big hammer head types have higher outputs: National, Metz and Vivitar are three commonly available types. The British built Norman 200 B/E marketed in England by Keith Johnson Photographic has a huge 200 guide number with 100 ISO film, but it is less than convenient to have to carry around and, unless you are doing a lot of this type of work, the outlay is probably a little high. If you plan to make really extravagant night-time exposures using flash, think about those 2000 bulbs used to light the Olympic stadium!

In England, Bowens of London are probably still the sole manufacturers of large flash bulbs. I am reliably informed that production will continue for the foreseeable future.

The bulbs are PF60s with edison screw fittings, and are about the same size as an ordinary household light bulb. Bowens also make their own single-bulb flash holder/guns as well as cluster units accepting up to four bulbs at a time. They can also supply all the wiring and detonating devices needed for really large operations and these can be purchased outright or rented for short periods. Who needs such equipment? Well, my informant disclosed that a government agency specializing in architectural photography uses a lot of bulbs!

In other parts of the world other types of flash bulb can still occasionally be found in the back rooms of older, privately owned stores but, in the land of plenty, American photographers told me that there is no shortage of either equipment or bulbs. For those of us occasionally tantalized by the amazing possibilities of night shots that snippet of information is heartening.

Probably the greatest craftsman in the art of night flash photography is O. Winston Link, an American photographer who spent five years documenting the Norfolk and Western railroad system before it finally ceased operations in 1960. Link's techniques for lighting some really amazing pictures are almost legendary and if you ever have the chance to see some of his work take note of how he made them. He invariably used a 5 × 4in. field camera with as many as 50 bulbs placed strategically at or around the subject, some in clusters and all fired in series using fairly high voltage techniques at exposures of around 1/100 second at between f11 and f22. One paragraph cannot possibly do his work justice, more especially since I am unable to publish any of his photographs. If you are interested in this photographer, doubtless the Photographers' Gallery in London will be able to tell you more since they exhibited some of his work there in a show called 'Night Tricks' in the summer of 1983.

NIGHT PHOTOGRAPHY WITHOUT FLASH

Night photography does not start (or end) with the use of flash to light the subject. It begins where daylight fades and the inky blackness turns the world topsy turvy into a stage that is a different colour, different shape and one of many different moods. If you like, it is a fantasy world as opposed to the real one we see so much of. It can also be an imaginative photographer's paradise, a place where exposures can play havoc with ideas and often where the final result is not at all what you might have predicted.

Reciprocity failure: facts and figures

Recently, I spent a day in London shooting pictures in near impossible twilight conditions around the streets and in underground stations. I used Agfachrome 50 daylight stock and shot all the pictures at 1/15 second at maximum aperture. The results were fascinating and in some cases not at all what I had thought they would be. The slight green cast in some frames was caused by fluorescent lighting which I did not filter out. I used a skylight 1B filter on the lens and, if anything, this added a little warmth to some of the street scenes and improved some colours.

Most colour is acceptable to the eye in reversal form; indeed, for professionals, the problems do not usually start until transparencies reach the printing stage, at which time the results cannot in any way be guaranteed, unless a Kodak step colour wedge is tacked alongside the subject at the time of shooting. Once, I made what I thought to be a superb colour night shot of a Guildhall. The original was exposed on 5 × 4in. sheet film using daylight Ektachrome. The exposure was one minute at f8-11 and the result was a cracking picture with superb golden colour rendering of the building against a deep purple night sky. I sold the postcard rights to a publisher about a year later and when I saw the result of their printing efforts I was horrified. They had somehow managed to turn the deep purple into a revolting shade of emerald green!

In Paris, I set up the tripod on a bridge looking down the Seine toward the vast skyscraper and office block complex of La Defense. At night time, this is a particularly eye-catching part of the city and well worth a frame or two. I used artificial light type reversal film in the Nikon FG, fitted with the 80–200mm zoom Nikkor and a skylight 1B filter. Most of my exposures were counted in minutes rather than seconds, using an aperture of f16 with 50ISO film. My black-and-white results were just what I wanted but the colour was badly affected by a vibrating tripod caused by traffic rumbling across the bridge. Since it was a relatively still night, I cannot think of anything else which could have disturbed the exposures.

95-98 *Effects of cumulative exposure can be clearly seen in these night shots of lighted towers on the banks of the Seine. The Bronica was tripod mounted and a series of exposures, ranging from 1 second at f 5·6 to 1½ minutes at f11, made. Fig. 95 represents the scene as the human eye would see it, lacking considerable detail but still clearly recognizable*

96 *Here, an exposure of 4 seconds at f 5·6, showing the scene in print form as clearly as we would want to see it for real*

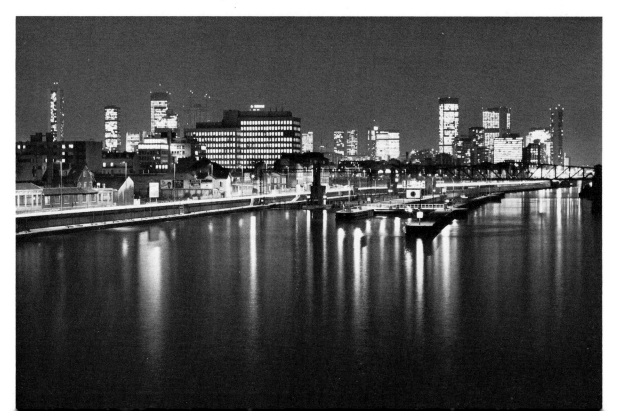

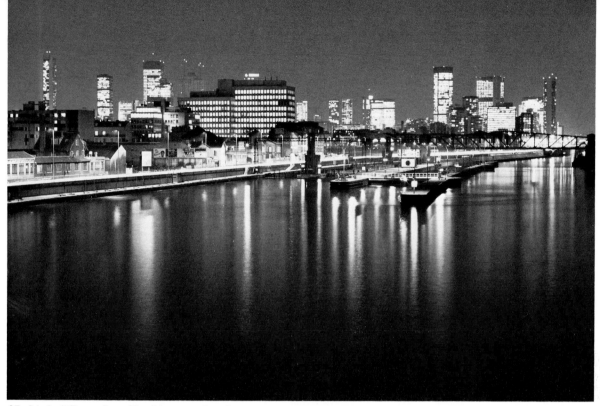

97 *Little different from Fig. 96 except that the exposure was considerably longer—30 seconds at f8—and begins to show signs of excessive highlight blocking*

98 *At $1\frac{1}{2}$ minutes virtually all detail has been lost in the highlight areas and shapes are indistinct*

Just how sensitive film is to light can be demonstrated with another picture. This time it was shot indoors. It was a first for me, in surroundings that appeared to be so badly lit, I imagined that no worthwhile image would be recorded.

In a bar in downtown Galveston, Texas, I set up an old folding Zeiss camera on a table. The bar was one of those typically dingy watering holes found in the seedier parts of most large towns and cities. There were about three frames left on the film in the camera and while the beers were being supped I made two exposures of a local character hammering away on a rather beaten up piano. I stood the camera on the table in front of me and set an aperture of f8, opening the shutter for about a second, which I hoped would be long enough for light from a single overhead tungsten bulb to illuminate the scene.

After processing, I thought the negative was so badly under-exposed that I left it in a drawer with other duds. Nor had I bargained for the vibration set up by the drummer in the little group and the negative appeared to be badly shaken.

Some years later I started to print some of those early failures to see if there really was anything worth keeping. The Galveston bar picture became a firm favourite immediately, not only because the picture which formed on the bromide provoked memories of a strange night which had ended in the small hours with a ride in a Texas police car, but because it was just an impression, rather than a clearly defined photographic record.

I could not have set out to interpret the scene in this way if I had known then what I know now about photography and it is sometimes only an accident of exposure which can produce pictures which work well. One of the reasons for this is that film has a much greater sensitivity to light than the human eye. When there is too little light, the

99 *Available light: it was the 'Rock-Ola' juke box that caught my eye and the waiter's attire seemed to epitomize an era of coffee bar life of the late 'fifties and 'sixties. A large mirror behind the juke box and the table served as a reflector for the image of the waiter who I positioned against the café lights before shooting it. (Nikon F; 35mm Nikkor f2; HP5 rated at ISO 650, 1/30 second at f4)*

eye has difficulty in seeing detail properly; long exposures on film tend to have an additive effect, thus, the longer the shutter is left open, the more dense the negative will be in certain areas. In very subdued light, as it was in the bar that night, the eye can only see parts of the scene which are sufficiently lit to be recognizable. Film often sees much more, but we do not always notice what it sees until the negative has been developed and a print made.

Long exposures can also have other effects on film, particularly colour film. With most reversal materials, colours are effectively changed when exposures are longer than one second. These changes will become more noticeable as the time increases and the effect is often referred to by technicians as reciprocity or Schwarzschild effect. Colours can also change when exposures faster than 1/1000 second are used.

The reciprocity rule states that the effect of exposure is equal to light intensity multiplied by duration. Where light intensities are very low or high, more or less exposure over the metered reading is necessary to compensate for the effect that such exposures will have on colour film. Long exposures usually have an unpredictable effect on overall colour balance, though some emulsions will only show dramatic shifts in colour in certain areas of the spectrum, usually where blues or reds are predominant. Short exposures can have similar effects, but are not always so noticeable.

For history buffs, the law of reciprocity was formulated in 1866 by Robert Bunsen and Sir Henry Roscoe: $E = IXT$. However, the noted astronomer K. Schwarzschild (1872-1916) discovered that this equation did not apply in the case of very long or very short exposures. He found that there was a definite tendency for exposures in the higher and lower ranges to be insufficient, causing under exposure.

This being the case, why is it then that in black-and-white photography the effect of longer exposure tends to be cumulative, rather than subtractive? The fact is that the effective sensitivity of film emulsion tends to decrease with increased exposure; simultaneously, the contrast range is effectively increased, so, if you continued to expose the film to light, eventually much of the detail you hoped to capture would be obliterated

by increased contrast and over-exposure of some highlight areas and under-exposure of areas dimly lit. Compensation can be given in exposure and development, usually by one or two stops for periods of exposure up to 100 seconds and a reduction in development of between 10 and 30 per cent, depending on the exposure compensation given (*see table on p. 113*).

In colour reversal materials, the primary colour layers on the emulsion react differently to longish exposure, but also to certain lighting conditions. If these are known, it is possible to compensate using colour correction (CC) filters during the exposure. A table of approximate exposure compensations and colour corrective filters is given on p.154 but they should not be read as gospel; they are a guide only. Shifts in colour balance will vary, depending on the type of emulsion used and the conditions under which it is exposed.

If you have not experienced any of these problems up until now, do not worry about it. Dramatic shifts, in colour particularly, only happen when exceedingly long or short exposures are made and modern emulsions seem to be able to cope with a variety of different exposures and conditions of lighting without noticeable malfunction.

Colour correction

It is, however, worth trying a few tests if you are uncertain and concerned about the effect. What is pleasing to one eye, may not please a thousand others and with night shooting, or exposing under very subdued light conditions, care should be taken to try and assess as far as possible what corrective measures will be necessary to produce colour transparencies that have no cast or unwanted tints.

As with daylight photography where hues are often affected by adjacent colours, night colours are changed in a similar manner. The human eye, because of its instant ability to adjust to a variety of lighting situations which are mostly seen without casts or tints, deceives the individual into thinking that the camera will see the same way. Not so. Emulsion stock sees only the colour it has been chemically designed to see and these are only usually correct (normal) under laboratory controlled conditions. As we have already discussed the use of certain filters for daylight use in Chapter 3, there is no need to go over it again, but the photographer of night scenes should be concerned about the effects which certain types of artificial light will have on the final result and whether filter correction is necessary.

Quite often we see reproductions in magazines where the photographer has attempted to mix daylight with tungsten light. The ordinary interior room shot is a classic example. In the original transparency, the resulting effect of the light mixture is often pleasing to the eye, but, as we have already seen, the effect can be over-emphasized in the reproduction stage, making a nonsense of any pleasurable effect of the original transparency. Mixtures of artificial light, tungsten, fluorescent and coloured neons, can have a devastating effect on colour emulsions, producing all sorts of unreal tints and casts over whole areas of a picture. Sometimes, this can be used in picture-making; the photographer is willing to accept a change in colour for the extra mood or atmosphere added.

With colour negative emulsions, the problems of colour correction are not nearly as acute at the shooting stage as they are with reversal materials and, in most cases, colours can be corrected or changed at the printing stage. In fact, with colour negative material, one can make the scene just about any colour required in the final print, just so long as it is acceptable to the eye.

Forced development

With black and white, it is not colour that concerns us, but tone, tonal separation and contrast. Ideally, we should be looking for average contrast in the main part of the subject. Forced development, or 'push' processing, is an effective way to increase the apparent sensitivity of film. Note that I said 'apparent', because emulsion is, in theory, only sensitive to certain wavelengths of light at a certain level, which is why we have all these different ISO rated films in the first place.

By pushing the development the photographer is effectively over-developing an under-exposed image. Hence we can cheerfully say that the film has been rated at 800 or 6400 ISO and exposed for that light value. Developing the film for its recommended time at the manufacturer's rating would show that the film had been grossly under-exposed; the extra development time simply

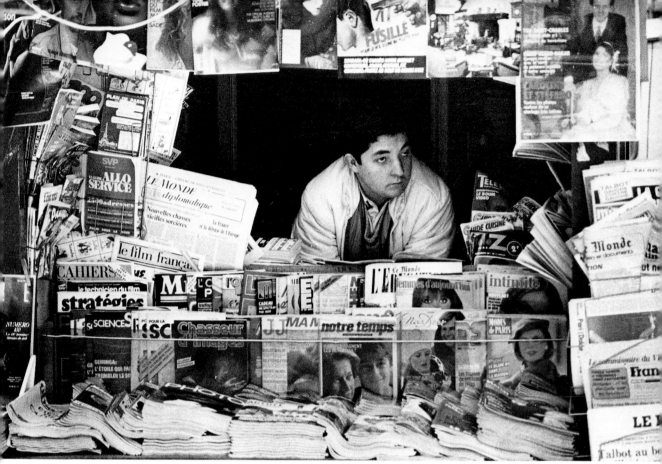

100 *Available light: Paris news kiosk late at night from the light of a street lamp and fluorescent poster illumination. (Nikon FG, HP5 rated at 650 ISO, 80-200mm Nikkor wide open)*

101 *Painting with light—see text for details. This block of flats needed more than the single street lamp illumination coming from extreme right of the picture, the rest of the façade being in total darkness. The building was painted with light and photographed on a 12 × 9cm VN camera using up-rated HP3 film*

makes the exposed image on the film more dense. In following this procedure with some films, the photographer risks an increase in grain clumping which is the result of silver halides merging together. Proper agitation is required to see that unevenness in clumping does not occur and that all other chemicals, wash water included, are of a near temperature to the initial process.

COMPENSATION FOR RECIPROCITY FAILURE

Film Exposure	Additional stops or filter correction		
	1 second	10 seconds	100 seconds
Black and white			
Agfapan 400	$+1$	$+2$	N/R
Ilford HP5	$+\frac{2}{3}$ (approx.)	$+1\frac{1}{3}$ (approx.)	$+2\frac{1}{3}$ (approx.)
Kodak Tri-X	$+1$	$+2$	$+3$
Kodak 2475 Recording	$+\frac{2}{3}$	$+1\frac{1}{3}$	$+2\frac{1}{3}$
Colour			
Kodak Ektachrome 160 tungsten	$+\frac{1}{2}$ (CC10R)	$+1$ (CC15)	N/R
Kodak Ektachrome 200ED	$+\frac{1}{2}$ (CC10B)	N/R	N/R
Kodak Ektachrome 200EPD	$+\frac{2}{3}$ (CC10B)	N/R	N/R
Kodak Ektachrome 400	$+\frac{1}{2}$	$+1\frac{1}{2}$ (CC10C)	$+2\frac{1}{2}$ (CC10C)
Agfa CNS400	$+1$	$+2$	$+3$
Fujicolour F-11 400	$+1$	$+2$	$+3$
Kodacolour 400	$+\frac{1}{2}$	$+1$	$+2$

N.B. Reference values for daylight
CC = Kodak colour compensating filter
Schwarzschild exposure corrections require 10 to 30 per cent reduction in development times for black-and-white stock.

TIMES FOR FORCED DEVELOPMENT

Film Standard ISO	New ISO	Developer make and time in minutes at 68°F (20°C)
Agfapan 400		**Tetenal Emofin**
	800 ISO/30 DIN	2×2.5 min (normal contrast)
	1600 ISO/33 DIN	2×3.0 min (normal contrast)
Fuji Neopan 400		**D-76**
	800 ISO	12 mins
	1200 ISO	15 mins
	1600 ISO	20 mins
Ilford HP5 400		**Ilford Microphen** (concentrate)
	650 ISO	8 mins
	800 ISO	8·5 mins
	1200 ISO	9 mins
	1600 ISO	10 mins
	3200 ISO	15 mins
	6400 ISO	20 mins
Kodak Tri-X 400		**Tetenal Emofin**
	800 ISO	2×2.5 mins (normal to
	1600 ISO	2×3.0 mins medium contrast)
Kodak 2475 Recording		**HC110 dilute 1:32**
	1000 ISO	9 mins (av. subject brightness)
	1600 ISO	15 mins (low subject brightness)
	4000 ISO	22·5 mins

9 Paris: a Personal View

The task of documenting graphically all facets of one large city, not to mention its suburbs, would be enough to keep even the most dedicated photographer at work on a full-time basis for a very long time. City dwellers will find the logistical problems involved in travelling from one point to another much easier to cope with than someone who lives miles away in the country. For non-residents, visits to the metropolis are – apart from work – occasional and often enjoyable affairs lasting but a few hours. Unlike the resident, their knowledge of city life, of interesting places, unusual architecture and general landscape, is sparse, albeit sufficient.

Curiosity however, is another thing. City dwellers are invariably no more surprised by what they see on home ground than the farmer on his land. The outsider, coming in cold, is often amazed by city sights. Photographers are no exception. If anything, their curiosity is heightened by the freshness of new sights and sounds, adding spontaneity and animation to pictures and ideas for pictures frequently taken for granted by the resident. In a way, that fresh approach is a mixed blessing. The resident photographer concerned with image-making has one simple but important advantage over the outsider: knowledge of the subject. What will often take the visitor several visits, possibly even years to discover, the resident may already know. Professionals required to make cityscape portfolios for magazines will return several times over a long period to the same location and, even then, they cannot be sure that sufficiently useful coverage will have accrued. Knowledge of the subject is the single most important factor that helps the photographer to produce consistently good material.

Faced with a blank sheet of pristine white paper, the writer can possibly be forgiven for stumbling over the first word of a sentence before the gist of an idea blossoms into a full blown paragraph. It may take ' minutes, hours, even days before the first word is written. A photographer's plight in finding new angles and in making interesting and creative pictures is not so far removed from that of the writer. One needs a degree of tenacity which is matched only by the artist's patience in repainting a potential work of art, to keep taking the pictures, until everything has been wrung from the subject.

Do not be overly concerned if you lack precisely the right or recommended equipment. Many great photographs have been made with the simplest camera. Feininger's first big telephoto lens was purchased in a Paris flea market and, as I have already pointed out, there is still a wide choice of almost antique but perfectly serviceable lenses which can be modified to fit many modern cameras by a competent turner.

There is little to add, except perhaps a reminder. Photographers should always carry a camera. The lesson to be learned if you don't is that for every picture missed, there will be a blank page in the memory, and an intermittent but nagging reminder of the one that got away.

And so to Paris, where impressions continue to excite and my cameras continue to work.

Paris is, for me, a city without parallel. It is all things to all people: a treasure trove of art and history, of love and romance, of wonderful architecture, of exotic, extravagant and expensive fashions, of a way of life as different by night as it is by day. It is an old city, torn and ravaged in the past by wars and revolutions and more wars and, today,

155

battered by pounding, screeching motor cars. Much of the past is still standing, coveted by Parisians and much admired by visitors. There is also a lot that is new, some of it despised by residents and much which is admired, again, by visitors.

Although there are other cities which I like almost as much, there are none that I have yet seen which attract me in the same way as Paris. While there is much that is familiar after many visits, there is still more I have yet to see and explore with my cameras. Treading its streets is a little like walking over the frames of a documentary movie; you feel the history and see new images at each and every turn.

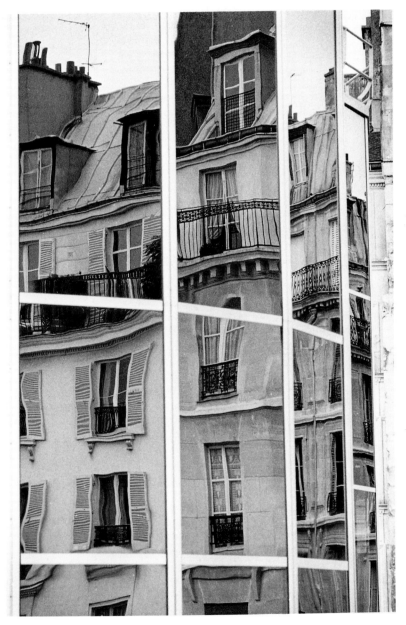

102 (LEFT) *Of Les Halles, the famous market place, there is nothing left except a monumental glass house garden development in which the old style Hausmannian-architecture is reflected. (Nikon FG; 80–200mm zoom Nikkor; HP5)*

103 (RIGHT) *Towers of La Defense; an almost monstrous but fascinating business development on the edge of the city and plainly visible from Etoile. (Nikon F; 20mm Nikkor; HP5 with red filter)*

104 (OVERLEAF) *In total contrast, but only a stone's throw from the modern towers, I found a side street of older buildings. (Nikon FG; 80–200mm zoom Nikkor; HP5; 1/125 second at f4)*

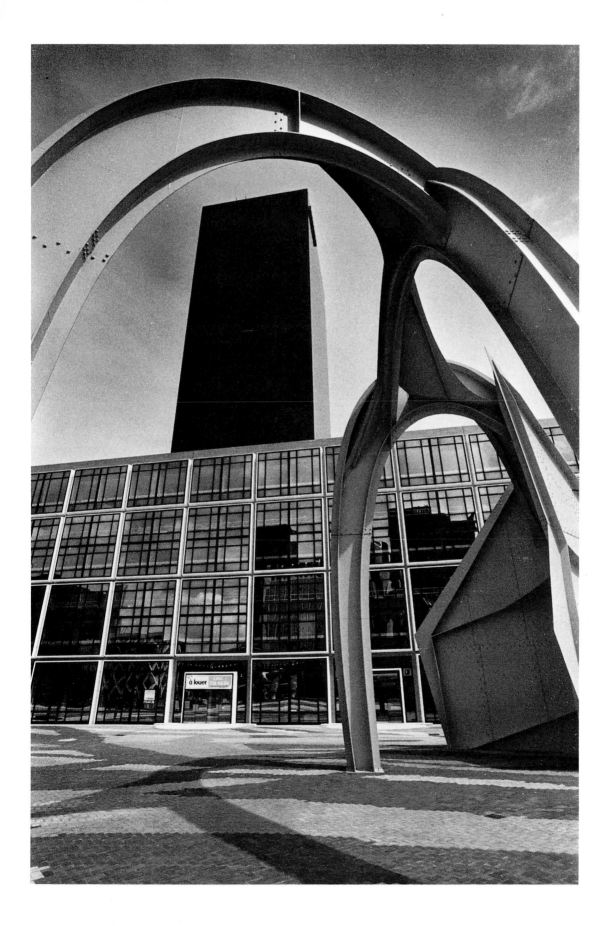

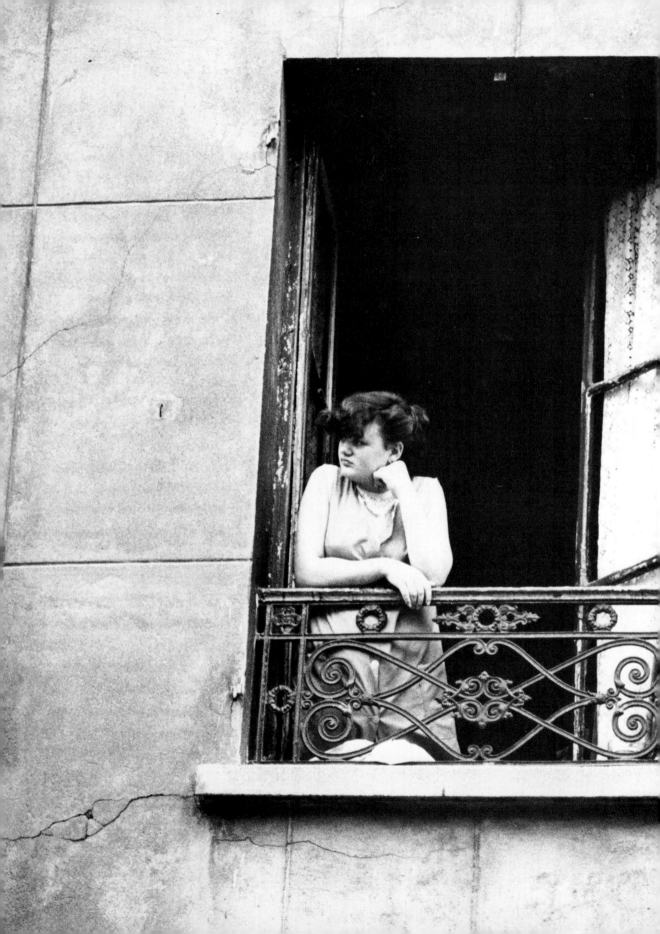

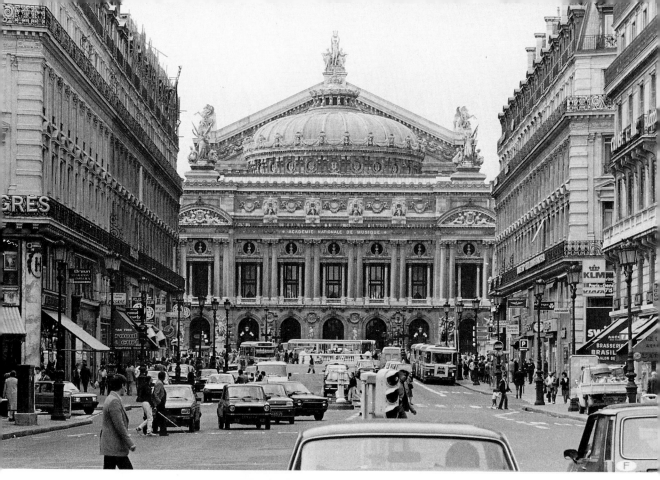

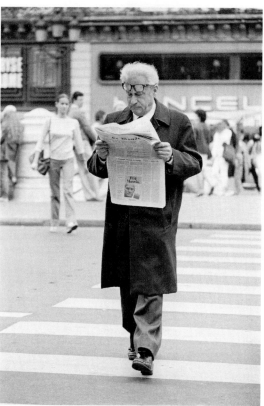

105 *Palais Garnier, after its architect Charles Garnier. Built in 1862, it is better known today as L'Opéra; viewed with a 200mm Nikkor along Avenue del'Opéra. (HP5; yellow filter)*

106 *The world at a glance. (Nikon FG; 80-200mm Nikkor; yellow filter; HP5)*

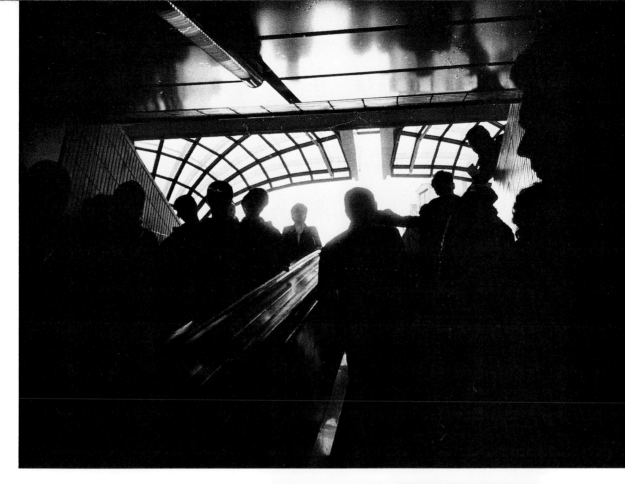

107 *Around Les Halles, images are reflected in all directions, even the Metro entrance is a glass house. (Nikon F; 28mm Nikkor; HP5)*

108 *Gare St Lazare (Nikon Rangefinder; 28mm Nikkor; HP5; 1/15 second at f3·5)*

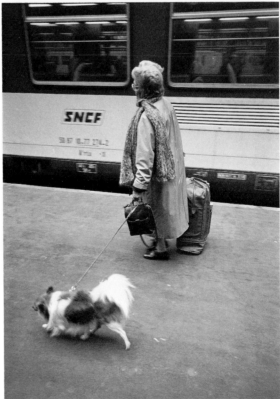

109 *Near Javel, in the backstreets. (Nikon Rangefinder; 28mm Nikkor; HP5; 1/250 second at f 6·3)*

110 *Gardens of the Palais Royale. (Nikon FG; 80-200mm Nikkor; HP5)*

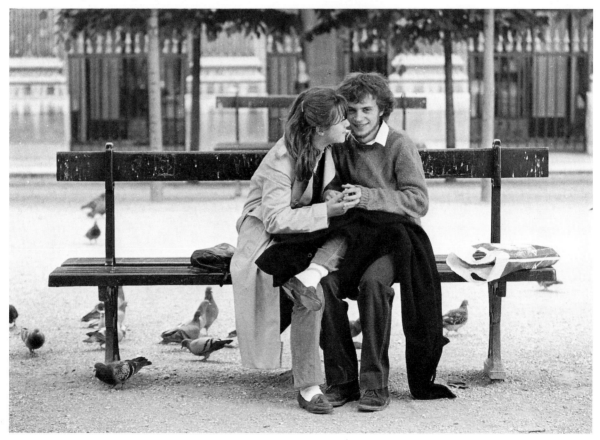

111 (RIGHT) *Nikon Rangefinder; 50mm Nikkor; HP5*

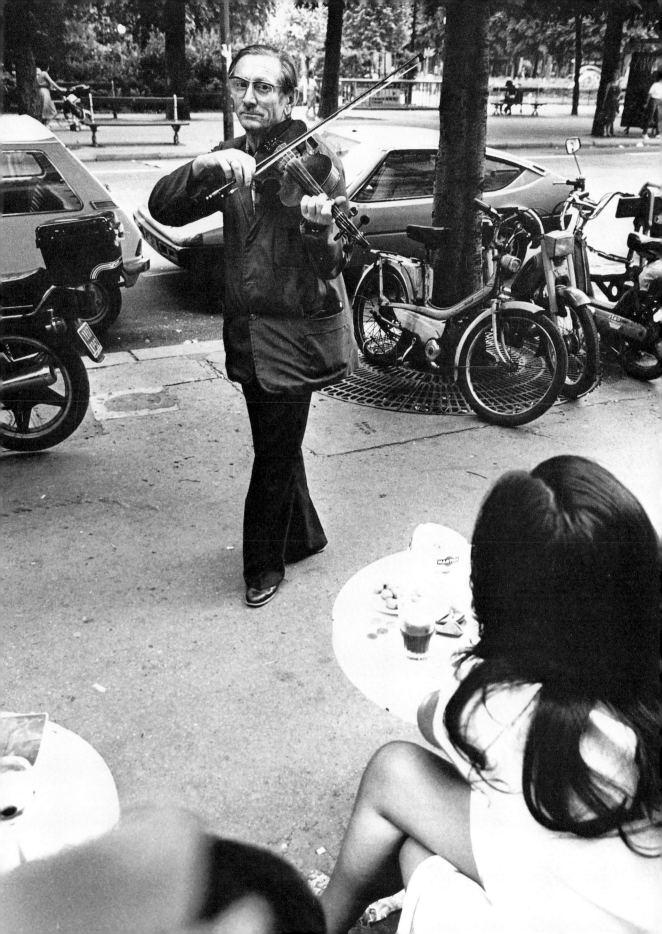

113 and 114 *Empty tables. Usually they are packed, especially when you desperately want somewhere to sit and watch the world go by. (Nikon Rangefinder and 28mm Nikkor; Nikon FG and 80-200mm Nikkor zoom, both on HP5 and both late in the day)*

115 (BELOW) *But tables at the Cafe de la Paix are always oversubscribed. Delightful company and superb Viennese chocolate! (Nikon Rangefinder; 28mm Nikkor; HP5; 1/250 second at f8)*

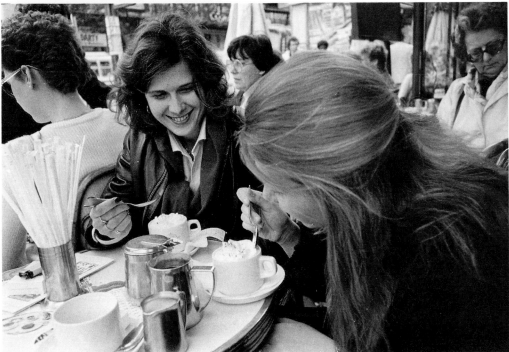

112 (LEFT) *Onze! Onze!—Citroen Eleven, last of an era depicted by painters like Frank Will and adored by Maigret fans. Now they are being given a new lease of life by classic fanatics. (Nikon FG; 28mm Nikkor; HP5; 1/60 second at f4; late afternoon near Boulevard St Germain)*

116 *Near Montmartre (Nikon Rangefinder; 50mm Nikkor; Plus-X; 1/125 second at 5·6)*

117 *A certain M. Gustaf Eiffel was responsible for this amazing construction, completed in 1889. The third floor observation platform is 280m high and affords superb views of the city. This picture was made at dawn on a wet autumn morning from the Trocadero. (Nikkormat FTN; 35mm Nikkor; Tri-X; orange filter)*

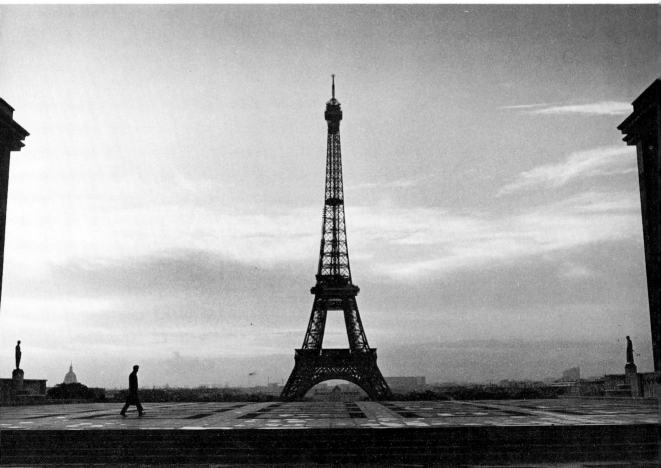

Index

References to illustrations are printed in italics.